EVERYTHING AND NOTHING

The Dorothy Dandridge Tragedy

EVERYTHING AND NOTHING

The Dorothy Dandridge Tragedy

DOROTHY DANDRIDGE
and EARL CONRAD

Perennial

An Imprint of HarperCollins*Publishers*

A hardcover edition of this book was published in 1970 by Abelard-Schuman Limited.

HarperCollins books may be purchased for educational, business, or sales promotional use. For information please write: Special Markets Department, HarperCollins Publishers, Inc., 10 East 53rd Street, New York, NY 10022.

FIRST EDITION

Designed by Stanley S. Drate / Folio Graphics Co. Inc.

Library of Congress Cataloging-in-Publication Data
Dandridge, Dorothy, 1924–1965.
 Everything and nothing : the Dorothy Dandridge tragedy / Dorothy
Dandridge and Earl Conrad.—1st ed.
 p. cm.
 Originally published: New York : Abelard-Schuman, [1970].
 ISBN 0-06-095675-5 (alk. paper)
 1. Dandridge, Dorothy, 1924–1965. 2. Motion picture actors and
actresses—United States—Biography. 3. Afro-American motion picture
actors and actresses—Biography.
I. Conrad, Earl. II. Title.
PN2287.D256 A3 2000
791.43′028′092—dc21
[B] 99-46218

00 01 02 03 04 ❖/RRD 10 9 8 7 6 5 4 3 2 1

CONTENTS

FOREWORD

Dorothy Dandridge died on September 8, 1965, at the age of 42.

It is not generally known that certain friends, unintentionally, hastened her death by warning her that if she told her life story, she would hold back the march of black womanhood. Dorothy Dandridge wanted to tell of her friendships and romances that crossed the color line. But her friends attacked her in full force, telling her that her autobiography was a disgrace and should be kept quiet.

She was so crushed by these "friendly" advisors that she became ill and for three days lay near death. Miss Dandridge came back from that illness and decided that she *must* tell her story. It took another eight months for her to write her autobiography and to die a death hastened by champagne and pills.

It was not suicide, it was a murder that took a lifetime.

Five years have elapsed since the death of Dorothy Dandridge. During the 1940's and '50's, it seemed as though the effort in race relations in the theatre was in the

direction of integration. She won a place in the white world, in the world of entertainment, in Hollywood, and in international cafe society. Sometimes she felt as if she had "made it" and at other times "success" seemed far away.

She had many white friends. She wanted to marry a white man—for all that might symbolize in our country, in her life, in the lives of all peoples black and white.

She had a transitional political symbolism. She thought of herself as an experiment in integration, a wedge into the white world. It was a killing experience. She suffered much personal privation and the disappointments of her days mounted and became more than she could bear.

Dorothy Dandridge, a sensitive, beautiful black woman lived a life during which she did not fail. The failure was that of others, black and white, but mostly white.

EARL CONRAD

PART 1

View from the Abyss

"Exotically beautiful saloon singer of the Western World," the critics called me. They never went in for understatement. ". . . One of the great beauties of our time, a sex symbol to magazine editors the world over, and Hollywood's first authentic love goddess of color."

My gross earnings had exceeded a million dollars when I was in my mid-thirties, and I was the only Negro actress to achieve both film stardom and a nomination for a best actress Academy Award.

By that time too I had been pursued and courted by leading Caucasian film people, North Americans, South Americans, and Europeans. That was me only three or four years ago.

Then, suddenly, within a three-week period, a portion of my world cascaded around my head like a gushing river.

First I learned that I was broke from poor investments in Arizona oil wells, so I filed a hundred-thousand-dollar bankruptcy. A day or two later I was in court to divorce my second husband, a handsome white man, Jack Deni-

son, with whom several years of living had become a nightmare. A few days after that I was legally evicted from my sixty-five-thousand-dollar showplace home in the hills overlooking Hollywood. As if this were not enough, just as I was losing my fortune, my husband, and my home, my retarded nineteen-year-old daughter Lynn was returned to me.

All of these events converged with paralyzing swiftness, with crisis upon crisis. At the end, all I wanted was to take a long walk off Malibu Beach. My career seemed crushed and over with.

That collapse of fortune left me as bewildered a human being as you could find. Not knowing which way to turn or how to recoup, desiring death more than anything else, I took pills. Pills to pep myself up, pills to slow myself down; I took Benzedrine, a dangerous item if you overuse it. I took Dexamil and Dexedrine, appetite deterrents. I took thyroid pills and digitalis.

Three trucks of the Bekins Van and Storage Company were moving me out. The truckmen were entering and exiting, carrying all my belongings, while the paper servers arrived with what I called "certificates." They tossed papers at me prepared by collection agencies, a supermarket, a pharmacy, anybody you can owe. My assets were down to five thousand dollars, and my debts totaled nearly one hundred and thirty thousand dollars.

You are supposed to smile and be helpful when you are sinking, and I tried. I ran to get hamburgers and French fries for the crew, while wondering how I was going to get money together to pay for the moving job.

"Oh, my God," I thought, "how will I pay off three trucks?" I don't know how many men there were, but the scene looked like a movie lot.

How do you convey your emotions about the sudden

loss of a showplace house in the hills, from which you look out across Los Angeles at night at a million lights, and you feel like you own the town?

I am nothing but emotion; I am nothing but a wind of emotion; and everything was blowing as I took a last look at the interior of the house: the long living room in beige carpeting that was deep enough to twist an ankle in, the beige walls, the cream-colored frames on the pictures, the long brown sofa, the low round marble-topped table on the brown oak legs, the decanters of brandy and wine on the table, the transparent ash trays, the ornamental lamps, the vases choking with flowers I grew in the side yard, the four tan and white square cushions piled in the center of the room, where I sat mostly on the top cushion, the roofed patio where Jack and I used to sit and have breakfast or squabble. I looked next door at the house where Sammy Davis Jr. and May Britt lived, and beyond it at the home of Herb Jeffries and Tempest Storm.

While the truckmen dragged out my belongings, I flitted from room to room, grasping final visions: the walnut-paneled downstairs den where I read scripts or played records, the shelves loaded with good books (now going in storage), the knickknacks on special shelves, the ornamental candelabra. And the bedroom for Jack and myself, where we didn't do very much except argue, but it was a beautiful room, beautiful enough to have been printed in color in *Ebony*.

Under my feet my two dogs traipsed, not understanding foreclosure and court appearances for divorce and bankruptcy proceedings. I didn't quite grasp that myself. Cissy, my little mongrel, and my husky, Duke, were getting their last romps through the rooms. I would have to put them out of my life too, and in my new small apartment

near the Hollywood Strip I must content myself with a half-dozen pink and white cloth dogs.

Outside, picking up another "certificate" from a server, I glanced again at the cerulean blue exterior of the house. A lonely palm tree at the side rose well above the rooftop. The green grass looked fresh and permanent. I took a long last look across the thickly settled city plateau of Los Angeles. From here you could see most of it, and on a clear day make out the bay at distant Santa Monica. Right now the usual haze hung over Los Angeles.

By coincidence, when the world was falling in on me and when I had to be in court daily for one thing or another, either the bankruptcy or the divorce, the woman who had been looking after Lynn from the age of nine to nineteen returned her to me. I was in arrears two months in support of Lynn, after ten years without missing a week.

While the moving men were at work, Lynn, impervious to the meaning of anything, sat at the Mason & Hamlin. Ever since early childhood she had liked to sit at the piano and play do-re-me-fa-so-la-ti-do over and over for hours. Over and over, merely the scale, never even varying it, until you could go mad with it. Once in a while she turned around coyly on the stool and wanted me to applaud. The truckmen noted the single-themed concert and got the idea. They applauded too.

Papers kept arriving and I, grinning as if this were all a routine ritual, served hamburgers and coffee, applauded my daughter, and patted the dogs. Yet inwardly I could see and feel my whole career in show business—and my whole personal life—tapping right offstage.

Alone as I was in this crisis, I didn't miss the presence of my husband. I preferred to go through this by myself rather than with him. Something happened to Jack during or even before the marriage. Jack lost his night club, and

with it he seemed to lose his will to recoup his fortunes. I tired of trying to get him up off the floor. He came to depend upon me as the breadwinner, and that irked me terribly.

When the house was finally locked up, when Lynn was in the hands of relatives, I wound up in a nearby motel where for many nights I stayed untill an apartment was available. As I stayed by myself in this neat, clean, well-equipped dead end, I asked myself over and over, What happened? How did I get here? What do I do now?

There is a saying around Hollywood, "I don't make a move without my lawyer." They also say this in other circles, in crime and high–finance. I have said this too, but in my case I now paraphrase it, based on numerous experiences: "I don't make a mismove without a lawyer."

You hire a man to advise you on legal and financial matters; he represents many important stars; he is a big man in the Hollywood scene. You have to place your trust somewhere, and he sounds reassuring. You take him on to handle your smaller affairs at first, bills that you don't have time to deal with, to issue checks that have to be taken care of on the spot, and so on. He looks over your contracts, takes an interest in your career. You are on the road for months at a time, so he handles your business mail. When you return after a prolonged absence, he goes over everything with you. It all looks good: there is money in the bank, the fortune is growing, you are getting picture deals, saloon appearances. Gradually you develop confidence in him, you talk about how to invest money. You know that he advises other top-name screen money earners. He likes you, you like him; the relationship is warm, and you take pride in the fact that he is one of movieland's

successes. There is a sense of security in that. There is a tendency to trust success and bigness, isn't there?

One day he phoned to tell me about a great money-making opportunity in Arizona oil wells. I could start easily with one or two wells. Oil was already coming in, this was no gamble, and many Hollywood stars were in on it. He named some names, and they really were in on it: Doris Day, Kirk Douglas, and others.

Rual Steddiman, that was his name, told me how much in round figures I might get from a well in the first four years of its operation, and so much a month for the next few years. There was much that I didn't understand from these early explanations. I didn't know that I actually had to finance specific wells—the labor, the equipment, the whole pumping operation. I didn't know that these wells might not become profitable for fifteen or twenty years, if ever. I didn't understand that in addition to sinking capital in the ownership of the wells, I had to have back-up capital for years and years. This wasn't explained to me, or perhaps Rual himself may have felt it would be no problem. I don't know.

In some way the partners in this oil operation were all screen star clients of Rual Steddiman. He handled their affairs generally, and they followed him into the oil deals also. In addition, they were paying his portion of the oil holdings. Though I was only a partner, I was well up there with the larger partners. I was also signing paper after paper, including power of attorney, giving Rual the right to handle my money, and I slipped all my available bank capital into the operation.

I found I was living, as far as annual expenses were concerned, on income I picked up from frequent saloon appearances. But all screen money was dropped into oil. The worst mistake of all—I allowed Rual to convince me

that I should take expected earnings for the following years and employ them as investment capital in buying more wells and keeping them operating.

In the mid-fifties, I had a three-year contract with Twentieth Century for seventy-five thousand dollars a year, one picture a year. Rual convinced me I should borrow on expected income—the whole amount—and put it into oil. I did. I was up to my ears in oil. Though it was being pumped (in not too large amounts) around Phoenix, I could smell it high up over Hollywood.

My accountant, Mel Parker, hinted to me that I had gotten in very deep and that I should get in no deeper or find some way of selling out. But how could I believe I had made a mismove when I would get a call like this from Rual? I was back in Los Angeles for a few weeks, and here was his voice on the phone:

"Hello, Dottie?"

"Yes, hello, Rual."

"I have wonderful news for you."

"Let's hear it."

"Besides the oil, gas is coming in."

"Is that good?"

"It's great. Gas is great. It's more than we counted on. You'll be rich."

"How much will the gas bring in?"

"All I can tell you is these investments will make you secure for the rest of your life."

"For the rest of my life?"

"For the rest of your life. You won't have to worry about anything. You'll be able to quit the saloons any day now. When you're forty, you won't have a thing to worry about."

"Wonderful, Rual. Is there anything I can do?"

"Just keep the back-up payments coming along. The others are doing it for their wells."

In my trilling singing brain I had this vision of something big going on. You know—you drive along the freeway and you see Shell, Texaco, and everything; it all looks pretty big, and I'm in on it too!

I got a call from Evie Johnson, who was Van Johnson's wife at that time. She was my friend, and she said, "Get away from Rual. Get away from that oil. Get away now."

"What are you talking about?"

"You'll lose everything if you don't get out."

"How do you know?"

"You can't keep stoking money into oil wells. Your money will run out. These wells are not paying off."

"They are bringing in gas now. They didn't even expect that."

"Yeah, you're getting gassed. I warn you, get away from that lawyer."

I was warned, not just by Evie but by others who were in the know, and by my mother. I should at least have investigated. I didn't listen. I told my mother I socked a hundred thousand into Arizona oil, and she said, "You made a mistake, Dottie. You should have put it into real estate. Real estate is the safest, the best."

I didn't listen to my friends, I didn't listen to my mother. I was now in high–finance. Nobody could tell me what to do.

Sharper warnings than Evie Johnson's came from my accountant. Mel talked very sternly with me one day.

"Listen, Dorothy. You don't have much operating cash left. Those monthly payments you are making to Steddiman will have you strapped very soon."

"You can't be right. You must be exaggerating. I am

living very well off my saloon earnings. I can put the screen money into oil, I'm sure."

"I'm warning you, Dorothy. I don't like the way it looks. Those wells are deep and they are souping up your dough faster than they are giving out with oil."

"Don't be silly. Let me handle that."

Around that time I had allowed myself to be talked into a last package of four oil wells. Like a kid on a bicycle headed for a fall, I could say to my mother, "Look, Ma, ten oil wells!"

I had been sinking several thousand dollars a month for three full years into oil. Meantime many of the other big-name investigators got out of the oil deal. Kirk Douglas paid to get out of it.

I received another warning from my accountant, but I didn't seem to hear him or to believe him. I blocked out what was unpleasant to me.

The calls kept coming in for more keep-the-wells-going money, and I kept sending it. But I began to owe money. The payment of bills slowed up. Then at a certain point when I couldn't finance the operation of the wells, the workmen simply stopped working. They just stopped pumping. I didn't know anything about labor, pumping equipment. I never understood that my money was actually financing the oil operations, and that I might have to keep these wells going for ten or fifteen years before seeing a profit—if I ever saw one.

Barnum came and passed away too soon to hear of me.

While all that was in deterioration, I still had dreams of ultimate oil wealth and thought I would be in a position to leave money to some people I liked. So one day I went to Rual's office to make out a will. I worked with one of his young aides who knew I was already broke, and there

I was making out a will and leaving money for the care of Lynn. This lawyer was impatient with me because he knew I didn't have any money left. He spent an hour and a half with me, and in retrospect I think he was inwardly laughing at what we were doing. I was making out a will to leave money and possessions I no longer had to a little girl I never really had.

Early in 1963 I got a call from Mel Parker. He told me I had made the last payments possible on the oil deal, because I had no more money to keep that—or anything else—going. "You're broke, Dorothy."

"What do you mean, I'm broke?"

"What I am telling you. You don't have another dime."

"That can't be."

"It can be. I've warned you. Everybody has warned you."

"What happened?"

"Let's say you invested unwisely. You signed papers. The papers you signed are legal."

"Migod, I have no pictures coming up. I'm getting older. I can't sing in saloons forever. What can I do?"

"File in bankruptcy. There's nothing else you can do."

"Bankruptcy? My name'll be mud. I can't afford not to pay the people I owe. I can't, I can't."

"You can't do anything else. It's the only way you can save your neck. You'll lose your house anyway."

"Do I have any assets at all?"

"Maybe five thousand."

"Only that out of the million I earned?"

"That's all."

"Can I sue Rual?"

"I don't think you can find a lawyer who will move against him."

And I never could.

If it is possible for a human being to be like a haunted house, maybe that would be me. Weird winds howl inside me as I seek in psychiatry answers to my confusion; chains clank inside me, echoing my success and failures; corridors of hope and despair creak; and there is a daily sobbing as if someone inside is desperately hurt.

If it weren't for my belief in God, I'd think none of it was worthwhile, the winding hole-ridden stairs, the shutters that rap and rap, the dust and webs of living, the too too intricate designs that a thousand spinning spiders can make. To wind one's way sinuously from the most tenuous Cleveland ghetto origin into the labyrinths of our day's concept of "success"; to feel stardom, love, excitement, triumph; then to spill headlong down into caverns of self-recrimination and inward loathing—it is an odyssey that should be told from the beginning.

Part 2

The Wonder Kids

I began show business at three with a recitation in church of Paul Laurence Dunbar's poem "In the Morning." This was a ballad about a man named Elias who slept all the time, and his wife couldn't get him awake in time to do any work.

Until the day I first delivered it before an audience, it had been a favorite piece of my mother, Ruby Dandridge.

When my mother was a young, lithe, light-skinned woman living in a small apartment in Cleveland, supporting my older sister Vivian and myself, she took part in local theatricals. She could sing, dance, she was an acrobat, and she had an expert way with Dunbar's poems. In the mid-twenties, Dunbar was the favorite poet figure of the Negroes, and whites lauded him as a master of idiom, mother wit, and folk quality.

Ruby Dandridge was in demand at socials and church affairs for her various gifts.

One day she was tired, and as I toddled around our kitchen I heard her say she wished she didn't have to go to that night's gathering. I had always gone with her and

listened to her performances, and I spoke up. "I'll do it for you, Mama."

"What you gonna do, baby?"

"I'll do 'Lias." That's what we called Dunbar's stanzas.

" 'Lias? You know you can't do that, baby."

I stepped to the center of the kitchen and recited the six long stanzas that my mother had made famous locally.

Mother grabbed me up. "I'll make you a promise," said my mother, starting me on my career. "If you go out there and do 'Lias for me, and you don't cry, when you get home I'll give you a great big fifty cents." She didn't believe I could do it.

But that evening, in a little wooden church a few blocks from where we lived, I walked up on the platform and, in dark inflection, cadence, and idiom, recited:

> 'Lias! 'Lias! Bless de Lawd!
> Don' you know de day's erbroad?
> Ef you don' git up, you scamp,
> Dey'll be trouble in this camp.
> T'ink I guine to let you sleep
> W'ile I meks you' boa'd an' keep?
> Dat's a putty howdy-do—
> Don' you hyeah me, 'Lias—you?

Plus five more verses carrying 'Lias to his still-napping conclusion. Today that verse might sound like a stereotype from another time, but valid then or not, it drew laughs that evening, and everywhere during the next few years.

After my recitation I applauded myself. The audience joined me, and they launched me, willy-nilly, into the theatre.

After that night I had an immediate career cut out for myself: reciter, jokesmith, dancer, and singer in the jim-

crow halls, churches, and meeting houses of every Southern state.

No sooner had I returned home from that first evening's success than I heard my mother say for the first time what she would say repeatedly through my childhood: "You ain't going to work in Mister Charley's kitchen like me. I don't want you to go into service. You not going to be a scullery maid. We're going to fix it so you be something else than that."

My sister Vivian, who was a year and a half older than me, said, "If Sister is on, I'll go on too."

From that time on, Vivian and I were in demand at church performances all over Cleveland's colored community. Vivian said she wanted to play the piano, and she did learn to play, but piano never interested me. I wanted to dance and cavort and act all over the stage.

My mother sat at the kitchen table and worked out skits, verses, and routines that Vivian and I could perform. Based on her knowledge of the Negro folklife and ways, she devised swift little entertainments that my sister and I could put on; and, to the restrictive dark environment of the Cleveland of those days, we brought some spark of laughter.

"Maybe you get your ways from my father," Mother told me. Then she would tell me about her three brothers whom I never saw and her father, who was a musical and religious West Indian known variously as George Frank and George Butler. He was born in Jamaica and came to this country late in the nineteenth century at the age of eight. He had a winning West Indian accent and charming manners, and when he was a young man he married a Mexican girl. My grandfather sired four children. He taught them music and religion, and my mother, the youngest in the family, took most to the music. Still it

didn't help her much in the early years for, like most Negro girls, she was in Mister Charley's kitchen where she was scrubbing and cooking when I was born. I never met my grandfather, but I heard tales of his intriguing accent and how when he entertained neighborhood children with Robert Burns' famous poem, "a man's a man for a' that," he pronounced it "A mon's a mon for a' that," which had particular meaning in the time when the manhood of a man of color might be disputable.

George Butler became known as an entertainer appearing before white and colored, but at last he settled in Kansas and ran a grocery for a while. Later he ran the local Negro school. He wound up principal of that school, and the legacy of his appreciation for learning was passed on from him through my mother to Vivian and to me.

My mother was born in Kansas, where she attended school, and from her father learned such ranging interests as dancing, singing, acrobatics, horseback riding, and in general acquired the theatrical flair that George Butler had. Later on she appeared on radio and TV with Amos 'n' Andy.

My maternal grandmother was Mexican, one-half Spanish and one-half Indian. Beyond that I know nothing of her, but the mixture is meaningful, for if I am in any way a symbol, it stems from my being a "mixed American." The melting pot characteristics are written into my features. By parental and grandparental relationships on both sides, I am one-fourth English, one-fourth Jamaican (which is often a mixture of Indian, English, and African), one-fourth American Negro, one-eighth Spanish, and one-eighth Indian.

Much of my mixture descends from the father I never knew as a child. No man was around in my early years. All that I received from my father was his name, Dandridge,

and all that I know of Cyril Dandridge's background is that he was the son of a white British gentleman and an African woman whose interracial marriage occurred about eighty years ago.

From these varied ancestral sources, I was bequeathed a light brown coloring. If it is true that the American Indian was of Asiatic origin, then my physiological composition is about as international as is possible. All that has happened to me in life seems in mystical ways related to this genetic inheritance.

My father and mother broke up while my mother was pregnant with me. She left him, and I have never learned clearly what the breakup was about, but Ruby Dandridge said she had mother-in-law trouble and also that Cyril was no provider.

The only association I have even with the idea of a father goes back to that same period when I began as a performer. It was Christmas Eve, and the evening began with an air of excitement. "Santa Claus is coming tonight," my mother said.

There were green and red banners over the doorways. In a corner of the living room stood a small tree decked with hanging ribbons, stars, and bells. An arc-shaped Merry Christmas was on one wall.

We had heard talk of Christmas from others, and now my mother seemed so excited about it. "Santa Claus is coming, and you children can't be around. You got to go upstairs in the attic while Santa comes."

"Why?" I asked.

"Because that's the way it's done. Santa comes and puts something on the tree, and you little ones have to be in bed."

It was mysterious and exciting, as Christmas Eve has been for children all over.

As the evening grew dark, I went upstairs with Vivian into the dim attic, waiting for whatever. In a little while we heard Santa arrive. Instantly there was a rising of voices. We couldn't hear what was said, although we listened hard. Santa was fighting with Mother. The voices rose to a shout. Bitter, hard arguing. What was Santa leaving on the tree? Vivian and I cowered and clung close as the noise went on.

It went on and on—not just for a few moments but for an hour or two. I grew afraid of Santa Claus. I said to Vivian, "I hate Santa Claus."

"I hate Santa too," she said. "He makes so much noise."

Vivian and I began to cry. We cried because it was fearful and violent below, and we didn't know what was going on or why.

Finally we heard the door slam. Santa must have gone. A few minutes later Mother peeked into our quarters and told us to come out.

"Stop crying," she said. "Your father is gone. In the morning you'll find nice things on the tree."

From what Mother said that night and at times thereafter, I have tried to put together what might have happened. Father had come to the house on the same night when Santa was to arrive. Had Cyril Dandridge tried to resume with Ruby? Did he want to see us? Had he wanted to leave presents for us? Mother often said that he was a nice man, but if so, why couldn't we see him that night? I've no way of knowing, except that on that evening Santa and my father became curiously rolled into one.

* * *

A proxy parent came into the picture. This substitute father—that is what it turned out to be—was a woman for whom I developed a permanent fear and hate. Somehow much that I am and much that I am not I attribute to the near-sinister creature who walked into our house to help my mother, and stayed for the first half of my lifetime.

My mother and this woman fell into an alliance based upon mutual desperation. Mother had two small children, no one to take care of them when she worked. This new-found friend was a minister's wife. For her, life with the minister had become intolerable and she had broken with him. She and my mother befriended one another. The agreement was that this stranger would find shelter and privacy in our house. She would take care of Vivian and me, in return for which my mother would work and take care of all of us and keep the whereabouts of Eloise Matthews a secret from the man she had left.

I can understand how my mother, with her rearing which prized education, could take to Eloise. This woman had been a music teacher at Fisk University. She was a good singer and had been musician and singer in churches with her minister husband. So there was an affinity and accord with my mother, and with what my mother had in mind for Vivian and me. The woman was qualified to teach us.

We called the stranger Auntie, usually Auntie Ma-ma, with the accent on the second ma. This woman who, from the first, became an ogre to me, stayed with us until we grew up and until I could break away from her. Now you don't do that, you do this, slap, bang, wallop, do what I tell you, be good, that's bad, bang, wallop. I had a crying childhood. This mistreatment could occur because my mother was always at work and didn't know what was

going on, and when I told her, it seemed not to register, nor to alter the whippings in any way. My mother must have badly needed Eloise Matthews.

Auntie Ma-ma was tough, a source of cruel and incessant discipline. In her querulous way she provided a certain stability to the house, the kind that an authoritarian hand may sometimes achieve. While my mother worked, worried, faced fears of the landlord, and carried the burden of food-getting because she had the complete economic responsibility, Auntie Ma-ma presided over our home like the Rock of Gibraltar.

Vivian wasn't treated as I was. She was a quieter girl. She would say to me, "Dottie, what happened today? Mama hasn't put the brush to you."

"Wait, Vivie, the day isn't ended yet. I'll get it." And I got it: brutal beatings across my backside, hard pushes and knocks, but mostly that hairbrush, sometimes the bristle side, sometimes the flat.

Never could I feel that she was kin, though I called her Ma-ma. It's conceivable that I received some kind of training or teaching from her which was helpful in show business, but in nothing did she endear herself to me. It was many years before I had a chance to rebuff her. I am unable to look back upon her overseership of me for a period of fifteen years with any gratitude. Later, when I speak of my first trip to England, I'll tell you one bloody reason why.

Auntie Ma-ma had the security of my mother's support, and her need to do something in the world was that she viewed herself as a stage mother to Vivian and myself. She cultivated our talents. She considered she was helping to make something of us. She had ability behind her stern nature, and she slammed it into me.

The entertaining that Vivian and I did from the age of

three to five around Cleveland was not money-making. We made frequent appearances because it was a duty, it was service and glory, and my mother and Auntie Ma-ma viewed it as training. Our repertoire broadened, and we developed a style during our abnormally early baptism in show business.

In the house where we lived was a Mrs. Phyllis Dunbar, a Negro woman who was fond of me and my talents. She cheered me at church, laughed at my antics. I was in her apartment often.

One day she asked my mother whether she could take me to Washington for a few days. There were to be Easter ceremonies on the White House lawn, including an egg roll for children, and photographers to catch the antics on that famous front lawn. It was the time of Calvin Coolidge.

On the green I took off my shoes—the same way as I would a generation later in the night clubs of the world— and did a song and dance for President and Mrs. Coolidge and the press. There were many other events that day, but I had my fragment of a moment, and even a few seconds of talk with the President as he bent and shook my hand.

I have little recollection of what he said then or any time thereafter, which places me in the same situation as the nation's historians.

Sunday School and the Shiloh Baptist Church are among my earliest recollections. Over and over I had drummed into me the Christian idea of forgiveness; you must forgive seven times seven the transgressions of others upon thee. Once when I gave away a lovely sweater that Mother had made for me, she asked why I did this. I told her I was taught in Sunday School to give. So my

mother told me not to overdo giving, but to forgive people who wronged me.

This contradiction of Christianity planted a confusion within me which would remain and bedevil me, making it inevitable for me in adult life to forgive men who injured me.

I sang in the church choir because Mother sang in the choir. When I heard her singing with the others, I also sang the old hymns like "Don't Let It Be Said." I memorized the words of "Swing Low, Sweet Chariot." First I sang in Mother's arms, then in Sunday School sitting with other children.

I had a jealous regard for my mother. I wouldn't let men sit beside her in church. Once after church, Mother asked me why I wouldn't let a man sit beside her. "Why should I?" I asked. "Because he felt like sitting," Mother answered. I did this over and over, not allowing men to be near Mother; I don't know why. I could tell when a chastising was due from her for this offense. I said to Vivian, "I'm in for it now." Mother berated me for my possessiveness. I had no father, knew no father. It had something to do with that.

Mother dinned into me what had been dinned into her: "No one is all good and no one is all bad. There is some good in everyone if you will look and find it. Even a bad one has a good spot somewhere." When I fought with other children and explained to Mother that I had been wronged, she answered with that philosophy: "Forgive. There is some good in that boy or girl." She would quote that line about forgive us as we forgive our transgressors.

This outlook handicapped me in a competitive environment, and later, when I would run with the wolves of cinema, theatre, and night clubs, is it any wonder I often did not know how to deal with those who could take me

in one way or another? I grew up on the Christian idea of meekness, forgiveness, and "understanding"—and I would one day have to "understand" producers, actors, agents, lawyers, psychiatrists, insurance agents, suitors, double-crossers, chiselers, parasites, and greedy magnates in search of beautiful flesh.

An incident in the life of Auntie Ma-ma altered our fortunes. Her grandmother in Nashville died, and she had to go there at once. This would leave Vivian and me at home with no one to care for us while our mother worked.

A hurried decision was made for Vivian and me to go to Nashville with Auntie Ma-ma, and in a few months, at Christmas, Mother would come to us. Meantime she would work at The Clints, one of the better-known restaurants of Cleveland, and send us money.

That is what happened. Mother stayed on making pastries, sandwiches, and salads at the restaurant, and we went to Tennessee.

No sooner did we arrive than Auntie Ma-ma went to Roger Williams University, a religious institution then in existence. The director, with whom she was acquainted, saw and liked our entertainment. He arranged for Vivian and me, chaperoned by Auntie Ma-ma, to go on the road from town to town in Tennessee, appearing before Negro groups in halls, churches, and barns as the Wonder Kids. We made four or five hundred dollars each time we appeared. But the earnings were chiefly for the benefit of Roger Williams University.

It has been by such amateur operations that Negro institutions have kept themselves afloat.

What Auntie Ma-ma received from it I don't know. I remember that Vivian and I were decked out in nice new

clothes as we became the big news in entertainment on the Tennessee colored circuit.

When my mother arrived in Nashville at Christmas, it was decided that if her daughters were good enough to make money for Roger Williams University, they were good enough to make money for themselves and for her. She repeated the refrain, "Maybe now you can be something, and not be cooks in Mister Charley's kitchen like me. My hands is worked to the bone, and you don't see rainbows in dishwater."

Mother arranged with the National Baptist Convention for Vivian and me to perform at churches in a different state each month. Having that organization as our sponsor was, for the Negro community then, a little like having a deal with MGM for white folks. There were forty-five thousand colored churches in the South at that time. Baptist churches were the most numerous. The black Baptists had earlier broken away from the white Baptists, who wanted to rule and run them. The National Baptist Convention became an independent body and a source of much of the culture, progress, money-raising, schooling, and protest of the colored community. These Baptists helped finance the NAACP, the schools and colleges. Money-raising became their prime activity.

The Wonder Kids became another means to this end. Thousands of Negroes in all the Southern states in the next three years came out to see and hear us and to leave a few bucks for the performers and for the church and all its works. Our traveling expenses were paid, and there was a salary for each of us that ran several hundred dollars a month. It was enough income to support my mother and Auntie Ma-ma. Vivian and I became the best-dressed little girls in the country.

Mother knew our aptitudes, and she invented our

scripts. She knew how to exploit our smallness and vitality. She dressed us as two urchin boys, with caps on our heads, knee pants, our pockets bulging with string and clothespins.

I went onstage from one side and met Vivian approaching from the other. She was a larger girl, with a heavier frame, pretty hair, and an aquiline nose. She stepped toward me as a swaggering little boy, calling out, "Hey, fella, where you goin'?"

Me: Boy, I'm goin' out to sell insurance, get me some money.

Vivian: Insurance? What's that? What's that for? (Both of us were busy with fishhooks and kites.)

Me: Don't you know what insurance is? It's for your old age. Everybody gets old, and who's going to take care of you then? Better buy some insurance. (I flashed a sheet of paper before her.)

Vivian: I don't know about that. How much is this goin' to cost me?

Me: Fifty cents down and fifty cents the next time I see you. Give me four bits, sign right here. You'll feel good when you're old.

Vivian flashed four bits, all excited about feeling good when she was old. I pocketed the money and the audience, for reasons we children never understood, was uproarious. The fun was in the contrast of such lively little creatures having any concern whatever about old age.

For the most part the charm of what we did was in something I did not understand, for it seemed to me that the audience laughed in the wrong places. Maybe it was our littleness, our mock professionalism. We didn't allow the stage to drag. Droll gags came on, conceived by Mother—that or she dressed up old jokes to fit our style and look.

Vivian: I see you're goin' fishing. What bait you use, worms?

Me: I bait the hook with cigarette butts.

Vivian: Gosh, what you catch with that?

Me: Smoked fish.

Or:

Vivian: How you doin' in school?

Me: Fine.

Vivian: You good at ciphers?

Me: Very good at ciphers, but I can't count.

In another skit, dressed as a boy in overalls and a cap turned backwards, I did a number we called "A Boy's Stomach." It was about a lad who ate too much too fast too unripe, and I wound up rolling over the floor simulating a tummyache. Everything I did turned to laughter on the other side of the footlights.

I did another stomach routine in which I stood alternately looking at the audience, then at my middle, addressing my stomach thus:

I give you candy,

I give you apple,

And I give you cake—

And now you go an' ache.

I looked at the audience; I looked down again at my tummy, and I said, "What's the matter, ain't I good to you?"

Vivian was lighter than I. I would say to her: You white or black?

Vivian: I am.

Me: You am what?

Vivian: I am white or black.

The Negro audience would laugh uproariously.

Vivian and I clowned all over the stage with a lyric we illustrated by dancing:

> Heel and toe we always go,
> First your heel and toe,
> 　We always go together,
> Heel and toe and heel and toe
> 　We always go together.

We tumbled and tapped and illustrated the rhyme,
glanced at the heel and then at the toe. My mother wrote
all the lines, prepared the skits, rehearsed us, directed us
where and how to emphasize, when to look at the audi-
ence.

Once I had a badly sprained ankle. They wanted me
to stay off the stage. But I went on and limped my way
through the dances and enjoyed defying the pain. Nobody
had to teach me about the show having to go on.

We didn't let the audience or ourselves rest. The show
went continuously through two acts, running three hours.
If Vivian wasn't out there playing the piano, then Auntie
Ma-ma played a piece on the piano that either was or pur-
ported to be classical. At the end of the first act, and again
near the end of the second, Ruby Dandridge went on with
acrobatics. She tumbled and did tricks with chairs. At the
finale all of us were out there together—Auntie Ma-ma at
the piano, my mother doing acrobatics, and the Wonder
Kids singing up a crescendo. I've no recollection what that
last number was, or whether we ever varied it. It vanished
on the Southern air.

Night after night I stared into a sea of dark faces. We
gave a performance for adults one evening, and the next
night we entertained the kids. Then we would be on to
a new town. We were on buses and trains, or we stayed
overnight in a private house or a shack called a hotel; then
we moved on again. In every town, on arriving we always
saw posters on the church lawns of the coming of the

Wonder Kids. First, Second, and Third Baptist Churches. It seemed that there wasn't anything in the world but God and His churches.

I liked the applause. I enjoyed making people laugh. I did a parody of Al Jolson's "Sonny Boy": once more I was dressed as a boy urchin, hair flattened around my head. Offstage I was handed a candy bar called a Chocolate Bunny Boy, and then I went on:

> Climb into my mouth, Bunny Boy,
> You were meant for me, Bunny Boy . . .

I went down on my knees, as Al did, to that chocolate bar. I emoted and salivated over it. Halfway through the song, the crowd was always in a gale of amusement. At last I received my reward—I gobbled the candy, going at it greedily as a little boy might, while the audience applauded.

I liked that. The rough time I had with Auntie Ma-ma made me look to the crowd out there for kindness that never emanated from her. Auntie Ma-ma was always there onstage, offstage, the family Svengali, with a whack across the behind for good measure to make me toe the line.

I had only to get some jam out of the refrigerator to warrant a licking. Or eat a slice of bread when I shouldn't. Of a sudden she would be on me. "What have I done now?" I might not even get an explanation—just that brush whacking away at my backside. If a day passed and she didn't get around to this, it would be only because she was too busy and didn't have time to whip me.

I would see her coming and I would ask Vivian, "Vivie, what have I done?"

"You must have done something."

Auntie Ma-ma played the piano while we turned on the fun. She would be a few feet away from us onstage,

harmonizing the keys to whatever we were doing. Always she was a presence, hard and masterful. As a child she looked big to me, but when I grew older I saw she was really short and rather chubby. She was dark brown, well spoken. She felt she was helping to raise us and that she was doing a good job for and with us. She was always counseling my mother on what had to be done next with us.

After each performance, Vivian and I were put to work selling our photographs for ten cents apiece. We stood backstage while people filed by, shook hands, and asked us silly questions. Do you like dancing better than singing? How long have you and your sister been doing this? Do you miss going to school? "I don't know," I answered, "I've never been to school."

Everything was pointed toward taking in money. There was an education in that, if nothing else.

So many towns, cities, halls, churches . . . and I really saw so little. Most churches were wooden structures, though some were built of brick or stone. Sometimes our performance was put on in the chapel, and the people sat in the pews; other times a church would be big enough so that they had separate halls for entertainment and meetings. Going from one town to another, always repeating, always hurrying, always sleeping each night in a different bed. For all those years we slept mostly four abed. My mother and Auntie Ma-ma slept the length of the bed, and Vivian and I were at their feet. I remember feet pushing against me night after night all through that time.

When we rode a train, they used to have me curl up in a ball so that I could go half fare. But I was growing, and my legs kept getting longer. A time arrived when I said, "I have to stretch out. You'll have to pay full fare for me from now on."

Sometimes we arrived in a city a half day or a day before we had to perform. Then Vivian and I would take a walk, go through the main street or walk through the colored section, or try to play outside for a while. The idea was to get out of sight of Auntie Ma-ma, if possible. But the minute we went out of doors, she would be after us, so that we wouldn't get lost or play so much that we became tired. I wasn't supposed to play; I was supposed to sleep and rest so that I would be fit for the next show.

Mostly we moved in hot sun and in hot trains. I remember cities of heat. I usually had a hot parched throat, and I was always looking to get in the cool somewhere. I had a recurrent dream of snow, for when you spend most of your childhood in the South, and you rarely see snow, you think that it may be comforting. I had a dream of disappearing into snow, of drifting into hills of cool white.

Beyond that ecclesiastical weariness which no child should have, I possessed a critical, realistic sense of what produces life. I didn't go for the stork story. When I was told that, I remarked, "Well, if the stork dropped the baby through the roof, the baby would be hurt so bad it would be dead." My whole world was already adult, so I didn't have to be treated like a child.

Music and religion didn't end with the entertainment we put on in the churches. When we were in our living quarters—that was usually a room in someone's house—my mother and Auntie Ma-ma went to work. Together we sang "Amen," "Down by the Riverside," or "Swing Low, Sweet Chariot." We were always singing or rehearsing. The church was a way to salvation, not only in some prospective hereafter, but actually here on earth.

The church was the only means at that time for making some kind of social advance.

Mainly, from all this I learned that money was the supreme need of people. You received nothing without it. It was the biggest lesson my travels taught me. Infected with commercialism at so early an age, for survival's sake, I have never gotten over it.

Very early I displayed initiative. I borrowed from the insurance gag in our repertoire. It was so successful onstage, I thought, why not try it in the streets?

In Boley, Oklahoma, in front of the tall-steepled brick baptist church which the Negroes supported, I stood, blank paper in hand, and tried selling insurance to passersby. I had audacity and I could make a pitch.

"Mister, can I sell you some old-age insurance?"

The big man beamed down at me. "Is that real insurance you're selling?"

"Just like Prudential."

"Why aren't you selling Prudential?"

"This is better, safer, take better care of you when you get old."

"How much is it?"

"Half-dollar down and a half-dollar each time I make the debit." I didn't know what a debit was, but it always came as the punch argument, and I made the sale then or I didn't. I would be given a nickle or a dime, or even a quarter, and I would hand over the sheet of paper. Sometimes I signed the contract, my name under the buyer's. "Now you're insured," I said.

Vivian saw me making a few such sales. "I'll buy you a candy bar," I said. "Just don't tell Auntie."

But Auntie Ma-ma put a painful stop to this extracurricular business.

* * *

One soft memory returns to me out of that grinding, blurry, abnormal childhood. It is curious, strange, perhaps symbolic. Sometimes I wonder if it happened or whether it has appeared out of my unconscious as a dream that embodies a wish.

This could have been when I was no more than four or five. After I performed, a white man in the audience picked me up and carried me on his shoulders through the crowd and out of the church. At first I had mixed feelings. I was frightened; then I was glad . . . I was holding on to his neck.

I did not know whether I wanted to be found or wanted to stay with him. I was happy with him, for he was a kind, nice man. He wandered around outside the church, carrying me in some emotion of tenderness. I thought, Well, can't we take him along too? He seemed so comfortable.

Then I was back with Mother, and that moment . . . or that dream . . . was over with.

I still don't know who that was or what the episode meant. But the recollection comes to my mind at times. It remains to this day a fantasy and yet a real incident out of those early travels.

Maybe it is symbolic of my later years in the white world, when I came to know and to be with and to work with and to be loved by many white men.

Our troupe went from one church to another, and as far as I could tell there was almost no other place people lived except in those brick and wooden structures. Church provided the only social life the people had. Here they met, and even sinners had to go to church if they were to have any friends at all.

Our arrival was always an event. The signs would be

on the lawns and on the bulletin boards of the social halls: *Coming: The Wonder Kids*.

I frequently witnessed Baptist meetings. If the sermon was good and the pastor inspiring, the communicants shouted and fainted. I wondered why they did this and why they cried as if they had done something terrible and were repenting. But I never asked for explanations.

I have since been told that such hysterical and fanatic religious denominations may have been, and may still be, an expression of the excruciating emotional tension under which my people then lived and now live; that this outburst may be a catharsis that replaces violence; that it is real, earnest, necessary, and it is not a show.

Even today, I couldn't escape that religious influence even if I wanted to. My earliest professional life was as bound with the church as an infant's first year with its mother's bosom. The church was the focus and center of Negro social life, and the breeding place of most later Negro growth.

I hardly knew then what any of it meant. Neither did Vivian. We were on a Black Belt treadmill. Bless de Lawd!

N o child could go on endlessly leading our kind of life, and my mother and Auntie Ma-ma must have seen signs of weariness in my sister and me.

When I was in my eighth year we headed northward to Chicago. The Depression was on, and work was hard for my mother to get. We didn't do any entertaining here. People didn't have the money to shell out.

We lived in an all-black neighborhood on Michigan Avenue in the heart of the South Side. Our apartment was small and drably furnished, so it was good to get out in

the streets. I saw hundreds standing at the curbs; never had I seen a neighborhood so swarming with people.

Some of the talk reached my ears, and always it was talk of welfare, of demonstrations. Over and over, one word seemed ubiquitous: relief.

Mother, Auntie Ma-ma, all of us went on relief soon after we arrived. It was scant help. Often Mother was hysterical about money for rent and food. She walked to the welfare offices with me tagging along at her side. The relief headquarters looked like an old warehouse. People came out of the doorway carrying sacks of potatoes and cans of beef. The street scene looked grim: black, brown, and yellow people in need, and always you heard the word "hongry."

We had poorer food than we had on the road in the South. The dinner table had cheap meat—chitlins, pig's knuckles, everything from the pig—and grits and potatoes; but Mother baked bread that was good. When the foods we received from welfare were served, Mother would say, "I hope this ain't poison." Auntie Ma-ma pushed greens at us and said, "Greens'll build you, greens never hurt anyone." The food was heavily spiced, for our mother was a good cook and also knew how to go far on little. And all the time there was the sharp reminder, "Don't leave none. Eat while you got it."

No matter how bad things were, and because they were so bad, we went to church, to the Independent Church, the one my mother belonged to. It was a hall on Vincennes Avenue.

Mother left the house each day and would be gone for hours, looking for work, but she never found it. Once I had a ride into the Loop. The buildings seemed enormous, and I felt lost in the city.

So did my mother. She saw no opportunity in Chicago

and began to speak of going to California. She would keep repeating, "I'll get the money, I'll get the money."

When Mother was out of the house, Auntie Ma-ma taught us. She brought out books and taught us to read. Yet mostly our learning was of the hard knocks variety, the kind you get out in the world contending with people, doing things, working. Vivian and I hadn't yet seen the inside of a school building nor had we ever sat in a classroom—not even in a jimcrow school.

The talk of the distant place called California increased. Since we were deep in show business, though still children, maybe the place to go was Hollywood. Somehow my mother put together the money to buy four bus seats to Los Angeles.

There were a few final hours of feverish packing. I ran out in the street to look down the length of Michigan Avenue, a last look. Not that I was fond of what I saw, but the large numbers of people impressed me. I felt dislocated, whisked here and now to be whisked away.

A few days after we arrived in Los Angeles, my mother took us to see Clarence Muse, the best-known Negro figure in Hollywood at that time. He was an actor and a musician, and he had led a Negro theatre movement. He was one of the few men of color to secure occasional film roles, for these were dim days for Negro talent.

Mr. Muse took one look at our light complexions and told Mother, "You might just as well go back where you came from. Your kids are too nice looking to stand a chance. If colored kids get into a scene here, they want them to look black and Negroid."

"But these kids are talented."

"Go back East, Mrs. Dandridge. They don't stand a chance. I can't help them."

"We can't go back East. We got to stay."

"Well, good luck. I really mean it, good luck. But you'll never make it." He was looking at me when he said it.

Mother learned of a Laurette Butler who ran a dancing school. Vivian and I performed before her, and she was impressed. Mrs. Butler was connected with the Lincoln Theatre, where there was about to be an annual show of her pupils and the pupils of other dance instructors. She persuaded the school people to let us appear there. A scout for Metro-Goldwyn-Mayer attended the concert, he saw us, and we were hired by MGM to do intermittent motion picture work. So much for the predictions of the estimable Mr. Muse.

Mother enrolled us in public school. Suddenly I had a new experience. Around me were children of my own age, peers, associates. I had no knowledge what it was like to be in a group of twenty or thirty my own size and age. I quickly became interested in boys and girls, school fun.

As I was admitted into the fourth grade, my education couldn't have been too much neglected. But I didn't know how to read. If I heard someone read a page, I could recite or repeat it; if I looked at a book while repeating it, I gave the impression that I was reading. I fooled the teacher this way for a while.

Mother gave acrobatic lessons and Auntie Ma-ma gave music lessons. And there was welfare. Some money and food came in each week from the government. When these sources didn't keep us properly, Mother began booking the Wonder Kids in big Western and Southern cities: brief overnight engagements, after which we returned by train to Los Angeles, in time to do homework.

Once, when we set out for St. Louis, I remember how Mother cried. She used to practically faint over bills that she couldn't pay. Even then I knew that none of this was

in any way her fault. She was a victim of her background, and she did the best she could. She thought she was doing the right thing by us when we entertained, for always she justified it by the refrain that it would help keep us out of the kitchen later on.

Though I worked and brought in money, it meant nothing to me. I had no allowance. I was only doing what I was told to do. Yet it seemed as though it was never enough.

My mother never took up with another man after she left my father. She devoted her entire life to Vivian and me. I understood this, and never more than when she would come back from the welfare bureau with sacks of potatoes and carrots. For a time she was on WPA with the Hall Johnson Choir earning about ninety-two dollars a month, and I recall the bitter visits of welfare workers who came to see whether Mother deserved the ninety-two dollars.

This childhood hassle left a scar of anxiety upon me. The mark of the Depression remained, as if hardship was the way life is, as if it couldn't be otherwise or shouldn't be, as if the pattern of decline and defeat was an organic thing always lurking outside our door.

It left me with an imaginary scar in the center of my forehead, like the Brahmins have, only the mark on my forehead was a hieroglyphic that said: Pay the rent. By that I mean: Provide yourself with the means to live.

My first real emotional feeling about a boy occurred when I was eleven. I was in Hawaii with the E. K. Hernandez Circus. With me, of course, were Vivian and Auntie Ma-ma. Mother, who was on the WPA project in Los Angeles, stayed at home.

In Honolulu, in a park reserved for entertainments, the circus tents were set up. We had living quarters nearby in colorful cabins surrounded by large palms. I had seen semitropic verdure all around Los Angeles, but here the color, the green profusion, the strong light were overwhelming. Without then quite realizing how much I enjoyed this change, I stepped into the most intense five-month period of my young girl years. It wasn't like it had been on the road in the South: this was all pleasant—the mixed scene and the mixed faces of another world.

We Wonder Kids performed at night in a tent that was off to the side, away from the main show. We were billed as a sideshow theatre attraction to distinguish us from the usual circus fare. A barker, Percy Johnson, stood at our side as we emerged from a tent flap and appeared before groups of people looking up at us. Electric lights illumined us as Percy ballyhooed the crowds to our tent, trying to steal them away from hokum shows, trapeze artists, fat men and fat women booths, animal spectacles. "Right this way, ladies and gentlemen . . . the Wonder Kids: two of the prettiest little gals in the E-e-united States of America, Miss Dorothy and Miss Vivian. They'll sing and dance and bring you all the hot jazz from the mainland. They even know the hula, these kids do, and they ain't been here no time. Now come on in, everybody, and watch these little ones shake it up American-style . . ."

We did a brief dance routine after the barking and then went inside. The crowd followed. In the center of the tent, on a hard dirt floor, with a background of flowers and low palms to set off our cavorting, we spun into our work. We sang the popular and changing lyrics of the day in the United States, even "Brother, Can You Spare a Dime?" and we wound up by switching into a little hula to show we were getting acclimated. The singing part of the

act was on the order of the Andrews Sisters or the Lennon Sisters, but somehow because of our coloring we inherited the name of the Creoles. White fellows, especially American soldiers, whistled at us and yelled, "Bring on the Creoles."

During the day we had the run of the circus: we could see the performances over and over, and munch popcorn, Crackerjack, and indulge in whatever other fun things went with a circus. Between times we each received an hour or so of schooling daily from Auntie Ma-ma. In this period she didn't whack me around quite so much. I found ways of staying out of her reach, and it was all too public for her to want to be caught too overtly disciplining me.

A Hawaiian boy came around to our tent several times. He looked at me in a wistful way. He seemed taken with the glamour, the tent, the way I dressed—and we smiled.

I asked him about the volcanoes that overlooked everything. He told me their names. Then he told me his name, Istio Ull.

For months I wandered about the city with him in what became a delightful and idyllic and most innocent romance. Istio was a mixture—part Hawaiian, part Japanese. He spoke English and Hawaiian. He was a sweet brown, with large, dark eyes.

Whenever I could get away from the others, he and I went hand in hand about the city and its suburbs, and once or twice to other islands. While he talked I took pictures of the volcanoes and made notes of what he told me. It became a project. I intended returning to school in Los Angeles an expert on volcanoes.

The most fun was at the beach. Istio and I walked in the sand, sat under the palms, cracked coconuts, waded in the water. He could swim and I couldn't. Part of the plea-

sure for me was in being away from Auntie Ma-ma. The
rest was a childlike awakening that became more physical
than I imagined possible. I felt a real yearning for Istio
that I didn't know how to answer and that I knew
shouldn't be answered. I must have been pretty, for Istio
seemed never to look at the water, the sky, or the sand,
only at me. And Istio was the first boy I kissed. All that I
can say is that they are wrong who say that ten- and
eleven-year-olds cannot feel love. I had alternately tender
and intense emotions about him. With it went a frustra-
tion. We were children in love, but must stay apart; hold
hands, have deep feelings, but do not do what one knows
can be done. I had sensuous feelings, but they were lost as
rapidly as they rose, like the waves hitting the beach.

Istio introduced me to girls who did the hula. I
became interested and took hula lessons. Later on, when
my sinuous singing and dancing style became likened to
the writhing of "a caterpillar on a hot rock," I realized it
could have traced back to my circus days in Hawaii.

One day Istio asked me, "Will you do something for
me?"

"What is it?"

"Would you talk to my class at school?"

"About what?"

"Anything. About the United States. About circus life,
about the way you traveled in your country, about your
school."

I went to his school. The foliage swarmed around the
windows and up to the eaves of the one-story structure.
Royal palms gave shade. Pineapple trees were in the yard.
Inside, I sat up front near Istio's teacher. Istio introduced
me as "the star of the Hernandez Circus."

I wasn't, of course; the circus had no star. But I talked
for a half-hour about the countryside of the United States,

my school in Los Angeles, what I had seen of life in the South. Only the generality of what I said comes back.

It was not long after that that I had to return to the States.

I had two goodbys with Istio. One was with him alone. We had a last walk on the beach. "People who come here do not come back," he said. "Maybe you won't." I told him I did not know, but I promised to write.

Tears have always come easy to me, and they came then. And Istio had outgoing, unconcealed emotions. I think his eyes had something of fear in them—a look that I would recognize many times later in my own.

The other goodby was when Istio and his friends came to the circus and placed farewell leis around my neck. This time we smiled and showed no one we had been so close. We exchanged a simple and plaintive kiss on each other's lips.

There was a pureness and a quietness about that early love with Istio that I was never to have again.

The old saying about travel being broadening might make some sense. When I returned to Los Angeles and lectured my class on volcanoes and showed them the pictures I had taken, the teacher skipped me from the A5 group to the A6.

Kid that I still was, by now I had an air and a manner and a slinky walk.

"Stand still," Auntie Ma-ma said. "I have to fix you."

"What are you doing?"

"I've got to bind you. You can't go around like that."

"Like what?"

"Getting so big in front. You'll have boys after you and you'll get in trouble."

"That hurts. It's tight."

"It has to be tight. You have to wear this around you tight as you can stand it. You're too young for them to bulge like that. I see how the boys look at you!"

"I'm not going to wear that thing!"

She wrapped a wide muslin cloth around my chest, twice around, and she closed the ends with a safety pin under my arm.

"It's for your own good!"

I tore the band off.

Auntie Ma-ma stepped back. She was smart and cool when she wanted to be. "Girls your age everywhere get bound up so they won't be so big in front. It's doesn't look right. Now's the time to keep you from getting big as a cow. The way you're growing out, big men will stare at you."

"I can't stand it. I can't breathe. I can't! I can't!"

"You can't stand it," she mocked. She was poised to start winding again. "You can't stand it! They do this all over. White folks do it with their girls too. In China they even bind up the feet of little girls to make them have dainty feet—but you want to be different."

"I don't believe it. I don't like it."

She wrapped the cloth around my breasts again, repeating how dangerous such fullness was, it was inciting, bad things could happen to me. "I'm doing right for you the way I always do, and you aren't appreciative. You're just bad, bad."

I looked at my breasts. They had blossomed, my hips had widened, and I was now the same height as Auntie Ma-ma. Her own bosom looked shapeless and flat; she was very round in the belly and her eyes looked like cold marbles. I never concealed my dislike of her. But she had force. The muslin band was around my breasts again. This

time when she closed the two safety pins my resistance was going.

She chattered. "You're sitting next to boys in school, and they're looking at you right there. You want that? And when you go out entertaining, you want the men to stare at them instead of listening to you sing?"

"It hurts!"

"You'll get used to it."

"How long do I have to wear this?"

"Two—three years, till they're flat and don't stand out."

I tried hard to believe that other girls were so bound. My breasts felt flat and tight against my chest.

"Why isn't Vivie's bound?"

"She don't need it. You need it."

Each morning for the next two years Auntie Ma-ma bound me herself or asked Vivian to do it. But she always checked to see that it was done.

This was not the first nor was it the least of the sexually inhibitory influences that Auntie Ma-ma would exert upon me. Because of her I would come to marriage frightened, ignorant, bedeviled.

Part 3

————∞∞∞∞————

A Wondering Kid

The Wonder Kids gave way to a new setup in 1934. While Vivian and I had been students at Mrs. Butler's Dancing School, we formed a trio to be known as the Dandridge Sisters. The third partner was Etta Jones, a girl older than I, who looked somewhat like Vivian and me. Our career as a trio began when we won an amateur contest on station KNX, Los Angeles, over twenty-five white contestants. Then, performing in a club, we were spotted by the agent, Joe Glaser, who became our personal manager. Through him we had bit parts in several movies—*Going Places, Snow Gets in Your Eyes,* and *It Can't Last Forever.*

I was an extra on a Hollywood studio lot with the Marx Brothers in *A Day at the Races.* The props, the paraphernalia, the zany business of a Marx Brothers film were exciting; the traffic of extras, bit players, the movement, the noise. I had little or nothing to do but to be around, be part of the scene.

From that time I began meeting the theatre folk of the last thirty years.

Lap-sitting was my forte. Leroy Prinz, the dance

director, used to sit me on his knee. Then I would scoot over to Bill Robinson and sit on his lap or that of his wife Fanny. They treated me as they might have treated a child of their own.

Bill Robinson was at the height of his dancing fame. He had been born in squalor in Richmond. He told me he hadn't been much of a student in school, and at eight he had run away from home and hung around a racetrack. He became a juvenile dancer for five dollars a week; he had a slow rise before there was any recognition, and at last he was making three thousand a week in vaudeville and appearing in pictures. We had in common our very youthful beginnings.

By then he was losing his eyesight, but he spotted me as pretty. "Keep away from the wolves," he said, adding, "like me." He must have meant it, for only a few years later he divorced Fanny and married a little girl who had also sat on his lap. Her name was Sue, and she became Bill's eyes as his vision steadily weakened. She wasn't much older than I.

When I was fourteen, I saw the man who would become my first husband. My courtship with Harold Nicholas, one of the two famous Nicholas Brothers, the dancing team, wasn't what you might expect of show people. It was a puritanical, idyllic relationship, a four-year romance replete with talk-talk, hot dogs, movies, chitlins, boxes of candy, long walks, hand-holding, flowers. It was corny as the stalks in Iowa; and our sex was limited to kissing and getting hot, but for me it was fun.

As a result of our small successes, the Dandridge Sisters received a bid to go to the Cotton Club in New York. The original Cotton Club had been founded in Harlem in the 1920's, but now there was a swanky Cotton Club in

midtown Manhattan where Cab Calloway and Duke Ellington reigned.

I saw Harold on the day I arrived at the Club. We were backstage, making ready to put on our singing act for Cab Calloway and his men. Harold was on stage with his brother Fayard, and they were doing a dance turn. As Harold tapped he was eyeing me. I had heard of him, had seen photos of him, and I knew that he and his brothers were already famous and money-making entertainers. He was dark, short, and slender, with curly hair. He was only five feet one inch tall and he had a lightness and speed of movement that made him a clever dancer. At his side was his older brother Fayard who looked like George Raft. I learned that they had a big car and a chauffeur, and that their mother, who traveled with them, had a mink coat. All of which was impressive to a fourteen-year-old suddenly in the company of big-timers.

As the rehearsals went on and we waited, I looked over the glamorous chorus girls who moved backstage. As they brushed their hair and came on with the hip talk of show business and the big city, I felt out of step. In contrast, the three of us from the West looked small-town and raw.

The entire Cotton Club company was at hand during the rehearsal as Vivian, Etta, and I whipped through a number that we believed was appropriate. It was all about,

"The midnight train came whooshin through,
The merrymakers were in full swing,
And everybody started to sing,
Da-da-de-um-dum-do."

The whole company broke into a fit of laughter that embarrassed us and cut us short. We figured we were finished.

But Benny Payne, a real music man who is now with Billy Daniels, came over and talked to us. "Don't you worry, kids, you can sing, and we're going to fix you up with the right music."

Cab Calloway strolled toward us and said, "Benny'll take care of you; you did fine."

"Really, Mister Calloway, will you use us?" I asked.

"Sure, that deal's all set. You know that. You don't think we'd bring you all the way from the coast unless we knew we could spot you in?"

What they worked out for us was a chorus for Calloway. He sang a song, and after he finished, we went on and, standing off to the side, repeated the song that he sang. It was only a momentary bit in the Cotton Club Show, but the swift touch that kept it alive, changing, moving. This was the blues period of jazz music, and Calloway was famous as a blues performer. They dressed us in blue, each of us wearing a blue hat that tipped over the center of the face. I was the one in the middle and sang the lead; then the three of us came on with the chorus.

In words you can't convey the music of songs. You can't easily portray a tap dance, nor the effect of three girls tapping. Not in the structure of a sentence. The body isn't there, only song titles. With a dull one like "Skeleton in the Closet," we could light up a stage, and bones and flesh would be shaking all over it. Cab Calloway would ask what might seem to be a perfectly inane line—referring to the Depression era:

> Cab: Was it blue?
> Us: No, no, no no!

How do you convey what such lines meant? Maybe today's young people, with their songs and dances and their own colors, might somehow understand.

Cotton Club Variety Shows bills usually featured Cab Calloway. On the program others might be listed in this order:

Nicholas Bros.
Berry Bros.
W. C. Handy
Mae Johnson
June Richmond
Dandridge Sisters

For whatever nostalgia there might be in a picture of the Cotton Club gang, other performers were Sister Tharpe, Timmy and Freddie, Whyte's Lindy Hoppers, Will Vodery's Choir, Dynamite Hooker, Jig Saw Jackson. The musical atmosphere was suggested by the way singers billed themselves or were billed. The pioneer nature of an act like ours, in relation to the Negro struggle to get into the theatre, was suggested in a line appearing in a magazine called *Flash*, on whose cover the three of us appeared. The comment was, "This is the first time the sisters have appeared in the East. They have appeared in several movies, and are a definite indication of the trend toward offering colored talent and beauty an opportunity to make good in the movies." The notice was a little premature. Cracking into the movies was enormously difficult, as I was to learn, and staying would be even more difficult. Acting roles for Negroes: that was to be the biggest obstacle of all. It remains so now.

For months we were part of the Cotton Club tradition. We were safe as a gold nugget.

Being a downtown performer didn't mean we lived with the white folks. We commuted daily to Harlem where the four of us were quartered in a tenement, renting rooms

from a Mrs. Breety. She had two children; one, an older girl about my age, would sneak into the bathroom and smoke reefers. The smell was sweet and nauseating.

When I wasn't downtown, I was part of Harlem. During the day we went to a Harlem school for a few hours, then we would subway downtown to the Club. The Club was a big, broad room, heavily carpeted and terraced. The bar, when it was open, swarmed with drinkers, and I was never allowed near it because I was too young. Peering toward the tables from the stage all I could see was smokiness, and all I could hear was the steady buzz and noise of table talk.

The older girls talked in hushes when I came around, as if I were too young to know. They shelled out money on the perfume man and the lingerie man and the other special salesmen who came backstage. How could they afford all this? I wasn't *that* young; I suspected that not all of their purchases were made on a chorus girl's income. Between shows their boy friends came around. Limousines rolled up in back of the Club as if it was a bus terminal.

I looked on with big eyes, not being allowed to be party to all this. They would glance at me as if I were a child that shouldn't be corrupted. One of the leads, Mae Johnson, blurted out, "Oh, don't be silly, Dottie's got to grow up. She might as well know."

I wanted to know.

Smoke wreaths of gossip reached my ears. They said that one girl who had been going with Harold had been so badly upset by a breakoff between them that she had had a nervous breakdown. I heard that Harold had been out with many of the girls in the company. "Oh, he's been down the line," they said.

From the earliest days, members of the company told

me that I should be outside the trio and on my own. I was pretty, I could be a star, they said. But I stayed on, I did my turns, took my bends, thought most of all of Harold.

It was the "Desperate Thirties," and I was part of the jazz era. The famous musical and entertainment figures of the day were close by: Ellington, Calloway, the Berry Brothers, Bill Robinson, the Nicholases. A jazz idiom of the day was that something big was "hitting on you." I was with it all, it was hitting on me. I was young and this was New York and I was hitting on it too. The thirties may have been desperate for many. At that time I wasn't desperate.

Bill Robinson, performing in a Cleveland theatre, called me at the Club. "I've just met your father, Dorothy."

"My father?"

"Yes. This man says he's Cyril Dandridge. He's your father all right. He wants to talk with you."

My mother had not mentioned him in ten years. He was dead to her, dead to us, and Ruby even told most people that her husband was dead. I had no recollection of anything associated with him, nothing but that remote Christmas Eve.

Because of the rumble and racket that night, I had always visualized a man with a big chest, a diamond clip on his tie—a dramatized and outsized version of a man. Over the phone, before I even talked, I was seeing him that way. Chorus girls were passing by, for the phone was backstage, and all I could say was, "Hello."

"Hello. Is this Dorothy?"

"This is Dorothy."

"How are you? This is your father."

"I'm fine. How are you?"

"Fine. I'm coming to New York to see you."

"You are?"

"How is Vivian? Is she there?"

"She's right here."

"Would you put her on?"

Father had the same talk with her.

Auntie Ma-ma took the phone, and afterward she told us, "Your father is taking a bus. He'll be here in a few hours. We better all meet him."

We waited for him at the midtown bus station, and I knew who he was as he walked up to us, for I recognized in his facial features a similarity to my own. But I was stunned to see how different he looked from what I had visualized. He was slight and meek of manner.

We climbed into a cab and drove to our Harlem apartment. I was silent and watched him, more from the corner of my eyes. What do you say to someone who announces to you of a sudden that he is your father?

At the apartment the awkwardness continued. We looked from one to another. My father stared at Vivian, then at me. All of us were forcing smiles.

Finally he said, "Stand up, Dorothy."

I stood.

"Turn around, daughter."

I turned, like a model.

"Turn around again."

I turned again, like a mannequin on wheels.

"You're very pretty."

We fell back into the same silence. He smiled. I smiled. Auntie Ma-ma smiled. You wouldn't know language had ever been invented.

There was a knock on the door and Harold Nicholas entered.

"You have a boyfriend?" my father asked.

"Yes, I have. We have to go somewhere." I wanted to

disappear. It didn't matter to me whether I ever saw him again.

All I could think of was, If I had turned out to be a criminal, if I had been in jail, would he have hurried to New York to see me?

J oe Glazer booked us to appear at the Palladium in London just before the Blitz began.

The theatre pages of the London newspapers were kind about our arrival too late to open as scheduled. We had had a rough crossing on the *Ile de France,* and our act was postponed a week.

During that time we stayed at the National Hotel. A young stagestruck girl of our own age became a frequent visitor at our suite. This was Eldrith Hogan, a very pretty girl. She went with us on trips to "the real London," as she called it. The city was markedly military. No one could see the Liverpool Street Station where the trains came in, jammed with crisscrossing soldiers on the move, and not feel that here was a country going to war.

I fell in love with the speech of the British, as if this were my own true language, instead of the accents and idioms of Los Angeles and the South. My ears thrilled to the sound of English as spoken in its homeland, and I picked up inflections and phrases that I would return to America with and use forever after. Vivian, Etta, and I walked in Bishopsgate and wandered the streets of the West End. All of it was close to me, as if some part of me had once walked in these places before—and so it had, for wasn't I a Dandridge?

Not long after we arrived, Auntie Ma-ma ordered us to stay at the hotel and go nowhere by ourselves, for the

bombings had begun. No one could believe that the city was being bombed, but there it was.

Our show at the Palladium was nothing to what now took place each night. Sirens shrieked; bombs fell in city and suburb. Each morning, after the previous night's bombing, we went into the streets to see the latest damage. During the night, as often as three, four, and five times, we would go down to the cellar and hide there till the all-clear rang. Below, in the dimly lighted cellars, we watched the British drink tea amid the raiding thunder.

I would take a blanket with me because it would be cool there, and pass the time in conversation with the English. It was in the shelters that I developed an affinity with the English which has been with me always.

You couldn't sleep when the attacks came. Sometimes before going to the shelter I waited for a few minutes till I saw flashings in the sky, the English anti-aircraft going to work. Then I would scoot below.

Later, when the attacks became frequent, we didn't always go below. We sat in the hotel room and coolly drank tea like the English.

For several weeks we toured Liverpool, Birmingham, Manchester, and Dublin. Wherever we went, the Three Dandridge Sisters, as they called us, did the close harmony singing and the tap dancing routines we had done at the Cotton Club. Everywhere theatres have similar names: Empire, Palace, Palladium, Royal, Hippodrome. At the New Hippodrome in Coventry, whose newspaper ads read "car park opposite—five spacious bars—two milk bars—snack bar," we worked in a blackout for two nights. Outside it rained fiercely. Our group picture, blown up, was in the lobby. Bombing and war threats didn't keep the public away. We sang "Swanee River" in swingtime. The English press called us "dusky," sometimes "Negresses," or "high

brown talent." One of our most popular numbers was called "Hold Tight."

Sometimes, before or after a show, we talked with reporters. One reporter asked me if I minded being bombed, and I said I didn't mind because I liked the country.

When we returned to the National Hotel in London, our suite was agog with excitement. Eldrith was pregnant. Her pregnancy had nothing to do with anyone she met in connection with us, but since we talked about it openly Auntie Ma-ma became very interested and, it seemed, alarmed.

She became suspicious of our association with the English girl. Were we going out with boys when we were away from her? Had boys gone on the bus rides with us?

For some time I had been wondering what I could do about Auntie Ma-ma. She still beat on me two or three times a week. She beat me till I cried, and then she beat me because I cried. Eventually it got so that I just guarded my face while she hit me, and I never let out a sound. I don't know when I stopped showing my pain, but I began to simply absorb that punishment, to grit my teeth, to give her a hateful look afterward, and then to walk off. I was getting stronger, taller than she. How do you handle a "parent" to whom you are bound by ties of money, daily living together, guardianship? When I ceased to let out a sound during her beatings, that irritated her and she ended in a fretful mood of perplexity, as if she weren't reaching me anymore.

Mother was back in Los Angeles, cooking and occasionally securing extra assignments at the studios, so there was no help from her. But I was becoming too big for whippings; I was making money, though I received little

of it for my own use, and I was thinking over and over, When will this woman leave me alone?

Auntie Ma-ma had to choose the occasions when she would turn on me. She couldn't do it when people were around, when we were onstage, or when we were in transit. It was a privately done and timed performance of her own.

One day, wittingly or unwittingly she chose a moment when she and Vivian and I were alone in our suite and when the sirens were sounding for a new raid. No one would disturb us now.

"Dorothy, get on the bed."

I was sitting before a mirror, experimenting with a skin scrub that brought color to my face and kept the skin smooth.

"What for?"

"Do as I say."

I turned on the stool and faced her. "What have I done?"

"I don't know. That's what I want to find out."

She looked squat and forceful. Her face looked ugly.

"*What* do you want to find out?"

"Get on the bed as I say!"

I rose and walked toward the bed, sat on the edge.

"Have you done what Eldrith did?"

"What are you talking about?"

She was beside me. I expected I would get a cuff. "Lay back."

"What for?"

"Do as I say!"

"Auntie Ma-ma, please . . ."

She pushed me. My head fell on the pillow. Of a sudden, she raised my dress and yanked down my panties. I sat up.

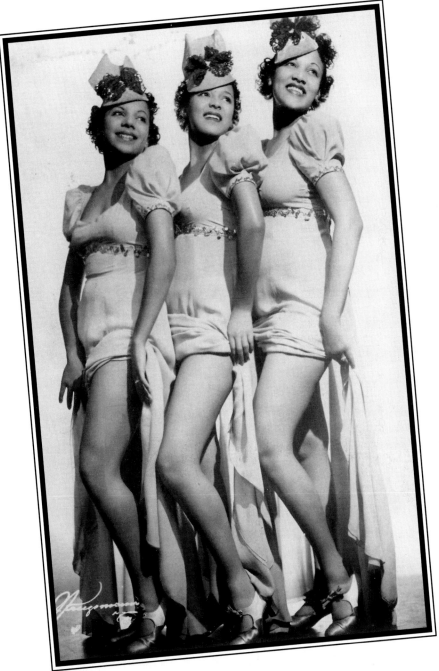

The Dandridge Sisters *(left to right)* Etta Jones, Dorothy, and Vivian Dandridge—Cotton Club, New York, 1938. The group sang in most of the top clubs around the country by the time Dorothy was fifteen. *(Earl Mills & Associates)*

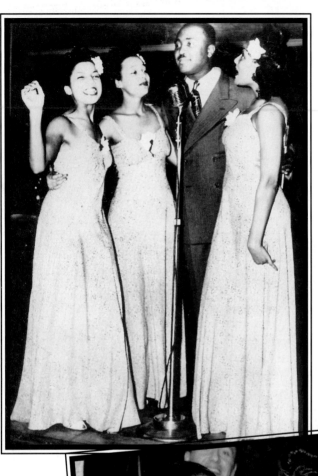

The Dandridge
Sisters singing with
bandleader Jimmie
Lunceford. They
toured with
Lunceford's band for
a year and a half and
recorded such hits as
"I Ain't Gonna Study
War No More" and
"Red Wagon." *(Earl
Mills & Associates)*

Newlyweds Dorothy
and Harold Nicholas
of the tap-dancing
Nicholas Brothers,
soon after getting
married in 1942.
*(Earl Mills &
Associates)*

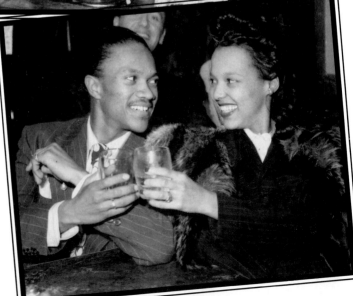

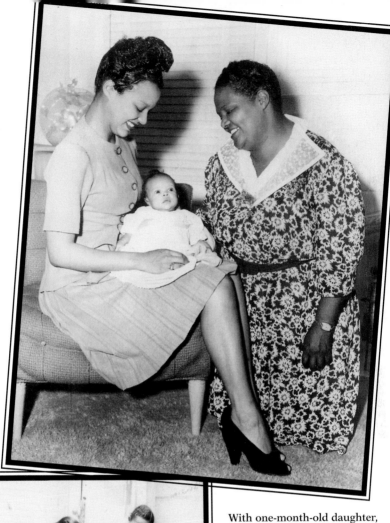

With one-month-old daughter, Harolyn, and mother, Ruby, in 1944. Ruby, an actress and comedienne, was known to millions of radio and television audiences of the sitcom *Beulah* as Oriole, Beulah's charming friend. *(Earl Mills & Associates)*

Happier times: Dorothy with Harold and Harolyn. *(Earl Mills & Associates)*

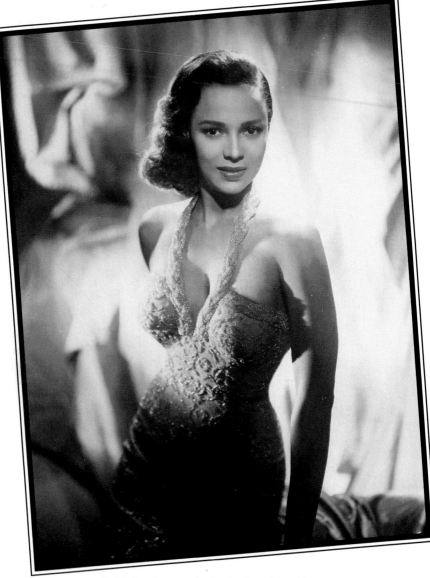
Publicity photo at the beginning of her film career.
(Earl Mills & Associates)

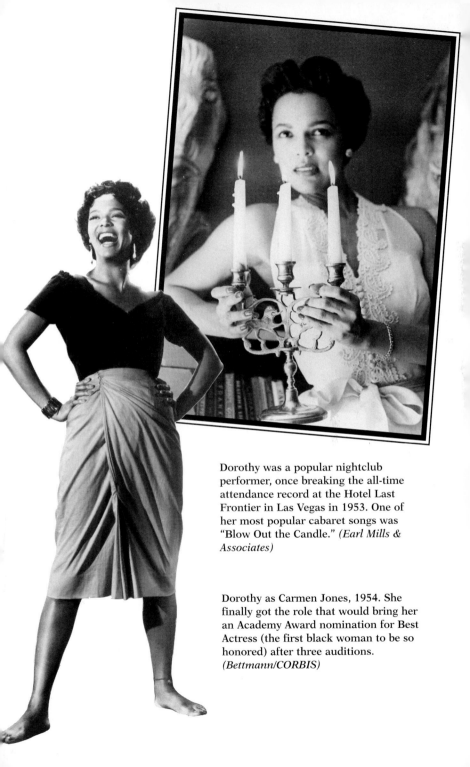

Dorothy was a popular nightclub
performer, once breaking the all-time
attendance record at the Hotel Last
Frontier in Las Vegas in 1953. One of
her most popular cabaret songs was
"Blow Out the Candle." *(Earl Mills &
Associates)*

Dorothy as Carmen Jones, 1954. She
finally got the role that would bring her
an Academy Award nomination for Best
Actress (the first black woman to be so
honored) after three auditions.
(Bettmann/CORBIS)

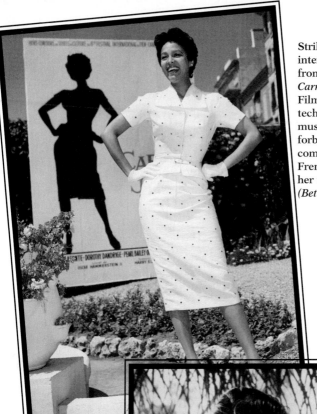

Striking a pose for the international press corps in front of a billboard for *Carmen Jones* at the Cannes Film Festival. Although a technicality in French music copyright laws forbade *Carmen Jones* to compete in the festival, the French government invited her to a special screening. *(Bettmann/CORBIS)*

A scene from *Island in the Sun*, with costar John Justin, 1957. She and Justin were upset that the romantic scenes in the script were so unnatural and scrubbed clean of any issues pertaining to interracial physical contact. The studio finally conceded to letting Justin's character declare his love for Dandridge's character, but they still could not kiss. *(Bettmann/ CORBIS)*

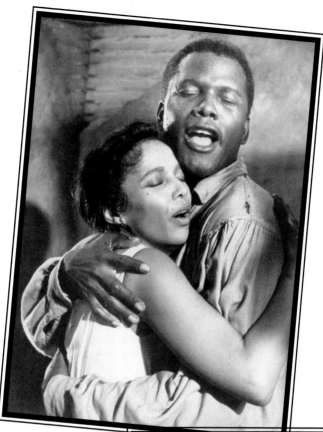

With Sidney Poitier in *Porgy & Bess*. Many black actors refused to be in the production, and Poitier later stated that ". . . *Porgy and Bess* was not material complimentary to black people." *(Bettmann/ CORBIS)*

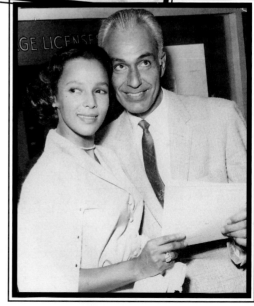

Posing for photographers with Jack Denison as they pick up their marriage license at the Santa Monica courthouse, June 20, 1959. They married three days later in a traditional Greek ceremony at St. Sophia's Orthodox Church in Los Angeles, then flew to New York for the premiere of *Porgy & Bess* after the wedding reception. *(Earl Mills & Associates)*

Harry Belafonte and Jack Denison at a birthday party for Belafonte. Harry and Dorothy were long-time friends from their cabaret days. *(Earl Mills & Associates)*

Dorothy and Earl Mills *(on the right)*, her long-time manager, in Mexico, 1965. He took her to a spa to regain her health after her divorce from Jack Denison. With Earl's help she was poised to make a professional comeback with several club engagements and two Mexican movies in the works, but died tragically before fulfilling her contracts. *(Earl Mills & Associates)*

"I'm not going to hurt you." Her voice changed. "I simply want to find out something I have to know. I'm responsible for you."

That quieted me. I was lying flat again. She told me to raise my knees and, as I closed my eyes in embarrassment and twisted with resistance and obedience at the same instance, she put her fingers inside. She was trying to find out whether I was a virgin.

"Auntie Ma-ma, stop it!" I pushed her hand aside, swung away from her, and scrambled to get off the other side of the bed.

She raced around to the other side, pushed me down flat again, and once more fingered me in spite of my resistance.

I began to call out, louder and louder, "Don't do that! *Don't you dare do that!*"

That angered her. She cuffed me. "You'll not cause me the kind of trouble that girl got into! I'll find out what you've been doing!"

"I haven't done anything!"

I slapped her hard across the face. It was the first time I ever hit her. She stood straight, put her hand to her face in disbelief.

Then the tight look of a whipping coming on settled over her. I felt a rain of blows come down upon me. She hit me across the face, the back, anywhere her hands could reach. I didn't cry out, but held my hands to my head.

She flailed at me with more energy than ever, threw me back onto the bed, pounded me across the buttocks with the flat of her hand, then reached for a brush.

It was the worst beating I ever received from her, but I didn't seem to feel it.

When I felt her tiring I asked, "Are you through?" There was another flurry from her, but it was weak.

Inside, my embarrassment hurt. That hurt worse than all her pounding.

I leaped off the bed, and clenching my fists as I had seen men do it on Hollywood sets, I hit her on the chin. Then I lit into her, storming upon her with blows harder than any she had ever given me with the bristle side of her brushes. I was in a rage. I had never struck her before, nor anyone, but it felt good.

"If they put my head in the . . ." I walloped her hard, "Tower of London . . ." I clawed and scratched and punched "like they did Anne Boleyn . . ." I had her against the wall and I pummeled and pummeled . . . "you'll never do that to me again . . . that or anything else."

She screamed, "Vivian, Vivian, get her away from me!"

Vivian was hiding in her room.

I kept on hitting, saying over and over, "Never . . . never . . . never again!"

She staggered over to the bed and fell on it.

The Germans were still bombing. Bombs had fallen all through the fight and we never heard them.

To get out of her sight I went down to the cellar of the hotel. In a dark corner I breathed heavily. I thought of what she had done, and it seemed as if I could still feel her fingers there.

That was the last time she ever put her hands on me.

The show had to go on and it did, but the coolness that was between us never thawed.

If this had only been a beating and a fight it might not be worth mentioning, but the puritanical feelings she constantly imparted to me, the abnormal emphasis upon virginity, the fears of sex she instilled—these were now

part of my psyche, and I was to have much bad experience because of her.

Auntie Ma-ma's fears of men were ingrained in me, and in large part helped produce for me a disastrous bridal night.

The fear, failure, and fumbling of that night led on to a dismal marriage where one unfortunate incident became compounded by another.

Harold had pursued me for four years, from the time of my first appearance at the Cotton Club. He discovered that he couldn't get through to me unless he married me and carried me over the threshold literally, in the ancient tradition. The courtship was cut of the same cloth: Victorian tradition finding itself in the theatre where it might least be suspected. All protocol observed. Kissing was the maximum; affection and sentiment and flowers were fine, but getting fresh, as the expression had it, was out. Harold was politely exasperated. He was young, highly sexed, and he couldn't keep his hands off me; and yet he learned to know that there was a limit. He too had been chaperoned by his mother, about as I had been watched by Auntie Mama. He was taught to expect to marry a "nice girl" who was a virgin.

Harold, who was short, wiry, and warm brown, excited me. I admired his talent. He was vital, all-male, and when we necked or kissed in a car, I was available and eager for that show of affection.

Often we drove into the hills around Los Angeles, found a quiet place, parked, and he put his arms around me. You can spend hours like that. As a teen-ager I liked it. But I was ignorant of real maleness, and by now somewhat afraid of the ultimate.

I had been raised with no man around the house; I had never seen a man shaving; I had never seen a male in his shorts. There was a mystery there, and Auntie Ma-ma, as well as my mother, imbedded a great fear of it. I knew that their marriages had failed—there was also that aspect of male-female failure.

As Harold and I talked more frequently of a marriage date, a fear rose in me about what happened between a boy and a girl when they were in bed.

I am certain that if I had gone the whole way with Harold during the courtship period, he wouldn't have married me. As it was, I held the aura of something unattained. I fitted those specifications of what a bride was supposed to be. I carried off that role in Los Angeles, in New York, and whether we were chaperoned by his mother or by his chauffeur. This romance at arm's length went on and on, by phone from England, by phone across the coasts, in hotel lobbies, in night clubs. When I was in England there was talk across the seas. If he was in Europe and I was in Los Angeles, there were wires and flowers. Occasionally there were those hours of idling, me holding out like a good girl, Harold getting hotter and hotter for whatever he imagined he was to get.

Only once did I have a hesitation about Harold, and he may never have known of this. For a time our trio went with Jimmy Lunceford's band. We did one-nighters and cut records. We moved from place to place by bus.

I had an interim small romance with a saxophone player named Joe. Joe was experienced; he was already married and divorced. He was older than I, and when we bussed across the country, he and I managed to get into the rear of the bus while Auntie Ma-ma was down front.

He put his tongue in my ear, and I nearly went through the roof. The ear can be one exciting spot. The

thrill was so intense that I wavered about Harold. Maybe I shouldn't marry Harold, but ought to marry this ear-splitting sax player. Drifting over the highways, with Joe next to me, I kept having this thought.

But I was a more calculating girl. The Nicholas brothers were moving up in the entertainment world. Harold had talent and money and a career before him, and he wanted me and I really wanted him.

Since then I have philosophized that that's what you might marry for at seventeen, a thrill in the ear, but at thirty—as I was to find out—you'll thrill as hard if a guy shows he can pay the rent.

My mind was made up when the Nicholas Brothers secured a contract with Twentieth Century in Hollywood. Harold came west, and during this period we saw each other almost daily. One day in the backstage of a theatre he was seated on a piano stool singing to me when he whipped out a ring, and just like they do in the movies he put it on my finger. I said yes and we set a date.

Harold might have had several motives for placing that ring on my finger. He wanted to get away from home. He was tired of making so much money and giving all or most of it to his mother. He wanted his own money, his own home, to be on his own, and he wanted a girl who hadn't been used by everybody.

I can't be sure—in the light of what happened afterward—that Harold loved me or knew what love was. He knew what sex was, and he knew he wanted that with me as much as he wanted anything in the world.

For myself I welcomed the prospect of marriage. I had learned early that show business was hard and brutal; there wasn't much glamour in it, except to people who weren't in it. Now I would put all that behind me. I would

have a boy or girl some day who, unlike me, would have a father.

Harold and I chose a house between Cimmaron and Arlington on 27th Street. We selected the furniture together, shopping at the good stores. We had the house remodeled and visited it while it was being redone.

Then it was the marriage night. Out there were twin beds. I had selected the twin beds. Why I wanted them I can't say, except that perhaps I had some fear of a double bed. Harold had asked me, "Why do you want twin beds?"

"I don't know," I had told him. "I think it might be nicer."

The tap water was running. I let it run. I let Harold think I was busy bathing, washing up, anything. What was I supposed to do? What was he going to do to me? He was in bed, probably with no clothes on, and he was waiting for me to come out, perhaps unclothed or in a filmy negligee. What do you do then? Do you get into bed? Do you wait for him to ask you into bed? Do you take off the negligee?

Yet I had to go through with this so as to get on with the marriage. Essentially this was what I wanted: a house, children, a domestic life, not the world of entertainment.

"Dorothy, are you all right?"

That famous expression men and women use when their spouses are in the bathrooms where accidents can happen. "Yes, I'm all right. I'll be out soon. I'm fixing up."

I puttered. I powdered my face. I turned off the bathroom light, turned it on again. I turned the faucet faster, I slowed it. I acted as if I was busy in there.

My feet were glued to the tile. I couldn't make the turn to the bedroom door; then I couldn't turn the knob. I stood with my hand on the knob and I couldn't turn it. I had a fear that some terrible thing was going to happen. There

would be pain and blood, and he would cause it even though he loved me.

What was to happen must be important. If by saying what Harold was now going to get I had secured him, it must be important. If it was that important, it must be bad for the girl to lose it. Would he see how afraid I was? Would it happen right away or in a few hours?

It was now two o'clock in the morning. I couldn't stay in the bathroom all night. I must get to that bed somehow, gracefully, smilingly, and not let him know how petrified I was. The tap water still ran. I turned it off.

I was perfumed, scented all over. I took a deep breath. I turned the knob.

The lights were on in the bedroom.

Harold sat in bed and he looked at me. They have always called me beautiful, and I must have looked that way to him. I came near. If he could read my eyes right, he must have known my inner trembling. He put out the light.

I was beside him and in his arms. "What kept you so long?"

"I had to get ready."

"Are you afraid?"

"A little."

"Don't be."

What followed was bad. I was inexperienced, fearful enough to be cold. I didn't know what to do. Harold had had much experience with girls, so whatever he expected he didn't get. I couldn't compete with those Cotton Club girls.

I suffered through it. I tried not to show it, but everything in my background contributed to making me feel that this normal event was a violation.

Harold must have been disappointed that what he had

waited four years for turned out to be less than he had expected. It wasn't just that I was a virgin—it was that I was so fearful, so inexperienced, so ignorant a virgin.

Boys and girls should be raised together. They need to know something about one another from the earliest days. You cannot overcome wrong teaching and alienation by reason or imagination.

They say many a marriage has gone on the rocks on its bridal night, and I fear that mine with Harold Nicholas was one of them.

Almost immediately after our marriage—within days—Harold started going out with a chorus girl in Los Angeles. His dissatisfaction with me was that instantaneous. He was used to experienced showgirls, and at once our relationship became acrimonious. I tried to stop him.

"Husbands don't usually stay out till two o'clock," I told him when I woke to find him undressing at that hour.

"Don't keep after me. My mother did that, too."

"I've a right to. I know what you're doing."

"Too bad."

"It is too bad, and I won't have it!"

"Don't tell me what hour to come in!"

I picked up a pillow and heaved it at him. I wanted to hurt him, I didn't want to hurt him. Soft pillows, but I threw them hard. I should have thrown bricks, fixtures, hard things.

Night after night, when he wouldn't come in, I would get in the car and drive over to my mother's apartment, a half-mile away. I would crawl into bed with her, crying that Harold was out with some girl. She tried to console me; maybe he would settle down, she said; it wouldn't last.

Inside I was humiliated. I knew that it stemmed from my sexual incompetence. I couldn't please him.

Once he came in at six o'clock in the morning. I remarked on the hour of his arrival.

"Stop nagging."

"I'm not nagging. That's a fact."

"You are nagging. You sound like my mother."

"How do you think I feel?"

"I don't know."

"Who are you seeing?"

"Nobody."

"You're seeing somebody. What's that on your trousers?" I pointed to a telltale mark.

Our arguments went on and on.

I liked marriage, home life, cooking. My mother had taught me to be a good cook, and I tried holding his interest with good meals. That didn't keep him from philandering. To complicate it, he was in many ways very good to me. He was a good provider; he turned over all of his earnings. I didn't want for any comforts. I had a nice car, clothes, and time in which to do anything I pleased.

What do you do with a man who is good to you materially, kind, charming—and kind and charming at the same time to other women? I liked him, yet I hated him for what he was doing.

Then, of a sudden, in three months, I was pregnant. I had never had an orgasm, nor did I know what one was; but I was pregnant.

The marriage tie became sharper and at the same time more dubious, untenable, even embittering.

I would have a child by a man who from the outset wanted to live two lives—one at home with me, on his terms, and a showman's life on the outside with other girls.

My main preoccupation became the pregnancy. I waited out my time. I kept the lawn looking fresh; I watered the front and side yards with a hose each day. I kept the house in order. I didn't miss show business. It was good to have a place of my own, to be through with the road forever.

I tried to understand Harold. I recalled that he had been in rebellion against his mother and now, in a similar way, he was rebelling against me. He wanted me to resign myself to his pattern: to stay at home, be a housewife, let him go his own way. And now he even expected me to remain sexually illiterate, for when I tried new things with him he rejected my attempts. "Hey, what are you building?" he asked. Now he wanted me to stay as I was.

I was exasperated and actually quite in love, in a tormented way.

Being a lover was casual with Harold. Once he caught me in the kitchen when I was cooking and, fearing that grease would spatter from the stove into my eyes, he took a paper sack, put two holes in it for eye openings, and put the bag down over my head. "Protect your eyes and skin from the grease," he warned. I stood there with that bag over me, in my bare feet. I was out in the back, and the possibility aroused him. He took me, made love right there in the kitchen.

Inside I was alternately emotional about him and withered, and by now far along in the pregnancy.

One morning at eleven o'clock I felt the pains beginning. "Harold," I said, "I think it's time."

"Take it easy. It's probably soft labor."

"There's nothing soft about it."

"You're overanxious."

"It's unmistakable."

Harold wanted to play golf, and he seemed unconcerned. I told him I was calling my mother.

"Call her," he said.

Mother said that this was it; it was time to go to the hospital. I called my sister-in-law, Jerry Nicholas, the wife of Harold's brother Fayard. She said, "Dottie, you have to get to the hospital." I told her Harold didn't think so.

Harold took me over to Jerry's. There he had a bit of an argument with my sister-in-law. She told him his obligation was to stay with me now and to forget golf. But Harold loved golf and said he'd only be gone a short time.

"If you go, leave your keys with us," Jerry told him. Harold took the car key off the ring and left the other keys with us.

By six in the evening the pains were coming regularly. I wanted Harold with me. I thought he should take me to the hospital, but he was nowhere around and we couldn't locate him.

All evening I fretted over Harold's absence.

Late at night everybody was in bed, but nobody was asleep. I rose frequently to move about. My suffering was part physical, part emotional, as it had been from the earliest bridal days.

At two o'clock the following morning we would have gone to the hospital, but we didn't have the car key. It was wartime; there was a shortage of cars.

Early that morning, the man next door who was going to work took us to the hospital. By this time, I am sure I had waited too long. Perhaps I was holding the baby back, if that's possible, when it should have been allowed to pass. Somehow the pain of birth became snarled in my emotional distress over Harold's neglect.

In Jerry's anxiety to get me to the hospital, she forgot

to call the doctor. When I arrived, nobody was ready for me. There was further delay.

I recall a point of vanity. I wore a blue ribbon in my hair; it kept falling off, and Jerry kept replacing it. After that, mistiness.

It was a difficult birth, and the obstetricians had to use forceps. Deep forceps marks remained on my daughter's head four weeks after the birth.

There was then no reason to suspect anything was wrong with Harolyn, as we called the baby.

I tell the story of the birth because of what was to show up after a time. Was it poor obstetrics, a basically difficult birth, or neglect from any source? No one can know. Nor can I be certain that there was a direct relationship between a delayed delivery and the kind of a child that matured—but in my deepest heart I think there was some connection.

In a way, all of this was my fault. Harold's indifference to me wasn't new. I should have taken the initiative and gone to the hospital directly.

Rightly or wrongly, I date much of what was to happen to me thereafter—in my personal life and in my career—from the incident of the delayed delivery. Whatever happened, I blame only myself.

Whether it was because the theatre was now so much a part of me, or because I had intimations that I might one day have to rely upon it again, or because my marriage was so inadequate—or all these reasons—I plunged into the work of mastering the craft of acting. Each day, after I deposited Lynn at the nursery, I went to the Actors Laboratory. It was an all-day stint, from nine to five. You received insights to all phases of show business,

ballet, fencing, backstage craft, costuming, makeup. The main occupation for me was acting in various productions such as *The Philadelphia Story, Gaslight,* and Ibsen's *A Doll's House.* I was at this school for two years and among my classmates were Marilyn Monroe, Anthony Quinn, and Morris Carnovsky.

I had a foretaste of a type of disappointment which would befall me frequently years later.

I was considered the best actress for a role in a play that would be performed for the public. But Tony Quinn had the hard job of telling me that it was a part I couldn't have. The role was that of a Caucasian, and it was decided that I wouldn't be believable or convincing playing that part. The Laboratory itself did not mind, but casting for the general public raised a question. This is the classic problem that plagues Negro actors—and it also plagues Caucasian directors and producers. If whites can play Negro roles in plays and pictures, why can't Negro actors and actresses be cast in roles of Caucasians? As it is now handled it is one-sided, and the matter is tied in heavily with the race-thinking in people's minds. For example, right now, if someone were to be considered for the starring role in an apocryphal Dorothy Dandridge Story on the screen, I think a white actress would more likely be chosen for the part than a Negro girl.

This rejection caused a deep frustration I can't deny. Later such problems would produce a more violent effect.

In those months following Lynn's birth, I had a busy, even a happy, mother's life. I shopped at lunchtime, cooked dinner, pressed laundry in the evening, ran the house, read scripts at night. I believed then that I wanted to be a comedienne.

When Harold came in at sunrise after a night on the town, I would be up and around sterilizing bottles.

"Good morning, honey," I said when he entered. "Would you like some breakfast before going to sleep?"

He was disturbed now because I didn't care. I was used to it; this had become our way. I had the baby to take care of and that was fulfilling.

Actually what happened was that I was trying to avoid the hurt, to face the fact that he never really wanted me. As a result, I fell overwhelmingly in love with my infant.

For the first two years of her life, neither I nor anyone else suspected that there was anything wrong with her. She wasn't talking yet, but we supposed she would talk late. She had an intelligent face; her locomotor responses were good. She was responding normally to hygienic training, and she ate properly with the proper utensils. She had a capacity for joyousness, and she cried like any infant of that age. She laughed heartily at the popular radio commercial jingle:

> Rinso White, Rinso White,
> Happy little washday song.

If you went through the pat-a-cake routine with her, she would smile and react as any other baby. She had a habit of neatness almost to a fault. She was too clean. When she got through in the toilet she lifted the seat, put the toilet tissue back into the water and wiped all around the bowl to make sure she didn't leave anything. Then she applied tissue to herself till you had to stop her. Her neatness made no sense and might have been an indication of an abnormality. She would brush her teeth forever—up and down, around and about; then she would struggle to get the toothpaste cap back on the tube and place the tube in the right place.

She started feeding herself at about the same age as other children. Nothing seemed wrong with her coordina-

tion. That was what was so confusing about her growth. Whatever was damaged in her brain, the coordinative centers were not. With time, when she didn't speak, I began to worry, and my mother and I talked about it, and I spoke with my friends about it.

As a result of her inability to speak, the only way she could express herself was to cry or scream wildly. I had to figure out what she wanted. She would wake up screaming in the night wanting some of the things she had played with during the day. She might want a block, a box, a doll. I would have to search for whatever object she had in mind until I found out, for not until I found what she wanted did she cease screaming.

Still I suspected no brain damage.

When she lay abed she lifted up her hand and hummed and worked her fingers; she looked at her fingers and made a steady m-m-m-m-ing sound. I thought it strange—a kind of limited vocalizing; but when my friends saw this they said, "Maybe she's brilliant and not necessarily slow." That might have made everybody feel better—thinking that.

At two and one-half Lynn couldn't speak one word, not even mama or papa.

There was now a fright in my eyes. My friends hinted I ought to make some inquiries, and I had been thinking along that line for months. Yet I heard murmured consolations and was influenced by them: that Albert Einstein hadn't talked until quite late, or that her slowness might be an indication she was gifted—gifts that might burst from her soon in some scintillating way.

I tried to talk with Harold, to suggest that Lynn was frighteningly slow about speaking. He responded to my anxieties about as he had done when I was in labor. He

had show business and girls to attend to, and beyond occasionally lifting Lynn up over his head, as daddies do, there was no help from that quarter.

So I began a special kind of round, an odyssey of despair—taking Lynn around from hospitals to doctors to psychologists to schools, to find out what was wrong with her or what could be done for her.

First there was an electroencephalogram. At that time this type of test wasn't too well developed, nor too reliable.

My sister-in-law Jerry went with Lynn and me to a Los Angeles hospital. Because the nurses wouldn't understand why Lynn screamed, since she couldn't speak, Jerry and I planned to be there to explain. We arrived with an overnight bag, intending to stay, but the nurses told us she must be there by herself, no parents or relatives allowed.

I knew Lynn would have a hard time, and the next morning, when she emerged from the room where she had been tested, I could see her hurt and confusion. All I could think was, She's so little.

We went into a dark room with three physicians. One of the medical men, pointing with a long stick at pictures tacked to a wall, described the nature of the brain and what should be a normal condition, and explained where and how abnormality might reveal itself. But they said the encephalogram showed no brain damage, no degeneration of the brain.

For the next year or two, I frantically tried one thing or another, spending Harold's money liberally and getting nowhere.

A psychiatrist told me that at eighteen months of age the child should be groping. Instead, said this adviser, Lynn had been made into a little lady: she seemed too disciplined. He said she should have freedom of expression.

I couldn't understand that, because when she first had

begun to move and romp around, she dumped ash trays and tore up magazines like any other child. At that time, when she seemed to be growing normally, I gave her the routine spanks that are given most children of that age when you have to begin instructing them in what to stay away from, such as, ultimately, streets and autos. She could understand what she could or could not get away with. We could discipline her, teach her some things; and she had acquired some sense of what was permitted and what was not.

But now they recommended complete freedom.

We let her do as she pleased. She threw things on the floor. She dumped the flour out of the cannister. She went into the refrigerator and poured out the milk.

When she did these things, the visiting psychologist would remark, "That's marvelous, that's marvelous, she hasn't had a chance to play . . . she's making mud pies."

Lynn would look at me when she tore up the place and I would say, "Oh nice, sweetheart," or ignore her.

She would scratch the woodwork and mar it, and I would take no notice.

I was in a total dither. Lynn was always a mess. There was no cleaning up. I bought a Do Not Disturb sign, posted it on the front door so that nobody could possibly come in while this was going on.

When Lynn finally saw that I was taking no notice of all this, such behavior ceased to interest her. The bedlam quieted down. Her field day was over—but still she couldn't speak. Always there was that plaintive little face staring up at me, trying to communicate, and then eventually communicating a scream. The main part of her life was choked up inside her.

I returned to the doctor who had prescribed complete

freedom and reported that there was no change for the better. I asked, "What do I do next?"

There was no answer.

Through Lynn's infancy, when we had no idea of her retardation and treated her as a normally growing child, I accompanied Harold on a few entertainment tours across the country, and even one or two trips to Europe. On tours east or west in the States, I took Lynn with me. On such tours I had help.

During a trip to a Child Psychology Bureau in Los Angeles, I was told Lynn might be a victim of our travels. She might have a psychological problem because she had switched environments too often; Lynn had no roots in any one place, they said; she ought to stay in one place. That might help her to become normal and talk.

That left me with the problem of being torn between child and husband. If I stayed at home with Lynn, then her father wouldn't be around. As a result I decided to leave her for a time in the Sunland School for Children.

Mainly they had disturbed or difficult children here, and it may have been right for such children, but it was wrong for Lynn. The adviser believed that Lynn was normal, only having some kind of temporary problem. She had learned to play the scale on my piano, and each day, for about an hour, Lynn sat on a stool and ran up and down the scale—nothing else.

That went on for three or four months, and when there was no change for the better, I wound up feeling that Lynn had been kept there because of the money involved.

Once more we began to look for physical causes. A physician prescribed an acid that was supposed to stimulate the brain. It seemed to me that if the brain had to be

stimulated, then there was something wrong with it. For a little while, under this stimulus, she acted more alive than usual, but this wasn't getting at the core of her trouble. At last the acid made her react nervously, and I took her off it.

She stopped eating and had to be forced to eat.

Once more I put her through an electroencephalograph test.

This time the results of the test were more explicit. There was scar tissue on the right side of the brain where the speech center and the abstract thinking center were located. It was explained to me that the scar wasn't deep enough to affect her general coordination. They said that it was a result of cerebral anoxia, a condition of asphyxiation. It was from either a lack of blood or of oxygen flowing to a certain portion of the brain. It was this analysis that convinced me that the condition might have stemmed from the delayed delivery.

I asked if there was anything that could be done.

"Only one course that might—or might not—help: an operation to remove the scar tissue. Three little holes to be bored in her skull."

"Holes in her skull?" I repeated.

I was upset and unwilling, and they didn't press me.

Later when I mentioned that proposal to others, some said it was no more than a mercy-killing alternative.

My love for Lynn was a little abnormal. If I had never had a child I wouldn't have known the difference, but there was something special with her—maybe it was that she was my very own and such a compensation for a poor marriage.

At night when I went to bed I always heard m-m-m-m-m—the only sound she made except for her

screams—in the next room. When she made the m-m-m-m-m sound, she was in a good disposition, and there were times when for days it was the only sound from her.

And in the morning I'd know she was awake and I'd wish she would sleep another hour because I was tired. The fatigue never seemed to leave me. I always had more to do than I was capable of doing. I had to get up to take her to nursery school, then be at the Actors Laboratory at nine.

Now, as I'd hear this m-m-m-m-m, I would call out, "Go back to sleep."

But pretty soon the door would open.

I would say, "Okay, come on." I would look at her little face and her smile.

She would jump into bed with me, and we would cuddle up, she naked against my naked breast, and I'd say, "Well, let's have ten minutes sleep."

M-m-m-m-m-m-m-m-m.

She would lie there close and we'd stay like that—the most wonderful, comfortable feeling.

There was too much love between me and the baby. We had mother and daughter pinafores from the Farmers Market. I always got such an elated feeling watching the way she slipped into her pajamas with the feet modeled into them. There was that wonderful baby smell when I washed her, when I took her out of the tub and oiled and powdered her. Then I'd let her shake the powder can and powder would fly through the bathroom. When she was cleaned up she would hug me—and there was no feeling like that.

When I washed her hair she didn't like that, for she had so much of it, it grew down to her waist. Sometimes we'd get into the bathtub together. She would splash and have a fit of fun. I would wrap her legs around me and

hold her back and put her head down, dipping her scalp into the water. She would splash and carry on, and then start crying. I'd apologize and tell her I was sorry and grip her to my bosom.

She'd hug me tight then, crushing into my breasts, and it was all warm wet nakedness.

I have known quite a few men, since then, but I tell you, you cannot get *that* feeling from anything else in the world.

Except this . . . except this: I knew that to everyone else she was hideous.

Finally I went to a woman physician who was the only honest or knowing person I encountered in this entire ordeal.

By now there was a history of medical attention which I could describe to her. I said, "Now look, everybody has been jostling me along, saying Mother this and Mother that. People have been trying to put it to me easy, not wanting to hurt me. I have been told this and that, and the child has gone through the mill, and I have gone through the mill. She doesn't speak, and people are keeping things from me and not telling me, or they are ignorant and don't know. I am sick of this. I want to know the truth, that's all. Tell me exactly what is wrong with her. Talk to me like you would to someone in your profession."

She gave me the whole sad story straight down the line. "Look, Mrs. Nicholas, I'm not going to take your money. I can't help your child. I don't know anybody who can."

"Let me hear it."

"Your child will never be normal. She will never mature. She'll never reach the level of a six-year-old."

She went through it all, told me what those tests

meant, what the work of the psychologists and the psychiatrists meant, what Lynn's chances were of improving by being in school. She wound up, "The best thing for you to do is to get rid of her. Give her up and have another baby."

"That's it, huh?"

"That's it, Mother."

"Thanks at least for telling me the truth."

I got into my car with Lynn. I was in a daze, and I don't know how I drove. People I knew saw me and spoke, I was told later, but I did not see them.

I had already known the truth. In my heart I had known it. I knew everything that this lady doctor told me, but when she told me—and Lynn was nearby listening and not making any sense of it—it was final, official, hopeless.

Now I had to make up my mind to give her up. How? When? How do you give up a live child you love?

On the outside I said to myself, "I've had it, I'll give her up." Inside I never gave her up. It was myself that I began giving up.

Throughout all this, Harold didn't go with me even once to any of the doctors. He played with Lynn in an affectionate way when he was around, but he couldn't face the fact that she couldn't talk to him, or he found the means or strength or whatever else inside himself to put it all aside. He had a faculty for disposing of problems, irritations. So, as far as I could tell, he was not too profoundly touched by what was going on.

What effect all this had upon our marriage I can't clearly estimate.

But this development, along with Harold's chronic need for an outside physical life and the way in which the

disaster of Lynn tore me up—all this wore away the fabric of our deteriorating marriage.

At this point, when my private world was sundered, I consulted with my mother, relatives, friends. What to do? Where to send Lynn? How to "get rid" of her?

Since my marriage I had more or less rid myself of the incubus of Auntie Ma-ma. I didn't want to see her, and what she was doing and how she lived was no concern of mine. But suddenly she was back in the picture.

One day she announced to my mother that she had had a vision—not a dream, but a full-scale vision. God had come to her in or out of a mist, she said, come right down to earth and told her what to do about Lynn.

She must take Lynn, she told my mother. Only she could help.

Both came to me, my mother and Auntie Ma-ma. Auntie Ma-ma was frenetic as she described the way God had appeared to her in the night with the command that she must take my daughter.

Although I didn't go for that kind of religion, I was desperate. I recognized some desire on Auntie Ma-ma's part to be of some help or to get into the act—and I let her take over on Lynn. Cost, fifty dollars a week.

Lynn was to stay at my mother's house where Auntie Ma-ma would care for her.

For months I tried to forget Lynn by traveling with Harold to one or another club, East and West coasts, big inland cities, another trip to Europe. But always I hankered to get back to Lynn.

On one of my returns I couldn't find Lynn. Someone taking care of my mother's place, while she was with the Judy Canova Show, said, "Go see Jonesey."

I went to a woman's apartment—a woman called Jonesey—and she sent me to still another place. "Have you

spoken to Helen Calhoun?" she asked me. I had never heard of her. "Your daughter is with Helen Calhoun."

"Who is that?"

"She's the woman who watches Lynn. Your mother and aunt send her over there to play sometimes."

I learned that Lynn was actually in the hands of a woman who was expert with backward children and that she was taking care of my daughter for fifty dollars a month. Auntie Ma-ma was pocketing the remainder of my weekly payment to her. So much for visions.

One thing good came of it. Mrs. Calhoun was patient and wonderful with Lynn, and she was to take care of my daughter for many, many years.

All through my marriage with Harold I retained my interest in the theatre, partly because I was intrinsically interested, but mostly it was because there were always undertones of failure that might thrust me out in the world again.

I was interested in acting, more in acting than in singing. As a child performer it was my acting that made them laugh. Even in the singing style I developed, I acted out the song. It was never my voice, it was the feeling I put into the words: it was the gestures of my hands, the weaving motions of my body that put over my music. People liked to look at me. I never regarded myself as a good singer, only one with a sultry or torchy voice, a voice I put feeling into. My vocal range was less than an octave; there was no mechanism for range or variety. This self-awareness, together with tactless comments from Harold that I couldn't sing, intensified my interest in the theatre, especially the screen.

"I like Margaret Whiting's voice. Now there's a girl who can sing," Harold taunted.

I could only keep quiet, aware of my limitations.

He thought I was wasting my time studying at the Actors Laboratory. All the talent in the family was in him.

I don't mean to be too harsh on him. As my mother had dinned into me, "There is some good in everybody if you look for it."

I read whatever there was to read on acting. I went to the Actors Laboratory religiously. There I studied the Stanislavski method of acting. I studied the stars of the cinema. I frequented the legitimate theatre. Around the house I clowned and acted, worked on a secret direction of my own: a readiness to move out as an actress if the need or opportunity ever asserted itself.

The Nicholas brothers were favorites in the biggest theatres in Europe. When Jerry and I traveled with them, we were stared at as if we were somewhat odd. Not entirely for our coloring (Jerry and I were rather light). It wasn't that. It was more likely because of our expensive clothes which branded us as Americans.

It was the habit of Jerry and me to catch the opening show in which Harold and Fayard would be appearing. Then we would go backstage and report on audience reaction. I also took care of Harold's business details, handled the agent, and paid bills back home.

It was convenient for Harold to have me with him. That way he could have his affair and then say to the girl, But I'm married.

With the years Harold acquired a Continental view. He was away from the United States much of the time, and he preferred to be. Why not? He saw and experienced less of the rejection that was the lot of Negroes. Abroad, in

Paris or some other capital, he was spared. Even there you couldn't escape some feeling of alienation (you always know who you are, wherever you are), but it was not as extreme as in the States. In consequence of this, Harold began preferring Europe as his "home."

More and more he was abroad while I stayed in Los Angeles, living in the shadow of a frustrated marriage, a disastrous child. Still, I was a wife, if an unhappy one. Still, I had a child, even though a damaged one. Still, there had been hours and days of real motherhood with Lynn— and I can say now that the only year or two of happiness in my life was in the time before I discovered how hopeless Lynn was.

By the fifth year, our marriage was battering on the rocks. A long period ensued when I didn't even hear from Harold. He was in Italy on a six-month engagement—and for the first time in our marriage he wasn't sending me any money. He claimed that he couldn't get the lire changed into dollars.

From having had hundreds of dollars a week to spend, I now knew what it was to go around broke. Lynn's bills began to pile up, and I sold the house to pay them. Then I sold the car to make payments on loans that I had gotten on the house. I telephoned Harold in Italy, but I couldn't reach him. I left word for him to call, but he didn't call.

I heard that he had signed another contract for a prolonged stay in Italy. He knew that I was in trouble, and if he had done that—signed for another long stay abroad by himself—and if he was letting me hock everything in order to keep his daughter and myself going, it was clear to me he was dismissing me. In order to drop me in that cold-blooded fashion, he must have had some cute Italian girl going for him at the time.

I wouldn't leave a man who cheated a little. Harold

cheated a lot, and I didn't leave him. But now I was being pushed out, dropped, abandoned. No woman in her right mind, with any guts at all, would stay in a situation like that. I wouldn't.

Like a gentleman, Harold allowed me to get the divorce.

Part 4

Sweet Talk

Alone, fears beset me. I had failed as a wife, a lover, even as a mother. My experience with Harold left me with an inner uncertainty about myself in relation to men. What happened with Harold might happen with another. Any man you took up with or married might do what he did—stay with you for a few years, then take off. After all, it had happened to my mother even before my birth.

I began to think, In a man's world every woman has to be ready to work and support herself. A woman can't rely on any man for monetary security.

After my divorce, living was precarious. I was broke. I was so desperate that, if I couldn't find entertainment or theatre work, there was the frightening possibility of having to live off men. Hollywood was filled with girls living that way. I hated that prospect, so I called an agent, Harry Ward, whom I had met a year before.

Ward had been in touch with me while I was still married because of a lark appearance at the Orpheum Theatre where I entertained on a bill with Sammy Davis Jr. and

Sugar Ray Robinson. Ward had heard me sing and had called to ask if he might represent me.

Now, suddenly, I called him, and he arranged for me to be auditioned by Charlie Morris who ran the popular Mocambo Club. Morris told me that my style wasn't right for his place, and he referred me to Phil Moore, a well-known Negro composer. If Moore could find the right style for me, he would engage me.

It chanced that I had known Phil Moore, but not well; now, thrown together with him in a professional capacity, working closely with him as he studied my voice, manner, and possibilities, the professional relationship swiftly became personal.

He was brown, stocky, of medium height. His hair was thinning; he was perhaps not handsome, but he had numerous qualities of charm. He was very aesthetic, prone to using the word "esoteric," and in a way that word described his own manner and mind and to some extent his approach to music. He smoked a pipe and went about with a calm and sureness that I admired. He looked the way I imagined a father ought to look.

At this time he was well established as the organizer of the Phil Moore Four, a society band that played sophisticated clubs and big money spots. His band recorded popular songs, and he arranged music for Lena Horne. He was no jazz musician, but he had knowledge of all music; he leaned to a light classical tonality, and he was to bring much of this character into the way I styled my singing and my singing personality. As I became Phil's protege I attended musicales which he had at his apartment.

He conceived of me as a ballad singer on the order of Sarah Vaughn. But it was the other music we made that was to have the significance.

From Phil I was able to learn about physical intimacy, and it was he who helped me to "come out." With him I went about the details of lovemaking with a certain will, as if to end once and forever my ignorance. Phil enabled me to break through my own duality, the conflict between the taboos instilled in me and my own outward sensual image. I looked sexy, but I was not. Phil's facility, his ease, his knowledge of female psychology warmed through me. He understood that I required precoital cultivation, after which the rest followed.

I became passionately involved, but never in love. I had been too hurt by Harold to let myself go that way with anyone, as yet.

Phil told me that he wanted to live in Hollywood. He worked there, but he was living on the other side of town, the West Side. It wasn't easy for Negroes to make a move into the white side of Los Angeles. Phil was darker than I; apparently the shade of color could be a factor. I made the move into Beverly Hills with no difficulty at all, perhaps because of my lightness, my confident manner, and what they all said were my good looks. I managed to engage an apartment near the Sunset Strip, and after that Phil moved into the apartment overhead.

Curiously, at the time, there was some criticism of this among certain of my Negro friends. They wanted Negroes to break away from ghetto living and to get into white neighborhoods, but there were groups and committees which felt that this ought to be accomplished in an organized, vocal smashthrough. They disapproved of just quietly moving in, as I had done, followed by Phil. But for an artist in Los Angeles—if you want to sing and act, Hollywood is the place.

Phil became fond of me, even possessive. We were together constantly, and he showered me with attentions.

There was no question in my mind of marriage to him, nor was there such thought with him, as far as I knew. The affair had its own beauty, a touch of *La Bohème*.

We were two artists simply and clearly shacked up.

Phil asked his agent, a young man named Earl Mills, to come to one of his musicales and listen to me sing. Mills was from Chicago; he had come to Los Angeles as the associate of Burl Adams, a reputable manager of Frankie Laine, Vic Damone, Kay Starr, and Louis Jourdan. When Adams decided to join with Music Corporation of America, Mills was free to go on his own, and he became Phil's representative. When Mills heard me sing he told Phil that I could be successful as a personality singer, not as a ballad singer.

Earl was a quiet chap with an unfortunate background. He had been orphaned at an early age and had spent numerous years in an orphanage. His experiences left him with a strong social sense. He was interested in the challenge of helping to build a Negro girl singer. He reasoned that because of my looks and my air of elegance, I ought to be groomed for carriage trade entertainment. I decided to let him be my agent, and he helped me perfect my style and repertoire. Under his tutelage I began singing songs of the Cole Porter type and to project a style of cosmopolitan sophistication. A manner like that required a wardrobe which I didn't have.

I took singing engagements around the Los Angeles area in outlandish little clubs that were adjuncts to hotels. A date might be in an old hotel where the phones were in the hall and several people used the bathroom. They were one-night appearances.

I had one engagement in New York for three hundred and fifty dollars a week, which was exactly what my

expenses were. I paid a hundred and seventy-five to an accompanist, ten per cent to my agent, and I had to put the remainder down on my installment-bought gowns. I arrived at that club penniless, and if they hadn't fed me I wouldn't have eaten.

I spent most of my earnings on clothes, for what I looked like onstage was a large part of my act. I intended, if money came my way, to get a wardrobe the equal of anyone's in the business. If you are supposed to be an attractive woman up on a platform singing to a few hundred people, you better look right. From the earliest days of trouping I had been conscious of clothes, and they were even more necessary now. I acquired jewelry, a black kid bag, a couple of gowns, a hostess dress, and I paid ten bucks a week to the shop I had bought from, sending the money from wherever I was.

After a few months Earl suggested to Phil Moore that he and I team up. Phil wrote special songs for me, and Earl booked us at the Gala Club in Los Angeles. We were so successful there that the attendance at the club leaped sharply. One result of our appearance was that the newspaperman Dick Williams did a feature article about us that was read all through southern California. From then it became easier for Earl to book me at the better clubs and hotels.

At the Gala I began singing songs that Phil wrote for me. Two of them, "Talk Sweet Talk to Me" and "Blow Out the Candle," were to be part of my repertoire all through my career—and these same songs were to be a subtle factor in my subsequent parting from Phil.

Immediately after my initial performance at the Gala, the first attack of my own private plague struck me. After I sang and wove sinuously for the drinking crowd, appearing to go through the motions easily but actually with a

great strain, I took sick—a sickness peculiar to myself and one that will probably lead to my death one day.

In the dressing room, after the show, I couldn't breathe. I had chest spasms, my legs cramped, my feet and hands tingled. I was unable to talk. I stayed in this contracted fit, doubled up, until I came out of it.

Phil's secretary was the wife of a psychiatrist, John Berman. She thought she spotted an emotional disturbance and suggested I ought to have help. Phil said he would pay for my analysis if I went to Berman for treatment.

I told the doctor as fully as I could of my marriage and what happened to Lynn, and his diagnosis was that I was suffering from guilt feelings over Lynn. My paroxysms were a reliving of Lynn's own sufferings and frustration. He counseled me that it was useless to relive my child's destruction and to take her pain so deeply into my own body.

With time I was to acquire from him and other psychiatrists and doctors a superficial knowledge of the whole dim world of the psychological. Sometimes these people could help me, and I never thereafter was out of their hands—never for very long. Once or twice John Berman and his wife saved me from taking my life.

Lynn was never out of my mind. I managed to see her from time to time, but she didn't know who I was. Although she seemed to like me, she didn't know that I was her mother. Time meant nothing to her. It meant little to her who she was with—one person or another, it made no difference. Now she was with Helen Calhoun, who was patient with her, and Lynn liked her.

As I plunged into show business I had mixed emotions about it all. I had to escape from Lynn, from Harold, from suffocation and failure. I had, if I was to find any reason

for living, to prove to myself that there was something I could do and do well. I had to shoot ahead. I had to show people—and myself—a validity to replace my six years of failure.

A motive like this can be a terrible thing. In the coming months and during the next few years, I moved like a rising star, somehow mingling a hectic personal life with the strange neurotic professional needs and drives which now controlled me.

There was a turn upward in my fortunes when I opened at La Vie en Rose in New York for two weeks, and the engagement was extended to sixteen. I asked the management to let me make an impromptu appearance on the night before my opening so as to get used to the place.

I told the audience, "I am new to solo singing. I'm a little nervous. I've been living a quiet married life for six years, and now I've got to be out on my own again. I have to open here tomorrow night and I'm wondering if you'll let me practice on you tonight." La Vie en Rose was a small place; it seated less than a hundred people; it might have been two-thirds full then. I talked on and on until they were calling out, "Sing!"

I let loose. My voice filled that small room.

I ran from mood to mood through a half-dozen songs, and by the time I was four or five numbers along they were cheering, clapping.

My way is to act the character of each song, as determined by the lyrics. Each song is about three minutes long, and for that time I am the girl of that song, a different person each time. I am a puzzled girl in "What Is This Thing Called Love," a philosophical girl in "Just One of Those Things," a happy girl in "Everything Is Fine and

Dandy," romantic in "He Called Me Baby All the Time," and sexy in "Talk Sweet Talk to Me."

On that very evening I struck my stride for the first time, made my audience realize that the words and their meaning were my only reason for singing.

On the night of the opening there was a line outside, and people were queued up each night for weeks thereafter.

By this time I had learned how to present myself. I went on, three shows a night, wearing a gray suit, carrying a bumbershoot (an umbrella), and I swayed in a sinuous way as I sang Cole Porter songs and the numbers Phil Moore wrote for me. There was nothing in my accents or emphases that suggested traditional Negro singing. It was a style closer to the mood of upper-class Caucasian life; it was sophisticated, with no hint of blues or the jazz idiom. Coming at this time, after World War II, when there was an awakening of interest in the Negro presence in America, I represented a midway identification. My looks, acceptable in the way Lena Horne's appearance was also acceptable to whites who were just beginning to open their eyes, had something to do with the response. The audience could at least go this far—could "integrate" with a colored woman who had Caucasian features.

I would make the most of this stage of acceptance, publicly and privately, everywhere I went in the coming years. It was to be a trademark of mine.

Look magazine interviewed me, did an extensive article about my success at La Vie en Rose, and took many photographs. For the first time, millions of readers had a look at me. It was that publication that likened my style to that of "a caterpillar on a hot rock."

Harry Belafonte and I had the same press agent, a woman. Harry was at the Village Vanguard, and the agent said to me, "There is only one person I know who is more beautiful than you. It's a man, and he's in New York now."

The agent told Harry the same thing: there was only one person more beautiful than he, and it was a woman, and she was now in New York.

One night the agent took me to the Village Vanguard to meet him. His voice was tremendous, with a unique timbre. The calypso-Jamaica idiom he used was charming, and he had great stage presence.

I went backstage, and when I saw him I said, "Oh, my goodness, he is just beautiful." He simply said, "Dorothy."

We liked each other on sight and were destined to become theatrically and personally involved thereafter. Nightly, Harry came to La Vie en Rose after his own performance to see my show. He stood against a wall and waited for me to go on. At that time he hadn't made any large breakthrough, and he seemed to be studying my performance.

In the succeeding months Harry and I regularly saw each other, and as I told him, I would have dumped show business entirely and have been happy to be Mrs. Harry Belafonte, if he wanted it that way. It wasn't to be. But an intermittent professional relationship was in the making, and a neurotic fussing that would continue for several years.

But about now, when my New York success was a fact, my troubles with Phil Moore began.

Only a few months before I had been Phil Moore's protege. He had already won a reputation as pianist, writer for leading singers, and I had been a mere beginner. He had been my teacher, and I had listened when he spoke

music, and I had been as responsive as I knew how to be when we were lovers.

But it was all changing.

The attention was more and more directed toward me. The press seemed primarily interested in me. I made copy; newspaper people liked to talk to a pretty woman.

Phil developed a professional rivalry. I was getting out of hand, and he couldn't control me. He suggested that I couldn't be successful without him, and I resented that. I had been a success, of a sort, at the age of five. My confidence was growing.

Entertainers have a hard time living together. Perhaps they see themselves in one another and do not like what they see.

"Phil," I said to him, "when we're on stage, I don't like it when you give the impression I'm your woman."

"Do I do that?"

"You do, and it's embarrassing."

"I thought we understood each other."

"We do. But you are playing Svengali. I am nobody's Trilby. I'm an artist in my own right."

"Right, baby. I don't want to take that away from you."

"You make me think I can't work without you."

"I have helped you come along, Dottie."

"Yes, but I don't want to be owned. You shouldn't try to run press conferences as if I'm not in the act."

When we were on stage Phil would be at the piano playing as I sang. He would talk sweet talk to me, and I'd give him a hard look that told him to cut it. It seemed to me that there were double entendres in the way he handled me. It dawned on me that he was conducting himself in a manner that said to the audience, This gal is mine.

Phil felt himself to be part of my success, and he assumed he was indispensable. To him I became a hunk

of music which he wished to compose and recompose. As the feud deepened, it reached a point of racial dispute. Phil intimated that white women would object if I sang certain songs in a certain way.

That was the outermost limit. When a Negro pulls rank on a fellow Negro, implies that he or she is Tomming or doing something that reflects poorly on the group, that is strong medicine; it is the final argument.

It came down to whether or not I could hold an audience by myself. Phil wanted to believe that I couldn't and that I couldn't do without him. I believed I was a solo performer any time I wanted to be.

Maurice Winnick, an English agent, engaged us for the Cafe de Paris in London. His client was Phil, not me; but when we arrived in London, the press paid more attention to me.

Professional rivalry was having its effect on our love affair. We argued more and more, made love less and less. In London the response to my singing convinced me that I no longer needed to be dependent.

Phil and I returned to America with a coolness between us. Our theme, "Talk Sweet Talk to Me," was very thin.

One of the attractions between Harry Belafonte and me was that each of us was going to a psychiatrist, and there can be an accord—and discord—between people who talk the same language or have comparable problems. We had this in common, as well as both being Negro and in show business.

When the language of love merges with the argot of psychiatry, a routine difference of opinion over a fouled-up dinner engagement can sound like this:

Harry: You don't have to get so hostile because I'm a little late.

Me: A *little* late? That's the most frustrating thing you've said yet.

Harry: Look, let's not start rejecting each other.

Me: That's easy for you to say. I've been a pile of anxiety here for hours.

Harry: You don't have to act that dependent, you know. You could have found things to do.

Me: I expected you at eight o'clock. Why do you give me five hours of upset and insecurity?

Harry: Maybe it's because I suspect you castrate me and I'm trying to defend myself.

And so on.

There was columnist comment about us, and this led to a situation where, when Harry was being interviewed by disc jockeys, he was asked, "What's Dorothy like?"

He answered, "For God's sake, if you want to interview her, why don't you call her? What are you having me here for?"

Harry felt that I castrated him, and he frequently used that term. He didn't feel safe with me, and decided I was too much to cope with, too independent, too dominant a personality.

At the time he was separated from his wife and in the process of getting a divorce. Yet I think I represented exactly what he was divorcing—a woman who might overshadow him, and this he didn't want. Harry was searching for someone with whom he could be comfortably, clearly the dominant figure. He liked beauty in a woman, and he even liked intelligent women, but he needed someone who would not take the spotlight away from him.

It dawned on me that, as a suitor or a romantic figure in my life, he was vanishing. He would show up late for appointments. He would be forgetful of little things. At last he simply disappeared.

I couldn't forget him. He had a beautiful voice, he was utterly handsome, physical, a real male. But from the earliest days there was an undercurrent of professional competition. At least he seemed to feel this, and finally he was frank to say so.

I didn't know, in those early days, that we would be together in various pictures, but he and I were to continue on a different relationship.

When I look at Harry in retrospect I realize that I was rejected.

I tell this story of my rejection by Harry because in the next ten years I was to be pursued by many men, mostly Caucasians, and I was destined to be rejected—for marriage anyway—by *all* of them.

During the years 1951 and 1952, my twenty-seventh and twenty-eighth years, I did as much traveling possibly as anyone in America. With me went usually my pianist Nick Perrito and my personal maid Veada Cleveland. Sometimes Earl Mills flew with me to a club engagement. There was as much work for me as I could physically undertake: supper clubs and my first moving pictures—B pictures. I was between Los Angeles, New York, Chicago, San Francisco, Miami, London, Rio de Janeiro, Mexico City, Paris. My picture was on the cover of the biggest-circulating magazines in the United States, England, and France. My income zoomed. I could get three, five, or ten thousand dollars for a one-week singing engagement. Money was coming in from movies, TV appearances, recordings. Still, most of all I was bent upon an acting career.

I was achieving reasonable forgetfulness by intensive living. If I got a report that Lynn was all right, I smiled

inwardly and pushed on. Throughout, I went to a psychiatrist. When I returned to Los Angeles after days or weeks away, a visit to my doctor might be the first thing I did. For something was wrong with me. I still tended to suffer after singing: tightness at the throat, cramping, occasionally a paralysis.

Ruby Dandridge was now a regular on the Judy Canova Show. She worked for Amos 'n' Andy, she had bit parts in a couple of movies, and she was living well for the first time in her life.

A flattering process was taking place in my life. Men— handsome, rich, talented—were pursuing me. Especially older men who owned fortunes, hotels, stocks, banks— they came to hear me sing, and their flowers piled up at my dressing room doors. Calling cards and gifts of perfume and jewelry arrived.

I usually accepted the gifts but not necessarily the men. Mostly I wouldn't even meet them. Sometimes, when I did, I swiftly found out what they wanted: a night, a week, an affair, a trip to a resort. They wanted to take me to a night club, to be seen with me on their arm.

I dismissed an automobile racer, a young merchant who owned a large department store and numerous mistresses, a producer who implied advantages to be gained if I only played the game, a well-to-do man who wore flashy jewelry. I dismissed a baseball player—when I told him I couldn't care less about the game, his face fell, like a pitcher's drop ball.

As soon as I learned a man was after some rapid weekend boffing, he was out. Finding a man who wanted to go to bed was the easiest thing in the world. Finding a serious man was one of the most difficult.

About the friendships I did have, discretion was the keynote. I didn't go night clubbing with any of the men I

knew—I spent enough time in those spots. I never sought column publicity—that would have ended any relationship. I wanted privacy for my romances, for what I really wanted was marriage, stability, a real and permanent relationship. At this time I had no idea that beauty and reputation could be such an obstacle to obtaining seemingly so simple an objective.

My appearance at La Vie en Rose led to numerous acquaintances and to my first involvement with a white man. One of the callers at that bistro was the actor Harding Allbrite. He was so handsome and gentle that I couldn't brush aside his attentions. He had been a secondary figure in three or four New York plays, and things were to happen to him—things he wanted to happen—which forestalled an acting career. That is why his name will be known only to two or three dozen people in the New York theatre.

Harding fitted into the period when I was making my debut: Caucasians were all around me and few Negroes. Caucasians were acclaiming me. I was in their magazines and newspapers, and they were booking me. Harding also fitted into the introspective period of analysis into which I had entered. I was learning of the diverse, strange, and erotic relationships men and women may adopt or be born to or posture through. The whole lexicon of psycho-analytic expression—terms like hostility, frustration, mother substitute, father substitute, Oedipus, Lesbos, concealed homosexual impulse, and the rest of the vocabulary drawn from the power of the womb and the scrotum—intrigued and interested me. Perhaps it passed as knowledge. Certainly it was fad and fetish all through the theatre, and at the time, not to be in analysis was almost like being out of fashion.

Harding was white, handsome, neurotic, ambitious,

and under analysis himself. He was tall, heavy set, and brown-haired; he was photogenic; he had a beautiful voice. He had charm and wit. He traveled in the New York social set, a world I knew nothing about. Nonetheless I was amused at his picture of the inner world of Long Island society. Clearly that was the world he was headed for.

He was one of what you might call "the sweater boys." There was a group of ambitious and talented young men who still wore sweaters in their thirties, in a youthful, adolescent style. Harding always showed up in a turtleneck sweater or in some comparable sporty dress, and all this helped give him his special character.

I don't know what there was in his early life that made him as he was. Perhaps he wasn't around boys enough; there may have been too much feminine domination; whatever, he seemed at first to want nothing but kissing sprees. That will sound infantile and even amusing to readers expecting to hear of entertainers engaging in more forthright liaisons, but disillusioning as it will seem, this kissing went on for many weeks, until finally, in an adult assertion, we brought the relationship to where it belonged and where it stayed for a year or so.

We would meet whenever I was in New York for a few weeks, or as we did once or twice for intervals in Las Vegas and Los Angeles. When we couldn't be together, we would be in touch by phone. Owing to the fact that I am a poor speller, I always hated to write letters. This led me to roll up huge telephone bills, and my calls to Harding—from anywhere in the world—cost me hundreds of dollars. But that was the rub: I could spend hundreds in phone calls, but Harding had his sights set on millions. Harding had no prejudices, but I had no fortune.

Had I been worth a million dollars and could have

said to Harding, "Marry me and we'll go to the bank and open up a joint account," I think he would have. Moreover, life with him would probably always have been pleasant.

He was so candid, so forthright about what and who he hoped to meet and marry, that we talked of it numerous times. He told me, "Dorothy, I love you, but there is absolutely nothing in it for me. You know how badly I need money."

"I do know. I need it myself. I would like to marry someone who could pay the rent."

"I'm not making the grade. I get these bits in plays, and I've had too few darned good roles. I'm going about broke all the time, and I need someone who can give me a lift. A lady producer, a lady writer, or an heiress."

"You're handsome, you're dashing, you've a name in the theatre even if it isn't top drawer, and I'll bet you can marry a million."

"I'm glad you're so understanding, dear. This is wonderful, having you for a pal, lying here on the couch, making things together in the kitchen, guzzling wine together, having chitlins with you, and standing around while you cook them. Darling, this is wonderful, but you just can't take care of me, can you?"

"No, I can't do it. I just am not the girl. By the time I pay my conductor and my pianist and my maid, I'm just about making ends meet."

He asked me, "Darling, how long have we known each other now?"

"More than a year. We've spent a hundred nights like this, lying and loving on this divan, talking and being the greatest of friends. There is something about it that suits us both. Too bad we can't be of help to each other."

"That's the damned truth, Dorothy, and it's lovely to know that you feel the same way about it as I do—that

you have to find someone who can take care of you, and I
have to find someone who can take care of me."

"We're really birds of a feather, aren't we?"

If I were in Las Vegas or in Los Angeles, or wherever,
I might get a call from Harding. We would have the same
kind of talk by phone as we had when we were together.
He would tell me who he was interested in, and I'd advise
him that it might not work and he better look elsewhere. I
would cheerfully urge him on in his sport of chasing down
a rich woman who could care for him while he pursued
an acting career and a sporting life.

It was a distinguished and unique candor. He con-
fided his ambition in such unabashed innocence, with
such a complete lack of cant, that I had to admire him.
Other men might have ulterior designs about a woman—
her fortune, name, or reputation—and keep it to them-
selves. Harding was honest in telling me that while he
loved the fun of being with me, life was real, life was ear-
nest, and if you don't make a fortune as an actor, get it as
a male!

He was so ingenuous about this that in him it wasn't
opportunism—it was a way of life, a perfectly legitimate
way to settle his problems. His blue eyes stared into mine
in all simplicity as he told me of his latest divagations: this
one he met, that one, this one's fortune and the next one's
loveliness but, alas, her poverty. Then there was one who
was rich *and* lovely, but oh dear, she had a husband and
how the devil do you deal with that?

I didn't ask him but I could imagine him looking up
incomes in Dun & Bradstreet as he made his way through
society, jet set, and the cinema world in search of a woman
who could be mother, father, wife, lover, sister, and trea-
sury to him.

This story has a happy ending for at least one of us. He married into one of the wealthiest families in the land. He can be seen now at the sporting places of the nation, Palm Beach, Cape Cod, Lake Placid, Newport, at the fox hunts in Virginia, and at the West Coast spots, Palm Springs, Tahoe.

Look out on any lake in any one of these places, and if you see a tall, brown-haired, suntanned figure skiing across the water like a bird, that's Harding: getting older, skiing a bit less spectacularly perhaps, but his muscular arms vigorously hanging onto ropes from some boat up ahead. Beyond, at the shore, at the hotel, in the most expensive suite, there is his millionaire wife waiting for her skier to return to the nest.

Letter to Harding Allbrite:

Dear, dear Harding, darling:
 To my first sweet Caucasian friend, whose gentleness and charm are forever with me . . .
Dear heart, I'm glad you made it!

<div style="text-align:right">

Love and kisses,
Dorothy
</div>

During the Harding time I had singing engagements that led me into one adventure after another, primarily with elderly eager beavers who had all kinds of riches and claimed that they wanted to place them at my disposal *if I acted right.*

I recite these events in the hope that anyone reading them will see them in the same spirit of amusement with which I experienced them. These encounters helped brighten my travels, lighten the hard work, made it possible for me to sustain the repeated post-singing paroxyms. There was life and fun and variety for me in the new world

of which I was a part. It was a far cry from domesticity in Los Angeles, and certainly a farther cry from my jimcrow origins. I took it all in with wide open eyes and in the spirit of one who is learning something.

The first picture I made was *Tarzan's Peril*. I was the African Queen. It was a film featuring Lex Barker and I was surrounded by muscles and cackling monkeys, but the picture wasn't much and my part in it was less. I went out supper singing again, and then I had a chance at a second movie, *The Harlem Globe Trotters*. That was no world-shaker either, but it led to my meeting with the then head of Columbia Pictures, Harry Cohn.

Harry came when I opened at the El Rancho, one of the big night clubs in Las Vegas. I didn't learn until I was there a day or so why I was booked, I was making a fabulous salary, and I couldn't figure out that either.

As I arrived, I noted the name of the headliner, a famous comedian who, I was sure, wasn't being paid any more than I was. I figured that I was thrown in on the billing because it was a place that could afford to toss away money. A few months earlier I had sung at a nearby place called The Bingo. It wasn't much of a spot, the salary was small; but now, mysteriously, I was in Las Vegas' top night club.

On my second day, a knock came at my dressing room. It was Ron Tappel, one of the managers. He went into a routine that I was to hear from time to time thereafter. "Baby, there is a fellow you got to meet. He wants to meet you. Now this man knows what's good for you. Your dresses are wrong. The music ain't right. Everything's wrong with the way you're doing it, but you got *something*."

Something. A key word. Without it you get nowhere.

"Now, baby, you can't stay in your dressing room all

the time. You know the old story—it's not how well you sing, it's who you know."

I told Ron, "If you want me to get out on the floor and sit at someone's table after I sing, I can't do that. It doesn't fit my style. In this business I'm a lady, and I'm staying that way. I'm surprised a big club like yours would expect things like that. It's cheapening. It's not the thing for a girl to do."

He was exasperated. "You got me wrong, baby. You don't think I mean peanuts like that, do you? You don't do no sitting around no table. This guy is different. You know who Harry Cohn is?"

"He produced my picture."

"He sure did, baby. Now he's the guy who booked you in here at El Rancho. You see, you got friends in high places. Harry wants to talk with you. He wants to do something more for you. He wants to fix your act."

"I've had my act fixed."

"Aw now, baby"—the popular music world has not been able to do without the word baby since the year 1904—"listen to reason."

I listened. Ron told me that there would be a little party in Harry's place later on. I wouldn't be alone with him. Ron would be there with his girl and there would be other couples.

"Well, the least I can do is pay my respects," I said, "if I'm here because of his kindness."

"Atsastuff, baby."

Late in the evening I went up an elevator with Ron to a certain floor. Arriving there, the manager said he had to return to the lobby to meet his girl; he'd be right back up. Just push that button, somebody would admit me.

I pushed this button; a door opened. I looked in. There was no entrance hall, no butler, no maid, no salon—

just an office. There was a big desk, and from behind the desk there was a staring little man. He wore a smoking jacket, and he was smoking. He said, "Come in, Miss Dandridge."

I knew right away there was not going to be a party unless it was the kind Harry wanted, but I was cheerful and pleasant. After we shook hands, I sat on one side of the desk looking across at him.

"Dorothy," he said, "I've been taking a close look at your career. You're on your way. You've made a picture or two, they're not much, but you can do better and be bigger. You are doing fine in clubs too . . ." and so on and on for a half-hour.

Throughout Harry's evaluation of what good things might yet happen to me there was the implication of what was required. I was supposed to warm up, to register delight, happiness, gratitude. I was supposed to reach a sympathetic hand across the table, and he would pick up from there. Maybe we would both stand. God knows what: maybe we would both get right down on the floor, for there wasn't even a casting couch in this barren office.

But I never reached out a hand.

I kept smiling and being nice, but retaining my inward toughness. He too was nice enough, and also tough enough.

I don't know how I said goodby, but it was pleasantly done. I took the long trip down the elevator. I had the feeling that more pictures would be coming my way without Harry Cohn. Singing engagements were flooding me. Back in New York there was Harding Allbrite, young, physical, warming.

Beyond Vegas there was a world full of men and movies.

I sang on at El Rancho, and an incident happened that was as big a boost for my career as anything Harry Cohn could do, and I didn't have to crawl into a strange bed with a strange-looking little man for it to happen. This was simply a phone call.

Marie Wilson, then one of the most successful screen actresses, caught the show and liked my performance. She met me in my dressing room, and it was an instant friendship. "Wait here," she said. "I'm going to put in a phone call. Then I'll be back with someone."

She returned to my dressing room with Gene Cook, theatrical editor for *Life,* and she suggested to him that he do a picture spread of me.

In 1951 the *Life* spread did wonders for my still-growing reputation. After that it became easier for me to secure bookings at the most famous spots, the Waldorf-Astoria in New York, the Riviera in Las Vegas, the Fairmont in San Francisco, the Palmer House in Chicago, the Fountainbleu in Miami, the Savoy in London, the Terraza Casino in Mexico.

After my picture appeared in *Life,* other magazines wanted me for their front covers and for stories and picture layouts. *Quick, People, Today,* and in Paris *Cine Revue* and *Paris Match* swiftly followed. Later a Lady Fair portrait of me, covering two pages in *Esquire,* and a picture taken by Philippe Halsman, drew international attention.

By then there was some kind of clear-cut arrival. Marie Wilson's phone call and kindly intercession had sparked wonders. You can't do without friends in this world.

It seemed to me that moving pictures ought to be inevitable—if only there were roles suitable to my looks and background.

Only in America. And South Africa.

Booked to appear at the Sans Souci at Miami Beach, I learned that I was to get the usual Florida treatment for Negroes. I could perform on the beach, but I must go back to the city of Miami and there put up in a hotel in the segregated area if I wanted to sleep. Upon my arrival, the hotel management rented a car for me so I could drive back and forth. I had trouble finding my way and thought I would try cabbing. Then I discovered a typical insane problem of a colored woman getting over onto the beach side. A Negro cab driver couldn't take a white person there, and a Negro woman couldn't hail a white-driven cab. I simply couldn't get to work easily. I began to show up late.

Deep down I rankled over the jimcrow. I hadn't bumped into much of that, but I hadn't sung in the Deep South either in recent years. I was thinking, How the devil do you get over this wall when you're tan like me?

I talked to Al Bannon, the manager. He was a genial middle-aged man who enjoyed employing Negro performers, but he too had to contend with the local tradition. "Al," I said, "this is too much. I can't work here. I want to go back to New York or Los Angeles."

"Don't leave, Dottie. We'll figure out something."

Al went to Morris Landsburgh, owner of the hotel. Mr. Landsburgh agreed to let me occupy a room in his house while I was engaged at the hotel. The quarters might be likened to those reserved for domestic help, but I was able to stay on the beach side for the rest of the show.

This was no crackthrough, in terms of jimcrow, but everybody knew that I was staying on the beach overnight.

Still, that arrangement may have been the entering wedge, because a few months later I returned to the Sans Souci, and this time I registered at the hotel. So did my maid, Veada Cleveland. Veada is black.

I floated about the lobby, and nobody seemed to notice or have a care about it. Partly that might be because of my light coloring, partly it might be because most of the people there were trying to get a tan about like mine. Maybe it was because the guests were largely from New York and other Northern cities and didn't carry the vitriol that was characteristic of Miami and the rest of the South.

This time it was a real breakthrough for me, and it paved the way for other Negro entertainers later on to stay on the beach while performing there.

Incidents occurred regularly in that period, cracking the front pages of the press—episodes of entertainers who walked out on engagements or hotels or cities where they couldn't get equal treatment. Lena Horne at this time made one breakthrough after another in luxury hotels that were politely segregated. Still, in Miami and other cities, the issue had to be wrangled out each time.

Most Negro performers worked the so-called jazz or special clubs throughout the country in the early 1950's. But I worked the "Caucasian rooms," the small rooms of the carriage trade. Lena Horne had comparable experiences because her repertoire and mine bore similarities. At the time about ninety-nine per cent of all Negro performers sang songs with blues and jazz roots. While Lena and I and one or two other female singers adopted this so-called "white repertoire," Nat King Cole was the first male to branch out with popular songs and to acquire a primarily Caucasian following. Even after Nat became widely known for his number called "Route 66," most of his bookings were in the small "trio rooms" that employed Negro entertainers. Such performers lived away from where they worked, as a rule, in the ghettos. They ate food brought in from restaurants or purchased at nearby stores. They did not eat or live where the whites did.

But from the earliest days I wouldn't stand for this, partly because I could alter the situation and surmount it. I, or my agent, insisted I live where I worked. I went overboard to be well liked. I moved into these hotels with an air and a manner. I hit them with an elegance that bowled them over. It wasn't anything put on; it was a carryover from that rigid training in propriety that I received from Auntie Ma-ma and my mother. If I had beauty, as everyone said I had, I let that work for my color. I walked in, head high, as if I belonged, which I did. As a result I was invited to live and to go where other, more famous stars could not.

I was the first Negro that thousands of whites ever met.

So, in an anomalous way, wherever I went and sang, I brought the white-nonwhite question with me; and somehow, through my appearance and manner and my singing style, it was easier for thousands of whites to "meet the Negro."

The carrying of a burden and responsibility like this is a big thing. In a way every Negro does it, no matter on what level he lives. If you find yourself suddenly projected into a Caucasian orbit, as I did, you have an inner experience that is hard on the nerves. You must be at your best each instant, for, in a manner of speaking, you are "carrying the race." Negroes everywhere will recognize what I am talking about, but unless they have been thrown into the experience of having daily to deal with large numbers of Caucasians, they won't be able to grasp what this experience can do to your neurological and psychological system.

Sometimes it is how you go about your entrances and your exits that counts. If you move gracefully, hold your head up, keep your dignity, and act as if you are not doing

anything forbidden—which in essence it shouldn't be—
there is a telepathy between yourself and the white. There
is a human transfer that gets you across. It must be that I
have this, for I've gone almost everywhere into forbidden
or jimcrow zones and have just gone on through.

By the time the Waldorf-Astoria in New York booked
me—I was the first Negro entertainer at this hotel—I had
the feeling that, whether I liked it or not, I was one of
many Negroes who, for one reason or another, were "fly-
ing wedges" inside the Caucasian world.

There was an exhilaration about this which I cannot
deny. Some figures, involved in that way, smoked heavily,
from the tensions involved. Like Nat Cole. Others privately
drank or even took drugs. I had no such habits at this time.
But whenever I returned to Los Angeles I hastened to my
psychiatrist. There I received consolation and relief.

But no one, no doctor, no psychiatrist, and no medi-
cine could counter those persisting violent attacks of
paralysis which continued to precede or to follow my
appearances.

I n 1952, Earl arranged a singing engagement for me at a
Cleveland supper club. My mother needed a holiday
and I asked her to come along. She could renew a few old
acquaintances and take a look at the old stamping ground.
Even I had a nostalgic feeling about returning there.

News of my appearance was in the local papers, and
almost as soon as we arrived and took up quarters in a
suite of a hotel, I received a phone call. It was a woman's
voice.

"Hello, Dorothy? This is Sugar."

I knew who that was. It was my father's new wife.

"Dorothy," she said, "your father would like to see you. Would you like to come to our house?"

"I think not."

"Why not?"

"Look, Sugar, I don't know whether I like this man. I know I don't love him. I can't—I never knew him. There's been no connection. I met him once in New York. He seemed like a perfectly nice man, but you know, it's like somebody comes and asks you for an autograph. Can't you understand?"

"No, I can't understand. You're a fine Christian, Miss Dandridge! You are! You have no love for your father. Weren't you raised in the church? How can you be like this!"

I protested. "Dear heart," I said, trying to be patient, "because two people get together, and you know, make a merge, and there's an embryo, and here I come . . . that does not make love."

"What *are* you saying?"

"Just that. People have to earn love. You just can't get together with someone and have a baby and expect that baby to love you. First you have to live with that baby twenty years or so."

Perhaps I was hasty or only human. I said, "Look, I'm not going to come over to your place to impress your friends in the neighborhood."

She set me out and I set her clear. It may have been crude, but that was it. The thought still went through my head, If I were here in Cleveland in jail, would he bring me a basket of fruit? Now it's different; his daughter has it made, she sings, she's a glamour figure and whatnot, so Sugar is sent to act as an intermediary, and here he comes with love.

But that didn't end it. Before my singing engagement

closed, a call came from the lobby that my father was there. I told him to come up.

I had even forgotten what he looked like. I had no image of him whatever.

At this second visit I felt even more strange than at my first about thirteen or fourteen years earlier. I was still often tempted to tell people he was dead while knowing that he was alive.

Several persons were in my suite—the club manager, my pianist, my maid, and Ruby. I was very professional about it this time. I introduced him in a casual way, "This is my father," as if I saw him every day of my life. But there was no feeling. The most I could feel was a dutiful courtesy.

Ruby asked him to carry some of my clothes out to the car. In the street it was awkward when he gave me a goodby kiss on the cheek.

A few years later I was to have a third and more rewarding meeting with my father.

Early in the 1950's there was panic at Twentieth Century Fox, and at other studios too. At Twentieth Century actors were being let out. The company was going through shakeup and reorganization. It was a time when there was a surge of independent motion pictures created by private producers. Van Johnson went into a night club act at the Red Fox in Las Vegas. I was singing at the New Frontier in that city.

One evening Peter Lawford, June Allyson, Van, and one or two others were making the rounds of the night clubs. They stopped in to see me. My conductor introduced me to Peter as Peter wanted to meet me.

We went out of the night club together late that night.

Cruising in Peter's car we headed for a drive-in. I said, "Negroes can't go in there, Peter. Let's go somewhere else."

"You must be joking," he said. "I've heard of such things in your fair country, but I can't believe it."

"Let's give it a try," I suggested.

We went in, and nobody paid any attention. I thought, Well, Las Vegas is improving; for I had known this place to have a most considerable Dixie touch.

A good friendship can be cemented in a minor incident such as that. With a baptism in cracking the jimcrow barrier, Peter may have had thoughts of his own. Anyway, he knew he was with an American Negro. Light complexioned though I might be, I didn't want any question in Peter's thinking about how I regarded myself or who I was.

Out of the restaurant and back in the car, we motored through the night. We halted in a lover's lane. Peter put his arms around me and began kissing me in a delightful, gallant English style, if kisses can have nationality.

I liked being with him. Partly that was because I have always had an affinity for the English. I was in love with the way the English spoke the language, and I liked the style of this gentleman.

Peter knew how to socialize with the entire cinema colony. He was fond of the outdoor life, and he had a free and easy style of living, talking, and thinking. Such a person makes for a lively companion. He had—he'll want to kill me for this—a touch of Errol Flynn about him. He had zest, a genius for living, and he knew what he wanted.

Peter's acting career was gaining momentum. He was making pictures with Judy Holliday, Judy Garland, June Allyson, many people.

None of that interested me so much. Hollywood was filled with actors, famous, talented, some wealthy, and if I had wanted to meet them, I lived in Hollywood and it

would have been easy. But I never overly cared for party-ing. There was too much "party" in my life as a singer. Each night I sang it was a big party of a sort. Parties filled the clubs in which I appeared. When I had the opportu-nity, I became domestic.

When I returned to Los Angeles and Peter and I were in touch again, Peter took me to various parties in the sev-eral circles he was in, but I told him how little I cared for partying.

"Peter, it's more fun to be alone together, and that's the way I want it."

He gave me a startled look. "That's the way it shall be."

During the next year or so Peter and I were together frequently. Much of our friendship was in New York City, whenever I could get there, and then we spent long eve-nings together either at his hotel or at mine. We were close and loving and he helped me to forget some of that private sorrow that always nagged me.

There wasn't one "confrontation." No argument between us. Sometimes it has seemed strange to me how people emanating from traditions so remote from each other could be so harmonious together, but we did consort in the most unimaginable ease and comfort.

Color didn't concern him in any serious way, but he was intrigued and upset by my choice of food. He came by the apartment when I was cooking chitlings, and he caught the smell which permeated the place.

"My God, what in the world is that?"

"It's a kind of pork thing, Peter. It's good."

"What are they?" He was standing over the kettle on the kitchen stove.

"It's chitlings. The intestines of a hog."

"Oh my God, that's why it smells so bad." I was stir-

ring the pot, tasting the juice, and he stood there getting pale, as if he were going to regurgitate.

"Honestly," he said, "I can't understand anybody eating it."

One evening Peter came by with Rocky Cooper (Gary Cooper's wife) and others. I thought, I'll serve chitlings in a tall stemmed glass. I'll chop them up fine and make them into an hors d'oeuvre. I'll put a little paprika on top, some Tabasco sauce, and parsley on the side. I'll serve chitlings the way they've never been served before. I'll set the whole thing up with pretty little forks, underliners, and serve it steaming hot.

I figured this might well go over big with them, because Hollywood is absolutely crazy on the question of food. Everybody is trying to outdo everybody else with quaint or droll hors d'oeuvres; they turn vegetables into meat, meat into vegetables; and they do everything for new spices except send ships westward (it's too late for that).

I had the chitlings so well drowned in spices that nobody knew what they were. Peter whispered to me that he'd like a second helping. I went into the kitchen, plunged a fork into the chitling pot, and pulled out a long string of guts. Peter came in to see what I was doing.

"Don't tell me!" he said. "Is it that stuff?"

"Yes, it's that stuff."

"I must say it's marvelous the way you prepare it."

I didn't explain to Peter that chitlings—in fact, all pig products—represent emotional food to me. I turn to pork when I am in some kind of distress. It is a reversion to my childhood when pig products, greens, and blackeyed peas were my usual or most frequent diet.

I turned to chitlings after I came home from night club engagements. I could relax with pigs' feet, pigs'

knuckles, the smell of pig meat cooking on the stove. Then I'd put all that pretense behind me: the dim lights of the clubs, the people trying to have a good time over their liquor, the false sentiments of the popular love songs I sang, for there was little real love in my life, although I was singing about love all over the country.

When I was a child we also ate oxtail stew. There is something about picking up an oxtail bone, the way the meat melts off the bone, the succulence when you bite it—when I eat oxtail I can let down. I can stop being the elegant lady up on the platform singing Caucasian songs for Caucasian listeners. When I get into my own kitchen, I can find corn bread and hush puppies and rice, and it helps me to get my footing again.

Because up there I lose my judgment. I get thrown, I get conned by the emoluments of the white world, the overworld with its luxury hotels, its elaborate trimmings. I can only escape it in the sanctum of my kitchen. Then I am living with Negroes again, with my friends on the West Side. I can sit around a kitchen and spit those bones out and just *be*.

As time went on, I became inwardly troubled about my relationship with Peter. An English manner and accent could easily con me. It was a blind spot, like religion. Peter's liking for me and my feelings for him were an involvement which, it seemed to me, could and would come to no serious conclusion. Peter was single, and I knew he was ambitious. I had surrendered to him and fallen into this relationship of my own free adult will, and I had no right to hold him to any kind of expectation. Still, if I were honest with myself right now, I would have to admit that I wanted nothing better than to hear him say, Marry me.

* * *

Elmer Tyner owned several huge hotels in San Francisco. He was getting ready to retire, and his son George was taking over the management. I was singing at their mammoth hotel overlooking the bay.

Both propositioned me.

I don't say they proposed marriage—only this other. So many white men think there is nothing sweeter than having a brown boff on the side, under wraps, taken in the dark or kept behind the scenes.

The father, in his late sixties, had mixed gray hair and a receding hairline. He was suntanned and had a healthy look, but he was toothless. The click of his false teeth, I thought, would go fine in the rhythm section of a jazz band. When he talked there was a foam at his mouth, a foam or a froth that slid out of the corners.

I sang in the heavily peopled dining room each night, but often, during the day or at night after my performance, I would be in the Tyner penthouse suite.

I was in some slight dread of being kissed by the old man, because I could see the offer coming. When he was working up emotionally, the drool was a little more active. Pity, I thought, a man can have sixteen million dollars (I'd heard his wealth estimated at that) and a drool to cancel every check.

He couldn't take his eyes off me. He looked at me and he drooled. His tongue had an obscene way of running over the edges of his lips, as if he were trying to dislodge a sliver of meat that had found its way there. But apart from this unfortunate physical characteristic, he was eminently kind. He spoke gently and there seemed to be a yearning and a loneliness that I tried to understand.

While he had me under his surveillance, I was friendly

with his wife. She was an aging, charming woman who was also kind to me.

She knew perfectly well that her husband was interested in me, and I think her method was to insinuate herself into my confidence and make herself liked by me, in order to make it harder for anything to occur between her husband and myself.

I was amused, for the man had no attraction for me at all. I was intrigued also by his interest. He was so wealthy and so willing to make most or all of his wealth available to me, so he began to hint.

His son George was about thirty and quite good-looking. He was well built, but with a tendency to be paunchy. I liked him, and I supposed myself capable of associating with him if he made advances.

Mostly the situation diverted me: an old man, his son, an aging, possessive wife—and me, Kid Beautiful.

Papa's proposition made sense. "Your home base is in Los Angeles, and I'm here. I won't bother you, not that way at all, I really won't. I just feel that I could do something for you."

Out of the window I could see the sea. Coming into the shore were waves of foam swept in from the outer Pacific. The waves out there were beautiful, the foam close at hand something of a problem.

"I want to be in your company," he said. "I just want to look at you. You can do whatever you do now, be yourself, but be around me . . ."

Of course if I could bring myself to . . . He stuttered, "You know . . . be a little close."

"Uh huh," I said. I got the message.

"If I could give you a hug once in a while . . ."

We were standing near a window. He pointed to a

building across the way. I looked down at it; it was four-
teen stories high. He said, "See that building?"

"Yes."

"I built it six years ago. It is full with tourists."

"That's fine."

"If you decided to stay with me, it's a gift. You can
have that building, and you can live in it."

"The whole building?"

"Yes."

"You mean it? Are you serious?"

"Of course I am. It's worth three-quarters of a million
dollars."

"That's hard to believe."

"I'm not offering you a bouquet of roses or a few
dresses or something—I mean *that*."

Migod, I thought, how can I turn down a fortune like
that? And how can I accept it?

There is a hard core in me somewhere that takes plea-
sure in turning down old men and big offers. I was earning
my own money and felt that that would likely continue.

"Elmer," I said, "I couldn't do that to you."

He seemed crestfallen.

"I have to like someone, to love someone, to do that."

"Dorothy," he pressured, "you must think about this.
You smell so nice, and I would love to buy the perfume
that would keep you smelling so nice. I like the way you
look when you come to the door. I'm so relaxed with you,
so comfortable. Please think of all I can do for you."

The old man had a sense of beauty. He must have felt
life slipping away from him, and hoped I could help keep
it from slipping and keep him from slipping.

He said, "It doesn't matter to me whether you're in
love with me. I don't expect that. As long as you keep smil-
ing the way you do . . ."

Look what I could have had for a smile.

"It's kind of you, Elmer, and I ought to be delighted with what you have to offer, but I can't."

All this time I was kissing his son. His lips were nice, but he didn't know how to put it on the line as his father did. George told me that he was in love with me, but he couldn't come up with any kind of proposal, not even keeping me in a suite somewhere; and there was nary a word about marriage. For a time I found myself warding off the foam of the older man and trying to figure out what the son was up to and what he wanted.

The mother knew that her husband was ogling me, and her son had told her of his feelings for me. She was having a worse time than any of us.

It all became too much, the father, the son, and the mother with the knowing eye.

I chopped off George's cookie. I flew back to New York.

Phone calls began coming in from both. The father didn't know about the son's calls, and the son didn't know about the father's. Every time I heard from the father I visualized his wet mouth before the phone. I had always been afraid that if I kissed him, his false teeth would fall into my throat.

It is a curious thing that men think that if they have a lot of property to offer a woman, she will accept that—and him. She is supposed to be attractive, and he is supposed to be rich, and that is all there is supposed to be to it.

I have a sense of the physical too. I like to look at a handsome man. Beauty and charm in a male may be as important to me as these qualities in a woman are supposed to be to men.

There is a saying that a man needs nothing but his wealth and he can have a beautiful woman.

It doesn't apply to me. Not always. It didn't then.

Frank Gabriola—he had other names—had seen and heard me in Florida. He owned a night club associated with a New York hotel, and one of his aides arranged with my agent to book me for four weeks at eight thousand dollars a week. Later I learned that he owned a sizable portion of the theatrical community: night clubs, theatres, and subsidiaries like popcorn concessions, a printing establishment, bingo games, a perfume business, other holdings. He had a tangled network of properties of intriguing complexity.

Like many men he liked a change of ladies now and then.

His henchmen moved around the club, fast-moving men who did his errands. They looked tough, and they were tough. They passed freely in several worlds—the theatre, horse racing, prizefighting, and other sports. These men had endearing names for one another—Butch, Bull, and the like. They also had given names like Abe, Tony, Sam, and Joe.

From my first day, the club manager, Sam, was very attentive. Food, flowers, small details were all taken care of, every courtesy. Nicest place I've worked, I thought.

For several nights Frank watched me sing and perform at his club without my knowledge. On my fourth day, Sam knocked on my dressing room door.

He said, "Now the boss, he's interested in you, see?"

"Who's the boss?"

"You'll find out at the right time. They don't come no bigger in this city."

"What am I supposed to do?"

He blinked, as if how could a grown woman ask such a stupid question.

"You'll be interested, Miss Dandridge. When you learn who the boss is and what he can do for you, you'll be interested. He's the one booked you in here. I only worked it out with your agent, but it's the boss he's the one wanted you in here. He's a regular guy, see. He likes you. He wants to do things for you. Get it?" He engaged in the slowest-dropping wink of his right lid that I had ever seen.

"I think I get it."

"Eight thousand a week ain't hay, is it, Miss Dandridge?" He went on, "What the boss thinks you need now is gingerbread and whipped cream."

"Gingerbread and whipped cream?"

"Yeah, all the trimmings. Beautiful clothes, a setup like for a queen, drums and rhythm sections, big cars. Then you got it made, you are tops. He makes a star out of you."

"How nice."

"Now, doll, you got to look the part. You got to be dressed like a million bucks, see? Different dresses, they gotta be like this . . ." (he made a cupping gesture around his own flat chest).

"You gotta look elegant and swell. You follow me? The boss wants to take care of all this. Money is no object."

I said nothing.

Sam went on. "The boss is nuts about you. Can I say more?"

"Why?"

"Who knows why anybody goes nuts over anybody? The boss adores you. He's wild over you. He wants to do things for you. The first thing he wants, even before he meets you, he wants you should go out and buy yourself a

wardrobe. Here's the address of a swanky woman's shop; buy it out if you want, get all the things you need, anything, dresses, negligees, anything."

I had been given the bridal suite in the hotel. There were sheer curtains around a king-size bed. Velvet drapes covered tall windows. Far, far below was the muffled din of Fifth Avenue. Lying abed in the early morning hours, in luxury, I thought how different it was from the time I slept four abed with Vivian, my mother, and Auntie Ma-ma. Now I wasn't at the bottom of the bed breathing in somebody's toes. Elegant though it was, it didn't seem to me as though I should wind up a queen of the underworld.

Sam had several talks with me. At the last he said, "Now you know how to act, hey?" This was the first time he laid it out so clearly and horizontally as that.

A week after the engagement opened, Sam met me backstage and said, "Tonight's the night." He wasn't asking. "After your show we're putting on a big brawl. It's just for you, get it? The boss wants it that way. He wants when he meets you to do it up fine."

I went out to sing and, looking out over the smoky dining room, I could see Frank's bodyguards moving, moving all the time. There seemed to be a half-dozen men who had nothing to do but be present.

Sam escorted me into a well-lighted room on an upper floor. In the center were twenty chorus girls chattering around two tables spread with food and drink. The girls were white.

I was led to a place at the side of the Big Boss at the head of one of these tables. I had my first look at Frank. Before then and since I have always been astounded at the inconspicuous appearance of barons, moguls, tycoons. They aren't as big physically as the aura around them leads you to suppose. Frank was balding, a little paunchy,

lean-faced, he had a cigar in his mouth, and he talked in a squeaky voice. He smiled and bade me sit down. I thought of him as the proprietor of some small cigar store rather than the sinister presence he was reputed to be.

Again, in the backdrops, several of his men floated. Some I had seen about the club and now they seated themselves at the side of the chorus girls. There were four girls to each man.

I said to Frank, "These girls don't look very comfortable. It seems to me they all look a little uncomfortable."

"You don't like?" His manner became solicitous.

"I didn't say that."

"Should we get rid of them?"

"What are they here for?"

"I thought you might like a big party."

"With girls?"

He turned swiftly to Sam who was standing behind him. He looked not at Sam, but at Sam's cigar. Whatever he said, there was action all over that room in the next ten seconds. All of a sudden everybody rose, the men and the girls, and all the girls tiptoed out. They left in a line, like a chorus going offstage.

I was alone with Frank Gabriola and six of his men. Frank turned it into a company conference. "Fellows," he said, "we got the problem what we going to do to make Miss Dandridge the greatest star of all time. Correct me if I'm wrong," he directed his eyes at several of the men, like little gunpoints, then glanced at me, "it seems to me you ain't got a beat behind you."

No one said anything and he continued, "There's nothing wrong with your act. You got it, Miss Dandridge. You got something. I don't know what it is you got, but you got it. What you ain't got is a beat behind you. You ought to do like Lena Horne does it, with a rhythm sec-

tion, and we can put in the best rhythm section in the world, don't care what it costs. How'd you like that?"

"I can't work with a rhythm section. I put the rhythm into it myself when I'm up there, and I don't need a brass band to work it up. I'm an actress. I act out the rhythm myself." I added, "I gather I'm not doing much business."

"Oh no, the business is fine. Everybody that sees you says you're lovely, you're beautiful. If you had no voice at all they'd sit there for hours and watch you swing . . ."

"Something must be wrong, if you want to book in a background section and all the equipment to go with it."

"Don't you worry about a thing, beautiful. You do what I tell you. You can be so big . . . bigger than the best of them. You're doing great. We want to make you the greatest." He returned to the missing beat.

"No beat?" I repeated.

"No beat. If you had a beat you would look much more swinging."

"I don't want to look vulgar. If we get too much of a beat going, and I move my poo poo and things and push myself forward and around and get to look like I'm doing bumps and grinds, that's the finish of me. I want to look like a lady, and the less beat, the more lady."

"Doll, you need a trill in there. You need a brass drum and a piano. Like Lena Horne. Right now you do so much with nothing that imagine how much you'll do with that music in there."

Frank turned to the club manager and he said, "Call Harold. I want Miss Dandridge to make a slew of records. We'll plaster her records all over the world. Give the boys the payola. Make 'em play her records day and night. If the disc guys don't push her records, push 'em out of their jobs."

Harold was Frank's brother and in the record busi-

ness. Much as I appreciated promotion in my business, Frank's methods were a little alarming.

This was Proposition with a capital P. That also meant Payoff.

The next night, after my show, Frank and I had dinner in his suite, and he made his offer. I wondered if I had heard it right. He wanted me to be the sole performer at his club.

"Did I hear you say you are offering me fifteen hundred a week for the next five years?"

"Whether you work or not," he confirmed.

"I don't even have to sing?"

"All you have to do is stay around me. Just be close to me. Mix me a drink and light me a cigar sometimes. Look beautiful. You can't look any other way anyway."

I thought, Frank has a wife and a family and grandchildren. I suddenly realized why he was paying me so much each week when my reputation wasn't yet big enough.

"You saying yes?"

"I'm thinking hard, Frank." I was thinking and wondering how fast the next few weeks of the engagement would go, and how much I might have to contend with in order to stay on full time.

It was the same language every time: Stay with me, be around me. I just want to look at you.

He never put a hand on me. He never tried to kiss me. He simply couldn't take his eyes off me, but it was the most legitimate, clear-cut business offer anyone could ever make, and I had no doubt he would keep to his word.

He told me, "You know I'm in some rough things sometimes. If anything happens to me, my organization takes care of you for five years at fifteen hundred a week." He looked deeply into my eyes.

Three hundred and seventy-five thousand dollars, to be paid at fifteen hundred a week, five years, if I became his girl and acted right during that period.

I asked myself, How do you feel about doing what's right with this fellow? And I answered myself, Not very good. He's honest with me, he means what he says. I'll really be set up, but what am I getting into?

All I had to do was put my hand out and place it on his so he would know I would act right. But I didn't.

I didn't close it out either, just then. I said, "Frank, I have a lot to think about. I know lots of show girls would be flattered. Let me kick it around."

"Kick."

In the weeks that followed and as my engagement at the club continued, there was a tension to the work. Frank waited in the backdrops. The men in the organization knew what the deal was, and they sat at the tables and hi-ed me as if to say, "Well, we're waiting."

Would I become part of the organization? The female part.

I was afraid that if I sang in one place for five years, even at fifteen hundred a week, I might bore the rafters if not the guests.

I would be hooked for five years—on a golden hook, of course. Instead of being famous I might become notorious.

I had heard stories of the Prohibition era and how one figure muscled in on the territory of the other. I had a feeling that others would be waiting in the backdrops to move in for control of me if anything happened to Frank. I could tell by the way some of his boys looked me over that they were already waiting.

Casting around among the men to see who might inherit me if the boss died or was put away, I saw no one

my heart would flutter over. I had a vision of myself being handed around the syndicate from man to man as the five-year period went on, with the fellows all keeping the code as the departed boss had pledged them to.

All in all, I decided, if I get fifteen hundred a week, I'll earn it.

Telling these stories disparately, or separately, and singling out various individuals for specific anecdotes are necessities of storytelling, but the fact is that in these days my relationships overlapped.

I was being pursued by numerous men. Being pursued by them is different than being courted by them. Being chased by them is different than being close to them. Even being close to one or two now and then is different than being wanted for marriage. I might receive two or three phone calls a day from across the ocean or across the country. I had little time in which to write letters to the many men I knew, and I had to judge who was pursuing me and who might have more serious objectives. Down deep there was only one thing I wanted: marriage, but marriage to the right man. The right man would have to be one with money, position, charm. As I now knew many such people, I felt that one somewhere might be serious.

I couldn't know then what an illusion I was living in. I didn't know how many men there are with money and position who will pursue a woman in order to get her into bed.

While this was true of many men, it was in this period I was beginning to also learn that often white men have a deep-seated fear of intimacy, even association, with a Negro woman. I discovered what a deep block there is in many an American white male mind. They don't know

what to expect from a woman of color, but they think they should expect something different.

I continually read medical reports in newspapers and magazines hoping to hear of some super-drug that would open the mind or heal the brain of my poor child. My troubles with Lynn led to my becoming interested in special types of reading matter. I was searching. I became interested in the life of Helen Keller, though I discovered that there was not much in her life that was applicable to Lynn. Helen Keller was handicapped by blindness and deafness, but she had a good brain. Lynn's brain was damaged; it was a different thing.

In a way my daughter was fortunate—fortunate that she didn't know she was different. Someone who is selling papers on the street, or has some little job, or functions somehow, even though blind or totally incapacitated—if such a person has a good brain, he *knows* he is limited and handicapped. That person is more unfortunate than one with a retarded and unaware mind. The whole field of retardation, and of psychological and psychiatric treatment of people who are so unfortunately born, became a major concern with me.

Whenever I returned from a singing tour I hurried to Helen Calhoun's to see Lynn. Even though I realized Lynn no longer knew me as her mother, the tie that bound me to her was beyond my comprehension, and I was concerned with each detail of her life.

Her abnormal meticulousness continued. When she would be having her period, she just needed one pinpoint and she would change. She used up more boxes than most females, for she would change all the time.

Lynn received a bicycle for Christmas, and I thought,

If Lynn were on her bicycle and a man picked her up and put her in his car, that would be it. He could do whatever he wanted in ten minutes, and then put her right back on that bicycle, and she'd get on it and go back home and wouldn't even know what happened.

I remember how, when I was thirteen, one day I was with another girl and a man exhibited himself to us. We ran from him, but would Lynn know enough to run?

When Lynn was thirteen, I had her tubes tied so that she could not become pregnant. Should something miraculous happen and Lynn become normal, the tubes could be untied.

My friends rebuked me. They said, "You're treating her like you'd treat an animal." They accused me of being callous and hard. Actually I was only fearful of how she could be taken advantage of in her disability.

One day, an episode related to Lynn took place on the set of a movie I had a role in. I knew my lines but suddenly I couldn't recite them. When I walked on the set and saw the colored children—about the same age as Lynn—when I saw how happy and smiling they were, I started crying and had to leave the set.

Gerald Mayer came over to me. He was the director of this picture, *Bright Road*, the story of how a sensitive, young third-grade teacher in a rural Southern school copes with an unhappy eleven-year-old boy. I was cast for the part of the teacher, and Harry Belafonte, making his first movie, was the principal. This wasn't a problem picture, no Negro protest in it, merely a human story, one that could occur in any group of people anywhere in the world. But the simple act of looking at these lovely boys and girls touched me to the core.

"What is it, Dorothy?" Jerry asked.

As I fixed my face and made ready to start again, I explained briefly to Jerry about Lynn. Out of these beginnings there began an off-studio friendship with Jerry which lasted a year.

Jerry was the nephew of Louis B. Mayer. This was a Metro-Goldwyn-Mayer film. Jerry's problems—he had them—stemmed from his family relationship to the studio chief. The things expected of Jerry, as well as the limitations set upon him, formed the essence of his private woes. He quickly made me party to these grievances. I had not been with him more than two evenings when he cursed out all of Hollywood in four-letter words.

On the set, in the seventeen days it took to film *Bright Road*, Jerry went about with the dynamism of a knowing director. He was a man who sought to do better films, and he found himself limited by the clichés of the industry. It was these cliché approaches to pictures that he denounced. In our film, he saw an opportunity to do something good and to lift what was supposed to be a small-budget B picture to some level of excellence. That was what we sought in a picture which had only one reminder line in it. The maladjusted boy is told once that all men are brothers, and he asks, "If white people and black people are brothers, how come they don't act like brothers?"

I was profoundly fond of the theme—a picture in which there was no violence, no rape, no lynching, no burning cross—rather a theme which showed that beneath any color skin, people were simply people. I had the feeling that themes like this might do more real good than the more hard-hitting protest pictures. I wanted any white girl in the audience to look at me performing in this film and be able to say to herself, "Why, this schoolteacher could be me."

Jerry interested me for many reasons, one being that

he was Jewish, an aesthete, an intellectual. On the set he usually wore a light suit, but without a tie. Jerry had convex features, a high forehead, short-clipped dark hair; he was interesting looking, a person of warmth.

The fact that we each had personal problems brought us close, and for a long time, whenever I was in Los Angeles, and not in South America or on the East Coast, we met. We knew each other well enough to dispute over a few domestic details, but never over anything vital.

"Jerry," I said, "your problem is that you're not one of these hardboiled executives. You're too sensitive for this environment."

He knew that.

"You must ignore people who expect you to be a repetition of your uncle," I said. Louis B. Mayer was one of the financial geniuses of the industry.

"It's not pleasant to occupy a position where you imagine people saying, If it wasn't for his uncle he wouldn't have this spot."

I was sympathetic and urged him to stick to his guns and rise above the problem by making the film an art. But that wasn't easy. In Hollywood production, only money talked; art and artists were something to be used when needed.

"The rub is," he said, "I can't even get going with my ideas."

Had he pushed for the money-making, sure-fire films, the sure-fire name actors and actresses, he might have succeeded in movie-making—but an artistic director in Hollywood has it uphill.

I have always had a faculty of being a good listener for men with problems. We spent evenings going over his picture problems. He would set up miniature sets of whatever picture he was working on, explaining how camera

shots had to be made, through a window or from some other vantage, and he described how director and cameraman had to work together. I learned much from him that was useful to me in subsequent pictures I made, and after a time I ventured notions about what he should do in certain scene shootings.

He would listen to me even while I revised a whole motion picture approach for him, and though most of the time he went his own way, still I stimulated him. Frequently he adopted my suggestions. I even went over the budget of a picture with him, looking into the shooting time and suggesting how he could save money.

What disrupted my relationship with Jerry in the coming time was, in large part, my own travels, the usual singing engagements. Sometimes I was away for weeks. Then the connection with him was by phone. I found that either I had no perspective about Jerry or I was losing it. It wasn't clear what he was in my life—or whether he was really in it. Absence doesn't always tighten bonds.

In this period I was still zooming. Everywhere I went I was flattered by pursuing men. This affected my view of Jerry. I met so many interesting and fine people, and though Jerry was also fine and interesting, the bonds between us began to dissolve.

Jerry had no prejudices. I did not sense in him the usual sensitivities to color. He wasn't the marrying kind, I decided, but I admit I had thought of marriage to him too, as to many men who never proposed. Perhaps his family sense, or obligations he had that I didn't know of, prevented him from reaching such a stage with me. He did get married once, but it only lasted eight months.

By now I had a large problem. How much of my relationships with white men, and the way these relationships broke off, was their fault? Was it I who blew out the can-

dle? Was it because of my professional travels, the dizzy-
ing way in which I met new and interesting people? Was
it a curiosity I had to meet and know many varieties of
people? Or was I rebounding quickly from men in whom
I sensed vacillation, fear of sex-color involvement?

As I moved on in the upper circles of American life, I
was to discover how much the Caucasians respected the
laws on the books of so many of our states making mar-
riage and cohabitation between white and black a crime.
How many men respected these laws more than they did
my wish for respectability? I didn't yet know the answer.

This wasn't any conscious quest. I was no scientist
making an inquiry. I was simply flattered by an adulating
environment and placed in a position to see and know
men who were usually unknown to Negroes.

In what was now my world you went out with the men
at the studio. They were white men. At the big hotels
where I sang, the management and the guests were white.
Moreover, if, as I did, you could see thousands of white
people living useful lives, being pleasant to one another
and to me; when you saw, as I saw, that they too were
human beings, you couldn't view them uniformly as "the
enemy." They were not my enemies. I found them to have
the same human attributes as I hoped they found in me.

All this led me to think, to feel, to know, that one day
I would, I must marry a white man. In my romantic little
brain I visualized someone rich, famous, handsome,
charming—and he might even love me *for* my color.

Migod!

Part 5

Fool's Paradise

Rio de Janeiro has been described as a sensual city. Any time you hear a city described that way, you can be sure it has both noteworthy high spots where the elegantsia frolic and slums that are among the world's worst. The same simple truths hold for Mexico City and San Francisco. In Rio the social contrasts are so sharp it is like the difference between the top of a canyon and its valley. I had my heart well-broken in Rio and barely emerged with my life. In fact, I tried my best not to emerge.

Called to the Copacabana Hotel on the beach that runs along the length of Rio, I was part of the topper life, to regale the Latin rich and to help them ignore the vast Rio slum over which they preside.

It was the custom of the proprietor of the Copa to see that star performers—I was presented as one—are made comfortable after their shows and given a chance to meet the city's elite, or some other amusing circle of celebrities and jet setters.

On the first night of my appearance in the dining room of the hotel, after I sang and returned to my suite to

freshen up, I was met at my door by the hotel proprietor who escorted me to a table where, he said, some of the distinguished men of Rio were seated.

I was placed next to a man who looked to be in his forties. He was a Latin of pale olive skin; his coloring was such that I judged him to be unmixed with the Indian-African strains of his country. He spoke in Portuguese.

When I replied in English that I could not speak his language, he answered in excellent English.

He told me that my performance was marvelous, so much variety in my style, the way I moved my hands, how I was alternately sad, happy, wild, abandoned. He touched me to the quick when he remarked, "My dear, you are an actress." That thrust to the heart, to what I believed I was, was almost enough to sprawl me at his feet. But he was so ineffably good-looking that I simply stared at him and listened, and heard less and less of the chatter in Portuguese of a half-dozen other men at the table. The others, sensing that some unexpected accord had suddenly developed and being very respectful toward the figure at my side, ignored us.

His name, he said, was Juan Alvarez de Costigliana Freyre Vivaldez Martinez.

About an hour and a half passed at that table. I learned nothing about him except that he was well-dressed, suave, affluent. He had to be affluent to be in this company. Now, mere affluence has never thrown me. It was this man's charm, his looks, and his awareness of and interest in *me* that had appeal. The evening ended with his offer to drive me about Rio on the following day.

Some men wave champagne before a woman's eyes and she can melt. Others wave a wad of bills. In Rio a knowing native takes you for a drive through this ravishingly beautiful city and countryside.

Never have I seen a place where dense green mountains rush down to a seashore and a huge city straggled between hill and ocean. Ocean, hills, and skyscrapers merge in beauty, and all the time I rode in Juan's chauffered limousine—the chauffeur was named Sanchez—Juan pointed out this or that spot, and I couldn't clearly tell whether it was he or the city that was taking me over.

I had the feeling of a city dancing. We drove on a long boulevard far into the north of Rio, and there is no drive in the world more beautiful. Looking out the windows I saw the polyglot Latin, African, Indian faces of Brazil. So many people in these streets were light-colored like me. I had a feeling of belonging. Maybe the time of year, the soft air added to it.

The architecture of the buildings was often magnificent. Some tall buildings had windows that looked out on beautiful mountains. There were rich cars everywhere. Driving over the broad boulevard, Juan pointed out various estates and told me who lived in them. "And there," he said, pointing to a magnificent home that went up the side of a mountain like a forest of structure, "is where I live."

He said to me, "We'll have Sanchez drive us around the estate." The car moved over inner drives of Juan's property.

I now wondered who he was. "But, Juan," I said, "you didn't mention to me that you lived like this."

He smiled. "I forgot to point out my banks to you. We'll drive back through the boulevard to the business section." He snapped a word to Sanchez and we headed toward the city center.

This time he pointed out buildings to me that he owned, including a prepossessing structure which he said was one of his banks.

I have given this picture of the city only because I feel

that it was a background and a factor in what happened. Staging is something, and Juan staged his city for me, while sitting close by me, holding my hand, looking into my eyes in a loving, masterful way.

We drove back to the Copacabana, as I had to dress for the evening performance. He said he would be in the dining room later in the evening.

From my window I gazed down at the beach where girls danced in the sand. Swimmers bathed in the foamy surf. A breeze from the ocean swept into my open window.

I forgot everybody, everything. I forgot Peter, Jerry. I even forgot Lynn.

I had a moment of fear. I was falling in love. What if he didn't call me again? What if he didn't show up tonight as he said he would?

The corridors of the hotel were filled with samba rhythm music. Waiters brought trays of liquor and food through the hotel. In the lobby splendidly dressed South Americans moved in a leisurely way. No matter what I had seen in London, New York, and Los Angeles, there was a glitter to Rio that exists nowhere else. I was caught in the city's rhythm, and my heart was beating. All I could see around me, in my room, even in the looking glass, was the handsome Latin face of Juan-of-the-Long-Name.

If only someone were around to warn me!

That night I sang and flowed sinuously as if my life depended upon it. Juan was out there, watching my every motion, and I was singing for him. He was interested in me not as a singer, not as a name, but as a person, a woman. So it seemed. When a man appears to be interested in who I am and not what I do, and not whether I have money or a little fame, I like that.

I sang American songs in English but this didn't dismay my Brazilian listeners. That's what they liked, the for-

eign flavor, the American touch, the mood of "What Is This Thing Called Love," "I Get a Kick Out of You," and "I Found Out About Love and I Like It." Later I wondered whether I had fallen for my own propaganda. You sing so many songs about love, about romance, you may get to believe all that sentiment. Privately I had a song whose words often ran through my mind. I never sang it publicly, but I regarded it as my own song, for the lyrics fitted me.

> Lost was I;
> Drifting by,
> Drifting here, and there,
> Always searching for a love
> Love just meant for me.
> But all alone,
> Just like driftwood,
> I kept reaching for someone;
> Now my dream has ended.
> You are here
> Now I am with the one I adore,
> You're the one I am searching for.

That song had been drifting through my mind before I left my suite and went downstairs to the dressing room behind the dining room. And now I was singing my head off, Phil Moore's songs and Cole Porter's. I was like the little bird in the tree who chirped so loudly and so gaily and so happily that an eagle swooped down and swallowed him, saying, "You shouldn't have made so much noise. I wouldn't have found you."

I could not have known Juan for many hours, not more than a day or two, when he took me to one of his apartments in a downtown building.

I still knew little about him except he was very rich,

perhaps the richest man I ever met. I can't honestly say I was indifferent to this fact, but as I've mentioned, no man however wealthy appeals to me unless there is first a physical attraction and a basis of companionship. Juan fitted my idealizations.

Hidden away in a sumptuous room, with dim lights, seated on the edge of a large four-poster bed, we sipped a subtle Brazilian wine. I went through some inner feminine qualms about how zealously or gracefully or reluctantly to yield. He sensed these vacillations and made light of them.

Like a schoolgirl I began to giggle.

His arms were around me. He knew I must have been somewhat experienced, and he asked, "What are you afraid of? Am I so ugly?" He knew he was handsome.

I laughed. The laugh built to a fit of embarrassed laughter. He was embracing me and saying, "Let yourself go." He let go of me and laughed.

"Juan," I said a moment later, "don't men feel that you are common or cheap if you know what to do too well?"

"You are an actress," he blurted. I didn't know what that meant.

My problem was that until this minute I had carried myself with my best style, the style in which I sang before the public: it was a style of elegance, ladylikeness. I had been that way with Juan throughout until now when properly undressing was in order. Then I was confronted by my own duality and ambivalence. This had led to my embarrassment, laughter, and inability to know how to act.

There is another side of me—and much of my conflict is because I know of the existence of this other person. That side of me eventually was to play (so well, so they said) those wanton roles in *Carmen* and *Porgy and Bess*.

Juan soon brought out this within me and began calling me Cat, My Little Cat.

The next morning he said, "My little cat, you are the first woman I have ever met who is really a lady in the parlor and a bitch in the boudoir."

For days I was in a dream world. I felt like a girl in one of my own songs, "*I Found Out About Love and I Like It.*"

I sang on at the Copacabana, sinuously winding my way through my songs toward the moment when I could meet with Juan in front of the hotel and go for a late night ride through those glorious hills, heading toward one or another of his half-dozen hideouts, apartments, or palaces.

Ordinarily I would never want to be riding with anyone over the road at four in the morning, never want to dress to be with anyone at that hour. It was a time for me to be sound asleep after a strenuous performance. But with him, as soon as I finished singing, I had a new leash on my emotions. I had no post-singing attacks, collapses, or paralyses. That seemed to be gone. If my emotional life could be straightened out, perhaps my physical problems would be relieved.

Juan was never tired. He wanted to be awake with me at all hours. "Tonight I have a treat for you," he said. "We go to the *macumba.*"

I didn't ask what it was. Cuddled beside him in the rear of his spacious Rolls, we moved up long winding hills.

"Listen," he said.

I heard a beat that went tandem with my own heart. It touched a chord in me that roused and enchanted me. It was an African beat, the sound of drumheads.

"It's the catskin drums," he said. This was a voodoo-

like rite of the interior hills where African tradition was still alive.

The car turned into a dirt road. Even the big comfortable car swayed over the ruts. I saw a firelight. "I've arranged for you to see this," he said.

The car made a last abrupt turn and Sanchez slowed up.

Black-skinned Brazilians were dancing around a fire. They were chanting before something called a *peggy*. This was an altar on which there were crosses, a figure of Christ, figurines of Mary—but the rites were orgiastic and unlike anything I had ever seen in my travels among the Southern Baptists.

We walked close to the dancers. Men and women, black, barefoot, partly dressed, holding in their hands fetishes, sticks, cloths, furs, moved about the fire in a scene that might have been taking place at the same time in the Congo.

The women were already far into a frenzy. One woman's eyes seemed to be lifting into her forehead as she stamped about in an ecstatic rhythm. I thought that it far exceeded the scenes in the night clubs of Rio in its close meaning to life. Yet what it meant I don't know. I do know that in the South of the United States such atavistic expressions may reflect the heavy emotional strain of subjection. What all this might mean here in the mountains adjoining Rio I couldn't say.

Once more Juan knew how to enliven my senses and to prepare me for the succeeding hours in his apartment.

Another early morning Sanchez drove us many miles until we reached a promontory overlooking the ocean. Juan asked the chauffeur to park near a roadway while he and I walked in moonlight over a dirt path that was

already hard from thousands of footsteps of people who had before us walked to this cliff edge.

"This is lover's leap," he announced. "It's where disappointed lovers come. Many couples have jumped to those rocks from here."

We were hundreds of feet above the coast. Below, the surf roared in like the sound of a million cymbals. The sky was cloudless, stars rimming the whole overhead like diamonds in a crown, and the temperature was cool. A breeze tugged at my scarf as we stood there. I edged close. I stared below into a murky foam that hit against rocks. It was like a constant white line down there. I stepped back, a little fearful.

He had introduced a new mood.

I was glad when the car rolled back through the brilliant broad thoroughfares of Rio.

At first Juan stayed with me each night after my performance. But no matter where we went and at what hour we retired, he was awake by ten or eleven o'clock and he would be off to his offices in one of the skyscrapers. I didn't even know where he went.

Each morning a huge bouquet of fresh flowers was delivered to my hotel. Within a few days of the time I met him, my room was like the interior of a hothouse. I watered the flowers myself. I told the maid to leave them until I discarded them. I lived in fragrance and in infatuation.

This went on until my two-week engagement at the Copacabana ended.

I intended staying on. There was no reason to go anywhere else, not back to America; nor did I have any other singing engagement. The affair with Juan was alive; there

was no discussion of plans, either his or mine; nothing but incessant love and love-making.

Juan became deeply distracted and involved. He stopped showing up at his offices. He was with me days and nights. He stayed in touch with his business operations by phone, and he was curt with callers. He would say, "That will wait."

He was as lost in me as I in him.

When we weren't on the beach bathing, or in the room love-making, it was a trip over the city into the hills.

One of these trips turned out badly. Sanchez, cruising, chanced to take us into the waterfront section. Suddenly I was reminded of the Deep South of the United States, except this might have been worse.

People were crowded in shacks that had little or no roofing and should have been condemned, razed, and replaced. They swarmed in dirty paths in a congestion that was revolting. It was inconceivable to me that what I now beheld could exist alongside the splendor of the Copacabana and the homes of great wealth in the hills. Everywhere was malnutrition and clear-cut starvation, a sense of death and defeat. It went on for blocks and blocks and blocks as Sanchez drove on and I gazed dumbstruck through the thick glass windows. Here were people whose existence was unknown to the city and the nation's managers, it seemed to me.

A slow burn grew within me.

It was what I often felt back in my own country. I had these emotions in Miami, and in Harlem and other places. Now I looked hard at brown-skinned people and black-skinned people, and I was in a rage, thinking, Aren't the dark-skinned people ever to emerge anywhere? Aren't we to be allowed to live? I felt that this was once more my own flesh and blood.

"Stop the car, Sanchez!"

"What is it?" Juan asked.

"I must get out."

I stepped out into a puddle of mud and walked to the nearest hovel. At once a crowd gathered. What visitation was this from the upper world? They looked at my elegant dress. I couldn't talk to them. I didn't know their language. I only knew their condition.

I entered one of the houses through a door that was a hang of pinned-together newspapers. It was dark inside. There was almost nothing I could see. There was a stagnant odor and earthen floor. Could people survive in a place like this? How many millions lived like this in Brazil? I knew now that with Juan I had seen only the most rarefied level.

"Juan," I said as I reentered the car, "I am sick. I am sick. Take me back to the hotel."

He shrugged. "Why do you let this upset you?"

I snapped. "Why, why! They tell me you're the second or third biggest man in Brazil. Can't you do something about this?"

That same gesture of helplessness. I discovered that he had a hardness and an indifference that matched his suavity and charm and his gentlemanly façade. He murmured, "Many many people, a complicated problem . . ."

I stayed quiet as we sped out of this quarter and reentered the beautiful Rio section.

"You are too sensitive," he ventured.

"I feel for those people. I too am a working woman. An artist is a working person."

He stared at me thoughtfully.

I carried on, attacking him. I still saw before my eyes those Latin, African, and Indian faces, and the mixtures of these colors—all sharing a uniform rejection.

"It cannot be easily changed," he said. "We do what we can."

I began to cry.

"Surely you have seen the poor before."

"I have. Wherever I go. I am tired of it. Tired of this world. All of it makes me weary."

"What are you saying?"

I stopped crying. I didn't speak to Juan of my own jimcrow origins. It wouldn't have done any good to tell him that there were also hovels in the United States, that millions there lived in a sub-world too real for depiction. I murmured to him again, in a milder way, that he was a man of influence and he could raise his voice and put the power of banks and politics toward helping these—his own—people.

That day I went far, far with Juan, so far that I must have set him thinking. A blurred note entered our love affair.

It wasn't till later that I realized that I had snapped shut a door between us—a door of *class*. I had dared identify with these souls at the waterfront, with the children with swollen stomachs, the old people with sagging faces, with the hunger and the distance they must have felt from the Rio I was seeing with Juan.

Whatever transpired in his mind I have no way of knowing, but he couldn't have liked my denunciation of him, his society, his oligarchical indifference. I myself never dreamed I had such a depth of social compassion waiting to be tapped. But why not, with my own color origins?

My affair with Juan broke in the Brazilian newspapers. I was reputed to be a famous American lady of

song and screen. Juan was reported seen with me at numerous places. I had the maids and servants read and translate for me the items that ran in the columns. Each time they tried translating, they sought English words for the counterpart of tycoon, celebrity, magnate. It was from these translations that I learned still more of the reputation that Juan had, not only in Brazil, but throughout South America.

The press handled it as scandal. How, they asked, was a man of his position endangering his reputation with an affair with a North American entertainer? Some of the references to me translated as "siren."

I received a phone call from Earl back in Los Angeles. He said he read of it in Walter Winchell's column. Was there any truth to it?

"Very true, Earl," I said. "I'm in love. I think I've gone mad but I can't help it."

"Better phone me every day," Earl said.

We were in one of Juan's country places, a small estate of ten rooms, perhaps the smallest he owned. There were mountains all around, and a tall iron fence surrounded the property. Hedges, foliage, and trees set the place apart from any view from the highway. There was a small staff of four servants in the house. It was like being alone.

Migod, I thought, how does a man get to own such an empire? What does he need so many houses for?

Then a deadly thought came to me. How many women does he have? I realized I knew nothing about his personal life, for he had said nothing to me. *I didn't even know whether he was married or single.*

We were lunching in a cool room through whose windows you could see the perennial hills when the phone rang.

Afterward he said, "It was an associate. A member of my Board of Directors. He says everybody knows about us, and he calls it a scandal."

"Why is it that?"

"A matter of South American custom. Men in my position are not supposed to have friendships with women in the theatre or the arts."

"How do you feel about it?"

"We love each other."

"Why is a singer or an actress held in such contempt in your country? In the United States actresses marry the monarchs of Europe."

"We are different."

He told me it was the same in Argentina. He spoke of a former president of that country, Dr. Marcelo T. de Alvear. He had married a Portuguese opera star, and a great national scandal had developed. Political and economic figures weren't supposed to marry into the theatre. And me? I was only a saloon singer. I was getting the signals straighter now.

I asked Juan what his associate wanted.

"They wanted me to come out of the hills. They want me back at the office. They say the businesses are suffering. They don't like it that it's been on the front pages in Argentina. We do much business with our neighbor."

I have a streak in me where I go noble at times. I had this dubious Christian training when I was young, and that makes me want to do the right thing. I began to go noble on Juan. Not that I was in any sense ready to relinquish him.

"You mustn't let your business interests slide," I said. "We can see each other in the evening." I didn't yet know but the matter went far deeper than his doing a day's work. I doubt that I was any threat to his empire.

I went on, "You wouldn't want to lose everything, would you? I would hate to be responsible for anything like that."

"It won't come to anything like that. Rest your lovely mind."

"You must see me less frequently."

"They make it embarrassing. They're afraid of what I will do with you."

I interpreted it to mean that he might propose marriage to me, and I didn't question him.

"There is one more place I have to show you," Juan said the next day. "Sanchez is taking us there."

We drove through miles of afternoon beauty, far up in hills from which you could see the wide ocean. "In through here," said Juan, "I own much land. Of course most of those hills are useless. We do nothing with them. It is too rough and hilly for cultivation. But it is real estate; one never knows. Most of it cost my father only a few cents an acre when he bought it fifty years ago."

The area he described with an arc of his hand would have covered three or four counties in Alabama. Even there, some counties are as big as Rhode Island. I can't help it if I have to continually refer to his holdings. He always returned to them. I think in a way he was telling me what he had at stake in venturing to romance me.

Finally we turned off a road and went over a small bridge across a stream. A modest post stood there, and a sign somewhat askew at the top of the post said Estado del Paradiso.

We wound through acres of verdured lanes before any structure revealed itself. Then it loomed, with the proportions of a haunting castle. It came into view larger and larger as the car swept through obtruding fern. The drive

narrowed down to a lane big enough for only our car to get through and turned onto a road that revealed a large gardened lawn and a vast austere mansion.

Nobody was around.

It was nearing evening when we arrived. For two hours Juan and I romped in the environs of the house, if the term house applies to a sprawling winged edifice such as this was. We went through gardens, arbors, a hillside from which you could look down and across fifty miles of forest. Juan's dogs barked near us, and Juan played with them.

We had wandered some distance from the house and I was tired. I sat on a rock. The sunset had passed and the first stars were showing.

"I better take you back," Juan said.

He was so strong that he carried me all the way. It must have been all of a third of a mile, but Juan was powerful. I knew that he played polo, though I had never seen him play. I knew that he was a strong swimmer, for I had seen him swim under water for a hundred feet.

Back at the house and inside it for the first time, Juan carried me up a staircase, into a bedroom, and placed me on the bed. "Sleep a while. We'll have dinner in an hour or two."

I slept in my clothes.

It was nine o'clock when Juan knocked on the door and told me dinner was ready.

I thought we would be alone, and I said, "I shan't dress."

But as I entered a well-lighted, large dining room, it was full. Juan's entire staff was there to greet us. They were lined up, smiling, wearing uniforms, and ready to serve the two of us! A long table was covered with food, liquors, and flowers. The silverware shone and the candle-

light was everywhere, from fixtures on the sides of the rooms and from candlesticks on the table.

Juan introduced me to his staff, one by one: the chef, the assistant chef, the maids for this wing of the house, the maids for that wing, those who served dinner, the men who took care of the grounds, and so on down the line. Each wore a special uniform and a special hat.

"I wanted you to meet them because you may see much of them."

The scene hit me in my democratic center. If you are raised on chitlings, corn pone, burnt ribs, succulent greens, pig's brains, and the pig's pislum, you might well get an ornery reaction to such ostentatious tastes. "Hell, Juan," I said, "can't we dismiss that brigade and have some quiet hamburgers here all by ourselves?"

Juan Alvarez de Costigliana Freyre Vivaldez Martinez cracked up. He tossed himself on a chair and let his gut split for several minutes. I never intended being that funny. I just didn't want that fanfare and so many captains and pilots directing the food down my gullet.

Since he was so pleased by what I said I laughed a bit, and then together at the long table we dined lightly, though there was enough food to feed the entire staff of eleven. As Juan kept talking, I found myself nibbling less and less food and listening to the hard story that now unfolded.

"Though I am separated," Juan began, "you know I am a Catholic." He hit me with the two-ton brick that I never knew was there. "This prevents me from remarrying."

I hadn't given it a thought. Raised in Baptist and Methodist Churches, and yet with a private religion of my own, frequently attending Catholic churches while I was on the road—for I found there was more peace and accep-

tance for a Negro in that church—I hadn't thought about these matters.

"I can't marry you, Dorothea"—he always put an *a* on the end of my name—"but I can give you all the benefits of marriage." He gestured at everything in view, the house, the staff, the estate, the mountain itself. "Everything," he said, "all that you have seen this evening. It is yours for all time, and this can be your home if you will be my *concubina.*"

He used the Portuguese word for concubine. I had never heard the word before. It wasn't much used in the United States or England. But I knew exactly what it was: it was South American for kept woman.

The meaning didn't dawn on me all at once, not right there at the dinner table. It took hours and hours for the thought to grow on me that I was to live underground with him, in his big place in the hills where he would come and romance me, and in return I would have all the servants I wanted, the best food, comforts without end, a mountain and a sky to look at.

I am an actress and I never showed him what was going on inside me. I smiled throughout, but within I was totally collapsing. Why had I been such a fool? How could I be so blind? Why didn't I know about the customs of the country? A realization was seeping into me like an infusion of bad blood.

He would be away much of the time, he continued, for there were his business operations, his banks, his deals, his necessary travels between South American countries. While he was gone the villa was mine, his whole world was mine. I had only to wait for his return.

I realized now that his proposition was in some way a repercussion of the phone talk with the associate. He was going underground with me, if we were to stay together. I

could no longer be seen publicly with him, perhaps never in public again at all.

"Juan," I said calmly, with the same patience I displayed to the disturbed little boy in *Bright Road*, "I'll have to think about this. Let me have time to think."

Juan was serious. He wanted me to stay on that mountainside—his lover, his book of poetry, his at-his-convenience *concubina*.

"Juan," I said, "would you understand if I asked that I be taken back to the hotel?"

"Of course, my dear."

It was about an hour before midnight when we started down the long hills to Rio. We sat in the plush leather back seat of the car, and all the way we hardly spoke.

We agreed that I was to have five days in which to think. At the end of that time I was to meet him in São Paulo. He had several days of work to take care of in that place. I was to fly there, and he would meet me at the air-field. At that time I would let him know whether I would remain in Brazil on his terms.

As soon as I reached my suite, I knew that I wouldn't be able to sleep. The proposition started rolling in my mind, and I felt a glow in my cheeks, as if I were having a slow burn or a fever. Usually that reaction in me presages or is related to anger.

The complication was that I believed I loved him. Clearly I was infatuated. Infatuation can be an intense emotion. There may be only a slight line between infatuation and love. What hit me in the guts was that this was the same kind of proposal as I was always receiving in the United States. In my home country, color was the reason;

here it was religion, and perhaps a code that financiers weren't supposed to identify with theatre and entertainment people. Being with him had for me a storybook quality. He had a Prince Charming quality: his graciousness and consideration. Gentle with me always, I never knew about his interior inflexible core until he laid it on the line that I was to be on a back street in his life.

When you discover a new trait in a person you admire or love, you think about it. Even now, at the hotel, I had queasy feelings about the illicitness of the relationship. It was the same feeling I always had in the United States about being a Negro. As if it were a crime, just a little bit wrong to have the wrong color. That is the atmosphere that is bred around and about the Negro in America, and it is the reason why many Negroes have deep-seated emotional problems. Juan gave me comparable feelings. Naturally they struck a chord of resistance and resentment. I resented being treated disrespectfully in my own land; I saw no real reason for accepting it in another.

What do you do when reasoning like this is running through your mind, while your hearts says, Stay on.

I began to wonder, Was Juan letting me out? Did he want me to go back to America? Was he presenting me with an escape clause? Was he really serious? I began to have doubts.

Within the boundaries of his religion, this was the maximum he could offer me. Perhaps it was much. But if he wasn't serious, and was secretly hopeful that he was bringing an affair to an end, then it was dirt under my feet. More man-dirt. Man-dirt!

As this round of thoughts circulated in my head, my reason pumping doubts and my emotions pumping need, my fever increased. By morning I was delirious. I kept having these round-and-round talks with Juan, debating

with myself, with him, even with my friends back in the States what to do.

Nick, my pianist, never left the room unless there was a nurse who remained with me because I was suicidal.

Flecks of recollection of Lynn crossed my vision. This mingled with my latest catastrophe. Once more I felt anger at myself, the old feeling of guilt. Once more I had done something wrong, stupid, ignorant. How could I have been so unaware of Brazilian custom and Catholic law?

"Nick," I said, "what floor are we on?"

"The tenth."

I was thinking that a drop from the tenth floor would be sufficient. Nick called Earl in Los Angeles and told him what had happened and that there was danger I would leap out the window. Earl phoned me and said, "Come home. There's work and pictures. Forget him. He doesn't sound right."

"I don't know what to do."

"Let me talk with Nick." He told Nick to get me on a plane. Nick told him that I was too sick to leave.

On the third day of my illness, I decided that I must talk with Juan now, not later at São Paulo, but now. I must get this over with. I must have a final talk with him and either stay in Brazil or go back to America, but I couldn't wait five days. The time lag was killing. I was too torn up for such a delay.

I got on the phone and I tried to reach him. It was impossible. I couldn't get through. The private number he gave did not answer. I knew where one of his banks was, but secretaries put me off. I spent a day of wild phoning, until it dawned on me there was no way of reaching this man. I would have to wait it out for the five-day period.

Nick never left my side. A physician came to see me

every few hours. Once the doctor said, "Miss Dandridge, I must give you something to make you rest. You have to have a night's sleep. I am going to order something that will give you peace and quiet for many hours."

It happens that I have a great dread of opium drugs. A deadly fear. I knew too many cases of men and women in show business who had been caught in that net and gone swiftly to hell. It was a temptation to people like myself. Because I knew myself and knew that I was capable of impulsiveness, I feared myself and so built a sedulous dread of opiates.

Now I was to get one of these shots, but one, I thought, wouldn't hurt. I had better go out, or I'd go out of my mind. The doctor knew best.

Soon a man came to the door. Nick admitted him. The physician took a package from him. He stayed at a table preparing a needle. All of it came through in a peripheral way. I was a truly sick girl. Deep down inside me, I knew it was over, but I was fighting it by trying to say to myself that I might yet make some kind of decision in favor of Juan and Brazil, and I was trying not to face the fact that this was impossible.

The doctor shot me with a narcotic, and I went out.

Some time the next day I woke up. I felt clear-headed. The room glowed. Then, as I realized I had been shot with one of the drugs I so much feared, this other fear came over me, the fear that I would need this drug permanently now—that I was hooked.

"Nick," I said, "what was that they gave me?"

"I don't know. I wouldn't ask a doctor a question like that."

I was full of suspicion. "Who was that guy with the cap down over his head who brought the drug?"

"A fellow from the pharmacy."

"No, he wasn't. He was one of Juan's men. His Board of Directors hates me. They want to get rid of me. They're out to make a drug addict out of me."

"Dorothy, you're upset. You're exaggerating. I won't let them give you anything like that again."

"You don't know how easy I could be hooked."

"I do know. I'm sure you could be."

When the nurse arrived, Nick went out and phoned Earl again, asking what to do with me. Earl phoned and told me to come back.

"I can't, I'm sick."

I asked Nick what day it was. It was the fourth day since I had seen Juan. There were twenty hours more to do before I took a plane to São Paulo. Nick offered to go with me. I said yes, I might need him. Then I asked, "Why doesn't he call me?"

Nick answered, "He agreed to see you in five days. He said he was busy. He's a big man, you know."

"He knows I am sick. Why doesn't he call?"

"I don't think he knows."

"He must know. Everybody must know." I believed that everybody in the hotel knew what had happened. I believed that everybody knew what his proposition was. I believed that they knew what my problem was.

All through my hysteria I had visions of that lover's leap to which Juan had taken me. If I could only get out there, that would be the best place to jump from. But I would be doing it alone. This jump was for lovers together to do, and Juan wasn't going to do anything like that. Finally I decided I wouldn't give him the satisfaction of jumping off that cliff by myself.

I moved around that room with a deadly calm. The fever was gone. My head was clear. There was a cold deter-

mination which possessed me now. I would go through with this São Paulo meeting.

I planed with Nick to São Paulo, and I fully expected Juan to be at the airfield to meet me as he had said he would be. But only Sanchez was there. He had instructions to take me to a hotel, and I was to wait there for a phone call from Juan.

Once more I had a bad night. Juan had disappointed me. He was making me wait. He knew I was in São Paulo, but he was playing games. It must be that. All that night the same circular dialogue ran around in my brain. I was saying to him, "You have avoided me."

"I have been busy, my business affairs . . ."

"You said you would meet me."

"The publicity is bad, they are on my neck."

"You don't keep your promises."

Over and over that dialogue. The next day the call came.

Charming as ever, solicitous, perhaps totally unaware of what I had been going through, he apologized for being late. He described a large operation which he had neglected, and I was quieted. The thunder inside me died down. I purred like a cat at the sound of his voice. Everything seemed forgotten. Maybe I had mistaken it all.

Sanchez, he said, would drive me to his São Paulo apartment not far from where I was staying.

As I entered the automobile—a different car—I noticed that Sanchez was not wearing his chauffeur's cap. "Where is your cap, Sanchez?"

"I cannot wear it, madame."

I looked at him sharply. "What's the matter?"

He had by now driven Juan and me all over Rio de Janeiro and through the mountain backdrops of the city.

He knew our entire relationship. He felt himself to be part of our love affair.

He explained that he could not wear his cap, nor could he drive the large conspicuous car.

I was already going into the backdrops of Juan's life. There was an illicitness to the way I was being transported. Hush-hush, this is the mistress. It had been open at the outset, but steadily it had become secretive.

Sanchez delivered me to an apartment building. I went up an elevator, rang the bell at the apartment number. A servant came to the door. "Miss Dandridge?"

I was bored by now with the incessant splendor as I sat on a long divan and waited for Juan.

He entered, a combination of a poet, sportsman, and financier. He wore a smoking jacket. I had been through so much emotional turmoil that, as he entered, it was as if some new person arrived. I had already built a shield between him and myself.

He came over, took my hands in his. All he said was, "How are you?"

"All right now."

"I received your letter."

"You never replied."

"You must know what I've been through," he said. "It has been hell at the bank, with the board. The publicity, the talk in the newspapers. I have been under great fire."

He walked across the room, mixed a drink. He came back. "What am I going to do with you?"

"Dismiss me. Let me go back to America. What else is there for us?"

"I can't do that." He kissed me. I received his kiss coolly.

He paced about. "You must stay with me. You can

remain here, or at Rio, or on my yacht—anywhere you wish. I told you, it is all yours."

The air suddenly cleared. I saw myself now for what I was and for what he was. I was in a strange country, with stranger customs. Far to the north, on another continent, there were the jimcrow churches of my childhood. I smelled the smoke of the saloons, got a vision of Sunset Strip. Back in Los Angeles there was my apartment where I made myself at home with pig's feet, fatback, grease, and greens. *Dorothy, what are you doing here?*

"Will you?" he asked.

"I'll still think about it," I said.

There wasn't much more to think of. I knew I would be protected only as long as Juan's affection was alive and as long as he was alive. What might happen to me later when perhaps he found another *concubina,* and I might have to start a new career in show business again? I had had that happen before, and this could be a repetition. There was neither respectability nor security with him. How did his offer differ from the law and practice in my own land? If I declined and opposed a role of stealthiness in the United States, was a second-best arrangement in South America any better?

The next day Nick and I flew back to Los Angeles. All the way back I kept looking at the safety window in the plane. One could push that out, and that would be a good way. Except it might endanger others. I have never wanted to hurt others.

I was beginning to hate Juan. It is a terrible thing when love turns to dust. I was thinking of his inordinate wealth, his indifference to others, his capacity for being tough, for getting what he wanted, for arranging matters to suit his taste. I recollected his indifference at the water-

front. All he had done then was to shrug his shoulders. In a way that was what he had done with me.

I had the suspicion that in his heart of hearts he would be glad that I returned to the United States. I couldn't be the first woman he had hurt.

In terms of its sensuousness, ours was a beautiful love affair, but he was, like many baronial predators at the top of the world's society, a true bastard. I have to use the most detested word of modern times to describe how this man took advantage of me and of his own people: He was not only a bastard, but a fascist bastard.

It was the realization that I had been psychologically raped by one of the worst human types that made me want to kill myself, and now I searched for the swiftest and easiest means to bring this about.

By the time I arrived in Los Angeles the idea of self-destruction was a permanent part of my psyche. A great inner distress settled upon me during and after my first marriage, the largest part of it being the blow of Lynn. The other was my continuing failure with men. The two were converging upon me. What else must and would happen to produce a vector, a convergence point of death by psychological self-destruction I didn't yet know.

Part 6

Two-Two-Two

After my return to Los Angeles I stayed at the home of John Berman. He and his wife tended me, and if it weren't for their warmth and help I might not have wanted to live through that week. It wasn't strictly therapy *per se* that saved me, but the knowledge that these people cared.

I lay abed thinking about my latest disaster, wondering how I could let myself get into unpleasant experiences with men. What did I do that was wrong? Was it their fault or mine?

I now had another to add to a list of failures. But at this time such failures still touched a mechanism inside which caused me to rebound, to leap higher, to prove to myself and to others that I could succeed at something and not everything about me was doomed to failure.

In a few days my old energies revived. I went to the gymnasium each day and worked out for hours, slimming my figure, determined to try once again.

The survival instinct leaped upward.

During the next six months I was on TV, on Jackie Gleason's *Cavalcade of Stars,* and on Steve Allen's *Songs for Sale.* I appeared for seven weeks at the Empire Room in the Waldorf-Astoria in New York and was the first Negro singer to do this. I sang at the Park Lane Hotel in Denver and at the Last Frontier in Las Vegas.

As fast as I made money, I poured a portion of it into wardrobing. Hollywood designers Rudi Gernreich, Maria Donlevan, and George Karr worked out dresses for me. I wanted to startle people, but in a nice way. I had a black-sequined, form-fitting dress that audiences liked; another was a peach-bloom lamé, with a flattering draped bustline. It reached a point where no critic wrote of me without ending up commenting on what I wore and how I wore it. I shut my eyes, snapped my fingers, the fringe would fly from my dress, and I would shake "like a guy wire in a high wind," as one newspaperman put it. I sang one song, "A Woman's Prerogative," and I didn't even know the meaning of the word until I had sung it several times. I tried to key my selection of songs to the type of audience I entertained. "I'm Gonna Be a Bad Girl" went over at one place, didn't in another.

One designer, David Falkes, noticed that I had a small waistline and referred to me as "the girl with the most aristocratic midriff." My measurements were 34-22-36. If my hips were larger than the "standard" measurement for so-called well-formed girls, so be it; the swinging I did with my hips was a vital part of my act.

When I was in Los Angeles I drove a white Thunderbird, and I sometimes wore a white beaver coat to match it. My wardrobe was insured for two hundred and fifty thousand dollars. Though I sang with sultriness, I privately took lessons with a well-known vocal coach, Flor-

ence Russell, in some effort to develop a semioperatic voice, which never did happen. I was doomed to that narrow range of sound, and that may have been best for my type of singing.

In the autumn of 1953 I had a particularly successful return engagement at the Mocambo in Los Angeles. I had grown in style and reputation in the two years since I had first appeared there, and on this engagement Hollywood came to hear me. It was flattering, stimulating to know that there were stars out there like Maureen O'Hara, Olivia de Havilland, and Ella Logan who came to hear me. The newspapers were kind; critics and columnists helped build a sex image of me. "The swank crowd cheered loud and long for her songs of SEXperience." As one reviewer put it, "Every number had a thin lining of sex. The sly suggestions were in the lyrics, and her studied style with a dropped whisper to punch the right line conjured up comparisons with Lena Horne."

When you sing like that and make a luscious spectacle out of yourself, you can expect a certain amount of inevitable man-interest.

It was increasing enormously, and my problem was to ignore flowers and cards at my dressing room from men who, I now knew, could never be in love with me, but might like to tote me around for a few weeks. Some men in Hollywood pick a woman who they think will look nice with them on their arm, like a cuff link.

It was part of my character to retain my friendship with those who had been interested in me. By phone I stayed in touch with Peter Lawford, Harry Belafonte, Jerry Mayer. Not Juan—I would never have any further contact with him.

Scarred by my experience with Juan, I developed a jaundiced eye from this time onward toward casually

introduced men. I wonder if I can convey how many of these you will meet if you are a roving singing star. You occupy a position somewhat like a flame in relation to hovering moths. The moth-men flicker around you, but *they* don't get burned—*you* do if you don't watch out.

I met and knew casually several dozen men with whom I had fleeting one-hour or one-day meetings—not sexual affairs, but swift, intense friendships that could each have developed into a Juan-type situation had I allowed. What happened was in each case similar. They made contact with my room or my maid or my pianist or the club manager, and I might see them. What happened was always the same, as it was for example with Tom Griscell, manager of a Pittsburgh hotel.

I was booked a week in that city. After my third day I found myself spending much time with this amiable gentleman. He told me of his work, even of his family and his children. All of it was confidential, warm.

I told him about Lynn. We talked of books, personalities, ideas. He saw my serious side, and this discovery was upsetting to him. He developed respect. He saw a woman, a human being, not the sex symbol I appeared to be when I sang.

In a way it was my own fault. I gave off two images, the one on the stage, and this other serious creature offstage who looked for warm human relationships. Many men had made the discovery which Tom now made. It was upsetting to him, upsetting to me. He knew that if he continued his pursuit, he would endanger his family life. I could feel his thoughts and his waverings as his emotions, his warmth deepened.

Tom discovered in a few days of intimate dinners, fine talk, and some idle hand-holding that he couldn't react to me in the same way as he could to a white woman. He

may have had affairs with other white singers who appeared there, but with me he was restive. The color question came to the fore. I knew what he was thinking. "This is a serious woman who wants to get married. Can I try to get her in the hay and just send her on her way?" Once he began thinking like that, the relationship changed. He got a fleeting glimpse of the challenge of those two worlds which in our country live side by side. I may have touched his prejudiced core, and yet no word about color was uttered in the time we were together. Still I sensed his increasing nervousness, the intensifying care with which he spoke.

He was frightened, getting ready to run. I began watching the symptoms of his retreat. I had seen them before too, too often.

At the airfield in Pittsburgh I waited for Tom. He had said he would meet me there to say goodby, and when he didn't show up, I took it calmly. I was an experienced Negro woman by now. I knew how hard and cruel the whole realm of color prejudice was. The system was worse than the people in it.

At the risk of being redundant, I could recite more such experiences. In each case there was a similar pattern: the man ran, or the friendship simmered down to a phone call or a letter, or an excuse such as a suspicious wife or financial difficulties.

Once seeing the human woman, and all the possibilities and responsibilities that might lie therein, and treasuring their white status, they vanished through the walls of my life like ghosts.

What was I? That outdated "tragic mulatto" of earlier fiction? Oddly enough, there remains some validity in this concept, in a society not yet integrated. I wasn't fully

accepted in either world, black or white. I was too light to satisfy Negroes, not light enough to secure the screen work, the roles, the marriage status available to a white woman. I had been catapulted from a primarily Negro environment high up into white-peopled studios and salons. Subtly, while experiencing what seemed to be a full acceptance, I encountered not-yetness. Whites weren't quite ready for full acceptance even of me, purportedly beautiful, passable, acceptable, talented, called by the critics every superlative in the lexicon employed for a talented and beautiful woman. Yet the barrier was there.

How was it that the simplest and plainest of girls could find husbands who would stay faithful to them and support or help support them? Plain Negro girls, plain white girls. Yet I, with all the equipment nature had endowed me, with status, art, and now with much money—why did I encounter bad faith, vacillation, men who ran?

Beautiful women should not be envied. The dark streets of American life are filled with these failures. Beauty might even be the worst handicap life can give a woman. Beauty can be a curse.

And yet this very possession, my looks and style, was to gain for me at this time a coveted screen role. Earl telephoned me to say that Otto Preminger was about to produce a movie adaptation of the Billy Rose stage hit *Carmen Jones*.

For days there were rumors on the West Side about who would secure the lead, and from my informants I gathered I wasn't even being considered. There was a search for some natural Carmen, a new actress. For example, Ray Robinson's wife, an attractive girl who wasn't an actress and isn't now, was mentioned for the part. So were other Negro women based on their personal charm, looks,

or the community position of their husbands. A singer Joyce Bryant and a Broadway actress Elizabeth Foster seemed to be in the running.

Earl set up an appointment for me with Mr. Preminger, and in the interim I studied Oscar Hammerstein II's Americanized story based on the Bizet opera.

When I sat opposite Mr. Preminger in his offices there was a momentary misunderstanding. He believed that I was there to audition for the secondary role of Cindy Lou. I quickly set him clear about that—it was the Carmen spot I was after.

He laughed his special Austrian-accented ho, ho, ho. He was a bulky man, with large, strong facial features; he was baldheaded, though with hair at the sides. "Miss Dandridge," he said quickly, "you cannot act the Carmen role."

"What makes you think I can't?"

"You have a veneer, my dear. You look the sophisticate."

I tried to say something, but he went on, "I've heard you sing at the Plaza in New York. I've even seen you walking down Fifth Avenue, with a red coat flying. When I saw you I thought, How lovely, a model, a beautiful butterfly . . . but not Carmen, my dear."

"You disappoint me, Mr. Preminger. Very much."

His brows lifted. I raised my voice. "I thought that you—being an independent producer, something of an innovator—you wouldn't stereotype people." The word "stereotype" throws people, but I charged on. "You have to be able to have some imagination. I'm an actress. I can play a nun or a bitch."

He wasn't used to being called unoriginal or routine. "I could understand others in Hollywood having such a reaction, but you're . . . you're . . . I'm at a loss for words."

"Ho, ho, Miss Dandridge, I don't think you are."

Provoked, he handed me a script. "Here, read this . . ."

The mood was wrong. He could brush me off in a minute. "No, sir," I said. "I can't read anything now. Tell me what you want me to read and I'll return tomorrow."

He showed me what he wanted me to do, and I left.

I hurried to Max Factor's studios and looked around for the right garb. I would return looking like Carmen herself. I found an old wig which, I was told, Cornel Wilde wore in one of his pictures. I found a shaggy but brilliant blouse; I arranged it off the shoulder. Then I located a provocative skirt. I put on heavy lipstick, worked spit curls around my face. I made myself look like a hussy. Dressed like Carmen, I sidled around for a while feeling like a whore. Now I was ready for the next day's interview.

On the following day I gave everything a final twist, as if to look a little disheveled. I had my own interpretation of how a lady of abandon might conceivably look.

I needed one thing more: a tired look as if I had worn out a bed. I went to the gym and deliberately tired myself before going to see him.

As a final bit of staging I arrived a little late, late enough so that it was noticed, but not so late as to become an irritation. I arrived at his offices, passed by his secretary, and dashed inside. "Oh, Mr. Preminger, please forgive me . . . I just got back . . . I am not dressed . . ."

I presented him with the most startling switch of personality he might ever have seen.

"My God, it's Carmen!"

He moved about with excitement. I had ceased to be the saloon singer, the lady, the sophisticate.

"Wonderful, wonderful, how did you dream up that look?"

I sat in the chair, leaning forward—there was a hefty bosom I had to offer. I usually kept that well-covered when

I sang. In the saloons I wore dresses that ran right up to the neck. I sold my form, style, face—not my breasts.

He said, "Open that drawer."

I opened a drawer.

"Close the drawer."

I closed the drawer. What could he possibly learn from these moves?

"Now open the other drawer on the other side of the desk."

I rose, moved around, opened another drawer. Was he testing alertness, the pace of my moves?

He pressed a button. An aide entered. "File a test of Miss Dandridge," he ordered.

For the screen test I did a bedroom scene. They were frank shots, and the word got out of the studio: "The tests Otto Preminger shot of Dorothy Dandridge would never get a seal of approval."

When it was over Mr. Preminger had only one observation. My temperament and tempo were too fast, he said, and throughout the picture I must slow everything down. This is a direction which is frequently given to actors and actresses who need to know how cameras record.

Word got around the Negroes on the West Side that I had won the Carmen role. With this a storm of rumor, spite, rivalry developed. News of it came swiftly to my ears. Competition is the spouse of the bitch goddess, Success. Together they breed always the same triplets: Envy, Jealousy, Resentment. The Negro community is plagued by fears of its image; it has been so much the victim of stereotypes that it has developed an understandable sensitivity about what will be done with the Negro theme in any of the arts.

I decided I didn't want the part. Too much politics

now: the social fears, the private responsibility. Too much stress. I feared my emotional system couldn't handle it.

I retired to my apartment and for days wouldn't see anyone. Earl spent hours with me, trying to reassure me, telling me it was my big chance.

Yet I had the fear I might displease the Negro community. I couldn't bear to think I might turn in a performance that would be injurious to that perennial spectre, race pride, the group dignity. This was the story of a prostitute. Sensitivities were high. There was fear of such an image of the Negro woman.

If I failed again, I didn't know what would happen. It had been a struggle to get the part. From having at first been overlooked and thought unsuitable, and having felt insulted over this rejection because I was the only Negro girl in Hollywood making pictures, now I had ambivalence and dread.

I asked Earl to tell Mr. Preminger that I wouldn't do it.

I had a duplex apartment on the Sunset Strip. The color scheme of the living room was pink, white, and gray. An antique gold sunburst clock stood on a mantel over the fireplace. My grand piano was near a window through which you could see the lighted forest of Los Angeles as it looks in the evening from the Strip. On the walls were a couple of original pictures—a delicate scene of the Champs Elysee by John Morris and a concept of Cuernavaca by Johannes Schafer. In vases here and there were gladioli and white chrysanthemums.

Otto Preminger liked what he saw. He called it lovely, tasteful, and he asked whether I had had this done by a

pro. No, I said, I chose it myself, the colors, the paintings, all were my own selection.

He had come to persuade me to take the Carmen role. It was our first evening together. I had fixed myself up so as not to show the signs of the distressed week. He couldn't possibly know, from watching me, that I had been frantic, bedridden part of the time, in my usual flurry.

When it seemed to me to be the right time, I placed a steak before him. "Not now," he said, seated opposite me, "I'll take a drink or two first. I like my steaks cold."

He asked me why I had behaved as I had. Not in his entire life as a producer-director, he said, did he know a rising actress to turn down such a role as this. I tried to tell him how it was being bruted about that I was the wrong choice for the part. I had been compared with others purportedly with more sex appeal, or more dramatic talent. I tried to indicate the pressures within the Negro community about playing the part of a prostitute. He knew little or nothing of these matters and couldn't grasp why I was frightened. I ended by saying, "It makes me wonder whether I'm doing the right thing."

"Will you please let me take over? Will you accept my assurance that you are fine for this? There will be no problem."

He was heartening, and I needed to hear him say more. Something inside me, the female, needed coaxing, urging. I heard him say, "We can make the best picture of the year."

"You believe so?"

"You must forget what they are saying. Forget everyone, all talk, all fears."

He cut into the cold steak and ate the cucumbers. Cucumbers and cold steak, his favorite dish.

I warmed to his enthusiasm, and I studied him as I

told him now that I would go through with the part. That delighted him. He drank champagne, poured a drink for me. I sipped it and tried eating, but I was studying his head, the head of a successful Hollywood man.

It seemed to me that the man of business and the artist appeared alternately in his features, each convoluting with the other in an inextricable form. There were both hardness and sensitivity. His features had severity, a convex force, and about his eyes, I think in the arch of his brows, there was some secret of his capacities. When you are with Otto you are aware of his skull. He seems to contain confidently inner worlds of which you have no knowledge. At times the artist within him—and it is always there—becomes totally lost in the network of the organizer and the driver. All of it appears before you as he talks, plans, and moves in his own directions.

He told me that basically I was a good actress, and that I should not have dramatic training; I was uninhibited, that my natural free motions were my best performing qualities.

This was the assurance of one of the town's most famous directors. He had begun his directing career here in the 1930's, and he went on to do such films as *Forever Amber, Laura, Centennial Summer,* and many others. I knew that he had beginnings in the famous Max Reinhardt Theatre, and I asked him about his own acting days in Europe.

His face clouded. He spoke of his origins as an actor and said, "Let's face it. I failed as an actor. But I found my milieu as the organizer of other people's talents."

Looking at him I saw how he could not possibly be a leading man in American films. He did not have the look of the king stars. He had never had this appearance. If he had such aspirations, he was doomed by his build, his

tendency to stoutness. But if he had frustrations about not having matured as an actor, they were submerged. He seemed to be a man who had discovered his proper niche. He had made himself more important in the industry than the handsome men he hired.

By the middle of the evening I called him Otto.

We drank on and on of the champagne. I cleared away the dishes. Otto drifted into personal talk. He was separated from his wife, he said. They still lived in the same house, and they entertained mutual friends, but they were not exactly husband and wife.

By midnight he had pretty much heard the story of my life and I of his. He said, "I've been in the theatre since I was seventeen."

"And I," I said, "since three."

We laughed, drank more champagne. Otto paced about the apartment with an increasing liking for the place. Always I had that curious image of a father, a man with force, a large chest, a paternal way. Otto was like that, perhaps twenty years my senior. By one or two o'clock in the morning, we had consumed much champagne. My hand was in his. The room was warm, our confidence higher and higher. His large arm went around my shoulders.

He told me of the Hollywood custom, how during the making of a picture so very often the people in the cast, especially producers and stars, did a two-two-two just for the duration of the picture. A coupling until the picture ended. He intimated that it was good for the picture, for the people involved. If each knows the other, if they feel all the heats of creativity, if star and director know each other heart and soul—and the rest—the spark of it all might well leap into the beauty of the film.

Otto talked on in a warm, accented way, gently, in

words I don't clearly recall for it was many years ago and
I had much champagne. But this was a man. He was phys-
ical, all-male—no problem there. He had said "for the
duration of the picture," I think, but if so I ignored it.

That night I became his girl.

Ten years before the making of the picture, the Ameri-
canized version of *Carmen* had appeared as a Broadway
musical. The movie version was not much changed from
the stage show. The original Carmen of Bizet became in
the new version a wartime American girl. Carmen Jones
works in a parachute factory. She has her eyes on Joe, a
member of the military police guarding the plant. She
seduces Joe into leaving his fiancée, Cindy Lou. Joe
wounds a tough-guy sergeant and runs off to Chicago with
Carmen. But in Chicago the goodtime gal Carmen leaves
Joe for a boxing champ, Husky Miller. When Carmen
won't go back to Joe, Joe kills her, just as in the Bizet
opera. All of the development in the Americanized version
followed the story line, music, and meaning of the Bizet
original, but it was brought up to date. Hammerstein's
interpretation had a certain irreverence and humor which,
in the Broadway musical version, charmed a wartime
audience.

Harry Belafonte had the part of Joe, Pearl Bailey
played Frankie, and all other parts were performed by
Negro actors and actresses and singers. Early in the mak-
ing of the picture I gave a party for the cast at my apart-
ment. Otto attended the party. Perhaps the members of
the production suspected our very close relationship. If so,
this did not matter much to any or all concerned. This was
Hollywood tradition, the two-two-two as it was called, and
others in the company were comparably involved.

Early in the filming there was a crisis that raged con-

cerning my ears. I had to wear earrings and my ears were pierced to carry the rings. But I have no lobes, simply no ear lobes, and they pierced the lowest part of my ears. The ears became infected; the pain was incessant.

There was a fighting scene where I had to run down-hill. With my ears hurting, I recollect complaining to Harry, as he chased me downhill, "Hurry, Harry, let me get this over with. I can't take it any more."

We finished that scene, but the next day when I had to put on those earrings again I refused. My ears were bleeding, the pain was excruciating.

I got word that the whole wardrobe department threatened to quit because of the problem I gave them.

"Let them quit," I said. "I can't go any further until this is straightened out."

They went to Otto and complained that I was being difficult. Otto came to my dressing room. Around the set he was always well dressed. He was wearing a white checked coat, dark pants, an expensive white shirt, a har-monious tie. He was the picture of authority and judg-ment. He placed his arms around my shoulders, asked me what the trouble was, said that the whole production was threatened.

"Otto," I said, "look at my ears."

He admitted it was a problem. He held the large ear-rings in his hands and wondered what to do. "Isn't it ridic-ulous that they call you temperamental?" he remarked. He knew me as a compliant, worshipful girl. By now I leaned upon him entirely. I listened like a small girl to his every word. Around him I was lamblike.

He assigned a girl to help me get those earrings on and to help out in other ways; but she saw the condition of my ears, how badly damaged they were, and suggested there ought to be some other way to solve the problem.

A special effects man devised a taping that held the earrings in place without penetrating my ears. The pain lifted. The crisis over my temperament ceased. The filming from then on moved rapidly.

Even so, I had the feeling that the other members of the cast held me in some mistrust. There was no undue warmth between them and me. Otto had a way of screaming at the performers. He did this with almost everyone except me.

One evening, at my apartment, talking over the picture problems, I said, "Otto, would you please scream at me about something, just to make me one of the crowd? Would you please find some reason to scream at me?"

"Ho, ho, ho, my darling. How can I scream at you?" He laughed.

I was sharp with him about one person in particular. I said, "If you scream at Glennet any more, I'll leave the set."

"Why?" he asked, in consternation. He had no view of himself at all.

"Because Glennet can't defend himself. He's a simple man who needs a job. When you scream at him, he falls apart, and I want to leave the set."

Two days later Otto screamed at Glennet. I left the set.

Everything halted. The cameras came to a stop. The actors went off to the side. There was a hush. As I left I gave a peripheral glance at Glennet; he looked so crestfallen. But he knew I walked off because of Otto's brutish handling of him.

Otto came to the dressing room. "Darling, what's the matter?"

"For God's sake, there must be another way of coping with people without batting them on the head and making them feel stupid in front of other people! I can't stand it!"

Otto was flustered. "I know," he said, "I promised I would not, but this man is an idiot."

I said, "Why don't you go over to him and say, 'Come along to the side.' Stop the cameras and talk to him quietly, tell him what you want."

He was quiet.

I continued, "Why do you have to scream from the booth? Then you start frothing at the mouth."

Once more Otto calmed me. He promised again to be kind to the actors.

I walked back to the set. Once more everything was fine . . . if anything in the making of Carmen was fine.

During the entire shooting period the only crutch I had, the only person I could talk to was the extra assigned by Otto to work with me.

I tried to ignore all the company gossip and envy.

I hardly slept through the twenty-one days of the shooting. The voice of a trained opera singer, Marilyn Horne, was dubbed in for mine. In the cutting room where the dubbing took place, I was told that I was handling my end of it, the synchronization, with no trouble. Harry's voice was also dubbed in by a male opera singer. Pearl Bailey's own voice was recorded.

From early morning through late day, the work went on. I had no idea whether I was turning in a good performance or not, except that Otto encouraged me and said, "You will get an Oscar for your performance."

But the overtones that came from the set intimated that I had done a bad job.

Regularly, during the picture-making and afterward, Otto dined at my house and often stayed the night through. Cases of champagne arrived. That was his drink; he was to make it mine. Otto drank it, I sipped it. We chat-

ted over *Carmen*, his next property, his problems at
home—everything.

By the time the picture was half done, I fancied myself
special, an exception to the two-two-two ritual usually
ending when the film was in the can. Otto hinted about
the future, vague things, perhaps an enduring relation-
ship, perhaps marriage. I began to live on these hints.
When a white man in power, as Otto was in the film indus-
try, hints to a woman of my color about better days com-
ing, and when in her silly mind she visualizes a happy
legal role which in actuality our society doesn't offer, even
when she is a celebrated beauty, she can develop illusions.
One day Otto Preminger, who was now contemplating
divorcing his wife, would marry Dorothy Dandridge.
There would be a considerable wedding. The Austrian-
born Preminger would walk down the aisle with the Amer-
ican Negro actress. All Hollywood would be out for the
event: the press, the moguls, the stars, perhaps a few big
politicians. I could see it all clearly.

While I had this ultimate objective working up inside
me, Otto was thinking along a different line altogether.
When I told him I didn't like night club work and dreaded
going back to the saloons, hoping he would propose some
other alternative—movies, marriage, something—he pro-
ceeded to chart a new night club course for me.

"I think I can do things to help you like saloon singing
better," he offered.

"Nothing can ever make me like it."

"Even if you were to become the most famous night
club singer in history?"

"Even that. What have you got in mind?"

He depicted for me a new style of appearance. I would
wear a rich black gown; there would be special lighting to
focus on my expressive face. He invented an Edith Piaf

manner. He painted such a compelling picture of how I might go over in this new image that I believed him or I wanted to believe him. That was because I tended to agree with anything he did. Actually Otto was ignorant of what the night club crowd wants: they want a sensuous lady with lots of hip action, plenty of bosom, and they don't want any portion of her concealed by lighting.

Once he revealed his essential philosophy. He told me why he was tough on a set, and tough with others, and tough in all his dealings. "Don't show kindness," he said, "people will construe that as weakness, and they'll take advantage of you."

Don't show kindness. What a key to Hollywood success. What frank self-revelation. Suddenly I realized why many men were at the top of Hollywood and why many women retained and maintained their queen roles. They were tough. Don't show kindness. I was trained in church to the Golden Rule, to forgiveness, even to turn the other cheek. I saw now that others in the world are either reared differently or they make themselves different.

Out of his Napoleonic drives and his own histrionic frustrations, Otto had fashioned a private *modus vivendi*. In this confidante period, he made me privy to his secret— toughness. No one could be more fully forewarned than I was about him and by him. It never occurred to me that one day he would be as tough about me.

In a way I felt a certain compassion for him. Out of his own hurt, whatever it was, he had fashioned his own drives. Otto was ugly. Truly ugly. Many of those little men who run Hollywood are ugly. It is the folklore of Hollywood; the ugliness is much commented upon; it is known and understood that out of their ugliness they fashion an armor or toughness with which to prey and rule and suc-

ceed, and these alone are the kings of Hollywood. Maybe
they are the kings everywhere.

I think now that Otto never loved and never was loved.
He could have been afraid of it. Love would weaken his
essential conviction about toughness as the way, the truth,
and the life. There are some who repulse love and are
repulsed by it. Their natures require other things: mastery,
power, conquest.

You may ask, If I knew or sensed all of this, why did I
set my sights on Otto? Why and how could I be associated
with him, love him, be willing to marry him?

The answer is: I do not know. But I was trying.

Behind what we saw and knew and felt of each other,
behind the confrontation of our polar interests, sex, color,
status, legality, all the other tangibles and intangibles of
human relationships, behind all that, we had a good rela-
tionship. I kept it harmonious. There was tenderness,
affection. He was a wondrous gift-giver. I did not love him,
but if he had proposed marriage, love would automatically
follow.

What is the why of all this? I don't know. I am only
trying to be frank and truthful and present myself as a
human being of my hour and to describe my needs and
motivations.

When *Carmen Jones* was previewed in Los Angeles a
group of my friends returned with me to my Sunset
Strip apartment. Not one commented on my performance.
No one said that I was any good or that I was bad. They
carped about the choreography; they said there weren't
enough Negroes in the fighting scene. I still had no idea
whether I was good or bad in the role, except Otto assured

me that I was fine and that it would show up in the reviews.

A few days later a preliminary report came in from San Francisco where the San Francisco-Oakland Critics Circle voted me the best actress of 1954, before the national release of the picture.

Otto and I went to New York for the premiere. For that event I had a special white lace sheath dress with a matching greatcoat designed for me by Robert Carlton.

When the reviews came in *Time*, remarking on my previous gentle schoolteacher role, said, "The range between the two parts suggests that she is one of the outstanding dramatic actresses of the screen." When I read that I felt that all that I had ever believed about myself and my creative potential was vindicated. I was human enough to say to myself, This'll show 'em. But it was only the beginning.

A few days later my picture was on the cover of *Life*, billed as "Hollywood's Fiery Carmen Jones," and its story remarked that I was the most decorative Carmen in the history of that opera, and it predicted that no one would reach nationwide fame so quickly as I. In these accolades I was to reach a high and also the beginnings of a decline inevitable for a Negro actress for whom there was no place else to go, no higher or better role to play, no new story available, no chance to play roles meant for white only.

For weeks I was on the road helping to publicize the picture. This I combined with night club engagements, and one night in December, when I was singing in Denver, my maid rushed into my dressing room to tell me that I had received the nomination of *The Film Daily* as one of the Famous Fives of 1954. What that meant was that one of the five, perhaps even myself, might win an award as best actress for that year.

Other accolades trailed afterward, that of the Academy of Motion Picture Arts and Sciences, the Council of Motion Picture Organization Audience Award, the Hollywood Foreign Press Association—all nominating me as the best actress of 1954 or as the most promising new female personality.

When the picture was initially released it was billed this way: Featuring Harry Belafonte, Dorothy Dandridge, and Pearl Bailey. After the awards and nominations came my way, the newspaper advertising everywhere and the marquees of theatres listed it: Featuring Dorothy Dandridge, Harry Belafonte, and Pearl Bailey.

All of it was satisfying in a peculiar way. I felt vindicated for my years of frustration in marriage, love, and motherhood. It was as if I had purged myself of feelings of inadequacy. As far as I was concerned, I had achieved as much as I thought I could or would achieve in Hollywood. I was in it and had got there because, after my marriage failed, I had to make my own way, and I had worked myself to that point. But having achieved whatever I did, I found that inside me there was this vast hollow of private frustration. Where was the right love and marriage and home life? If I didn't have that, all the rest was semirealization and chimera.

The fact is, I didn't care essentially for stardom. I don't now. I never did. That may seem unbelievable; it may seem contradictory; it may sound like sour grapes; it may sound unHollywoodlike. So be it.

Some people think work is the greatest thing in the world. They swear by it, they say it keeps them alive; they declare that this fulfills them and satisfies them. They put an aura of productivity about it.

I worked from the age of three on, and work is nothing.

A child, that's a creation. Several children, that can be a beautiful thing. A family life that works, that's ideal. That's what I wanted; and inside somewhere I was still hellbent on securing it.

All through my screen rise I was running backward from my bad marriage and my retarded child, and I wanted to make it as a woman. I wanted to be in the backdrops of some man's life. I wanted home life, and not to have to bat around the country in hotels for the rest of my life or hassle on studio lots. Something in me cried out for a husband, for marriage, a home, and to have somebody else out there hoofing it for me while I made a new life and tried again with another child.

These thoughts were with me before the picture's premiere; they were with me when the press raves came in; and they were with me in the period when it seemed possible I might secure the best actress award for that year.

They were with me because Otto was with me. He was running around the country pursuing me, being present at my singing engagements. He couldn't get me out of his system; nor could he make any proposals of substance to me—neither a new film nor marriage. He was hung up with me, hot after me, chasing me, and I wondered, What do I do now?

The situation went far beyond Otto's initial intentions. Passion and interest being what they are, the zooming fortunes of our artistic association being what they had become, he couldn't or didn't yet want to extricate himself. He might have been in love with the Svengali role. Now I was a well-known actress, he had launched me and groomed me, I was his protegé, and he took pride in this.

Otto knew something that I didn't know. Being mentioned as one of five candidates for best actress of the year was realization of much, for as *Life* put it, "She is the first

Negro ever nominated for an Academy award for acting in a major role."

"You will not get the Oscar," Otto said.

"Why not?"

"The time is not ripe."

He spoke the truth.

The time would be ten years later, during the so-called Revolution when Sidney Poitier would secure it for a wonderful performance.

In the succeeding months my relationship with Otto became entrenched. He put champagne into my life. Always the best, only the best—that was his motto, his way of doing things. He tried to pass on to me that philosophy, an outlook of luxury and royal eminence. He himself was an uncrowned king. He had about him the manner of a cinematic prime minister. I was in his court. He wished me to leap to the sky with him. Of champagne as of everything else he said, "Drink the richest and the best. Never settle for anything less."

Otto imparted to me an idea of what a star should be and how I should act. I must act very very big: fame was also a part that must be played. I must not be accessible. I must carry myself with an air of superiority and fit my head to the mantle of greatness—if that was what was happening to me.

I allowed him to make all my decisions. I was seeing less and less of Earl. The producer had groomed me and measured me to success; that was evident and I was following his advice. Until then I tended to shift over to Earl all of my details—handling people, scripts, finances, anything that was too much work or time for me.

But I had a daddy now. Otto was what you might call an overwhelming personality, and he overwhelmed me. I

allowed myself to be possessed by him. Although he was hard with most people, he wasn't hard with me. He took over on me exactly as he would one of his moving picture productions. I was a production too: my dress, my life, my friends, whom I saw, where I went, my perfume, my manner, my career. He wanted me to be seen at a public event with Michael Rennie. I did as Otto advised.

As he had shown an all-pervasive view of the film *Carmen Jones,* now he had an all-pervasive view and hold on me.

If he was trying to make me over into a personality like himself, then that might be harder, as in the incident of teaching me how to approach Darryl Zanuck.

Mr. Zanuck, a short man and also not handsome by conventional Hollywood standards, treated me as an arrived and accomplished actress. In his offices, he told me that his idea was to fit me into whatever pictures came up, whatever properties suited me. I would not be used as a "Negro actress." He said. "I see you as a rounded-out actress who can do anything. You can appear in a variety of castings, as Italian, Brazilian, Puerto Rican, Mexican, anything."

I liked his approach. When we spoke of salary I said I would be in touch with him. Otto had told me to do it that way.

Otto advised, "You must ask Zanuck for more than he wants to pay."

"Why?"

"He will have no appreciation of you otherwise. That is the only thing he will respect. I would be the same way."

Otto asked, "What is Bill Holden's salary?" At the time Holden was one of the highest paid men in the community.

"You can't mean it. I simply don't have Holden's experience."

"Do as I tell you."

I asked for it and I got it. I received a three-year contract with Twentieth Century Fox, with a starting salary of seventy-five thousand dollars a year for each film.

Not long after the contract was signed, I was offered the part of Tuptim in *The King and I*. Tuptim is a secondary role in that musical. It was a part I should have played, I now believe, but my father-mentor-lover-business adviser said, "Don't do it. You've got to be a star. That's what you signed to do. To be a star. So be a star."

Otto was sincere. He had never believed in playing bit parts as an actor himself, and he passed on his convictions to me. Though he was honest, his advice could have been in some part my undoing. I would have received seventy-five thousand dollars for playing Tuptim, and I would have been in a picture seen by millions. It would not have been the role of a Negro.

Later, when I saw the picture, with Rita Moreno playing the part of Tuptim, I still did not think highly of the part. Yet my decline may have dated from that decision.

Artistically I started going downhill from that moment. My decision not to play Tuptim upset my contract. Twentieth Century was not obligated to pay me. I bowed out, I thought very gracefully, but it is possible that it was too cocky of me to do so. There is a subtle line you have to walk in business relations. Make one wrong move and you can be sent spinning in wrong directions for a long time thereafter, even forever after.

The Tuptim rejection was one of a series of misjudgments.

With that decision and with the steps that followed, I upset several years of work. These were the years when I

should have been playing in one big picture after another, whether starring or secondary roles, but I should have been performing regularly.

Whether this is rationalization or not I cannot honestly say, but I think my misjudgments stemmed from the all-out objective of landing Otto. I did what he told me to. He was my mentor. If I made bad moves, he helped make them for me, or he directed me into them. I was in such a dizzying vortex of "success" now that the actual fact is I didn't know what I was doing.

Instead of taking the Tuptim role I accepted a singing date in Las Vegas.

Otto was hellbent on my becoming the greatest as a saloon singer. He was more interested in having me sing than act. I knew that as long as I was a night club singer I would be away from Hollywood, and away from there I would be away from him. Even though Otto had been flying out to my singing engagements and participating even to the point of arranging lighting, I asked myself, Why does he want me to sing? Why doesn't he get movies for me? Why doesn't he suggest the best thing possible?

Was Otto having his own conflict? No doubt he was. Sooner or later he had to shed me or marry me.

The question of saloon singing versus movies became a tension between us. "I hate it," I told him. "I must get out of it. There's something about singing in saloons. No matter how elegant you may think I am, no matter how ladylike an act I put on, when I'm up there before them it's still a saloon. Women who sing in saloons get an unfair image slapped on them. They are looking at your boobies, you are shaking your behind as you sing. They soup this up as simple sex, and you can't get away from it."

Otto stared at me as if he was challenged, as if this were a new kind of movie to be made, or an actress to be

coached into a different performance. The great producer fancied that he knew how to take another realm, the world's drinking bastions, and elevate them with a new woman, a new Dandridge, a new songstress, maybe give it all the aura of the Russian ballet.

He answered, "No, no, Dorothy. You must sing. You must stay with it, only become the greatest."

Before I went to Vegas, Earl said, "Otto is a producer and director and a good one, but he knows nothing about night clubs. If you go back to clubs now, when the movie world is open to you, you'll make a big mistake." He was right. A singing date passes, but a picture may have permanence and millions see you in a picture.

I was trying to accommodate myself to the big man with whom I lived. He was generous enough to put a down payment on a beautiful house in the Hollywood hills. Was it wrong for me to hope that the arrangement might solidify and legalize?

I disregarded Earl who I thought didn't know what was good for me, and I went to Las Vegas where I secured seventy-five thousand dollars for a month of singing at the Riviera.

With a film salary that ran ten thousand weekly and cabaret work bringing me seven thousand five hundred and up weekly, the world became mine. The money came in so fast that I had to hire an accountant, Mel Parker.

Unfurnished, my showplace house overlooking Los Angeles cost sixty-five thousand. The custom furniture inside and the added improvements to the house cost in excess of ten thousand. There was only a small mortgage on the house when I bought it, and now, there I was, a

solitary star above all those strivers on the Strip, way up, made it the hard way. I shared the luxury with two dogs— Cissy, a mongrel, and Duke, a husky.

When I was making my beginnings in pictures, the most exclusive delicacy at executive dinners was big golden shrimp. The bigger and the more golden, the better. The shrimp were netted in some far-out region of the Gulf of Mexico and were flown to the Farmers Market near the Hollywood Strip. The chauffeurs and maids of the stars and executives motored to the market and picked up the big shrimp. Now the cycle was complete. By the time I was on top, the vogue was small shrimp, shrimp so tiny the little darlings didn't have a chance to grow before Hollywood was there ready to gobble them up. I was now in the small shrimp phase of my glory. Small shrimp were on my diet regularly. They were expensive, there was a lot of work shelling them, but with a plate of the small shrimp in front of me the flavor was that of success.

While I was viewed as a success, an arrived star, and a moneymaker, I was actually balancing precariously. I was entering a stage where I would be mounting one large failure upon another. Was it my weakness or the pitfalls of the environment, or a combination of both? Was I being ground up by the temptations of wealth, status? To what extent was Otto's advice upsetting me? How did my present way of doing things differ from that of my early training? Was I engaged in some deep thrust for respectability? Of course I was, and for an American Negro girl, that was to engage in one of the most impossible gambles in the land, next to which the piddling gains and losses at a Las Vegas gambling table were nothing, for I was trying to surmount a wall called Insurmountable.

My life moved toward a crescendo of interrelated

events. New people, pending deals, increasing world notice—all of it rolled at me like a cyclone. All that was at the surface; within me there was only one undercurrent: Otto.

Whenever I could I ran to see Lynn, to see the smile she gave me. Then she was blank; I was only another person to her.

I phoned my mother every day. She was doing well on television. She had little idea how I was beset, and I tried not to concern her. She took pride that I was "so big." She too was show business.

I had a heartache over my sister Vivian. She had been married twice, and each marriage had failed. At the time of the *Carmen Jones* premiere, she was in New York with me, but after that I never heard from her again. The last I heard she was in Southern France. I knew Southern France, a region for many of the world's troubled and gone girls. I phoned, wrote, reached people who knew her. She was nowhere. I have not heard from her yet. Nobody has.

One day Auntie Ma-ma came to me and asked me for a thousand dollars. She was older now, her hair whitening, her face lined, her body stouter. I don't suppose life had been any easier for her than for anyone else.

I recollected the times when she turned me upside down, and I went cold. "No," I said to her, "I can't let you have a thousand dollars. Not anything."

"Nothing?"

"Not anything."

She telephoned my mother saying, "Dottie smells herself," meaning that I was putting on airs.

I took pleasure in turning her down. I wasn't that much of a Christian.

My friends complained that I had lost touch with

them, I had gotten too big, it all went to my head. Maybe so.

My growing reputation reminded me of when I was a small girl on the road, and I was happy with the plaudits of those who came to see me caper across the stage. I was getting magazine praise, prizes, scrolls, offers to sing everywhere, and a sudden flood of interest in me by all the studios. Applause, adulation, these are difficult noises to be indifferent to. They flatter the ego, they say to you, You're good, you're an artist, you have something others don't have. When I talked with my psychiatrist, he used another expression to describe what was happening. "It's good ego massage," he said. "You need it, for you've been hurt so much."

If you reach a small eminence in public life or the show business world and read what they say in the papers and magazines about you, you may well have the eerie feeling you are reading about someone else. They know nothing of you. In particular, in Negro circles, curious tales were moving about: I was a snob who no longer wanted to be around Negroes; I was a goddess and behaved that way; I was in an ivory tower; I was a Lesbian; I was frigid; I was a hot tamale; I didn't like men; there was no romance in my life. They asked, Why doesn't she remarry? If you are young and beautiful and you don't remarry, you can be the object of all the speculation in the world. They didn't know how badly I wanted to be married and how hard I was trying. They didn't suspect that I was ready to shed show business in a minute if Otto spoke the word.

I had everything and nothing. How many human beings are wandering around in the stratosphere of ephemeral fame, with everything and nothing? The tragedies, the suicides, the upset lives that constantly emerge

from the celebrity and jet sets suggest that it is a legion of its own.

I would be lying if I said that there was no change in my nature and that Dorothy Dandridge remained her same self.

What happened? About the only thing that could happen. It *did* go to my head.

I became imperious, willful, more spoiled than I had been as a child when I preened at the applause of adults. There is a well-known saying that power corrupts and absolute power corrupts absolutely. I had no power and did not think in terms of power, but clearly I could have paraphrased to say: Success distorts, and great success distorts greatly.

In Hollywood the term queen is not always used with love. It usually is applied to an imperious, whimsical, difficult woman, one who cannot be reached, who is unreasonable, even impossible. When Hollywood uses the expression, "She's a queen," this says volumes, and no further description is necessary.

Screen magazine buffs who read reams of publicist copy about their heroes and heroines—whether they sleep in pajamas and the usual nonsense about their being essentially shy—have no idea what life is like in the intimate circles of motion picture competition and production. Even though fictional portraits have been done of the queens and kings and producer prime ministers who reign and rule in Hollywood, the public doesn't really know about the true human material. There is a trait in human nature that people must have hero and heroine symbols, and for millions the queens and kings of Hollywood fill the bill. But all of us in our celebrity are thrice inflated, beyond all sense, reason, or comprehensibility. We often become aberrant, mercurial, insufferable people.

There is no doubt that at this time it wasn't possible for people to get too near me. I dismissed them; I rejected scripts, writers, deals, advice, men. I made people wait. Judgment wasn't as important to me as the opportunity to arbitrarily settle matters as befitted my whim. Like so many, I too became a queen.

I consider that in this bit of candor I have reached my greatest moment.

I asked Otto to give me a child. He said no.

I should have gone on and had that child anyway. I wanted a child. Over and over I had been advised by friends, physicians, well-wishers: Have another child, put Lynn behind you. I should have done what at least one other famous Hollywood actress did. I should have had his child and made myself talked about, exclusive, and controversial. But I had no desire to hurt him. If that was his decision, so be it. For me, it was the clue that I was out.

He still wasn't divorced, and he was a man with much at stake. He had one of the most brilliant careers in Hollywood moviemaking. And he had enough awareness of American society to know the social limitations placed upon a woman of color like me, and he could very well have asked himself, How will this affect me in Hollywood with all my associates? How far can I go with this girl? When and where and how must I cut it? I think that in the dark of night he might have had thoughts like this.

As I realized that we were in a game—I to get him, he to lose me—I had bitter nights of weeping. No one will ever know how I wept.

In the morning I rose like an automaton, went through my paces, off to the gym where I whirled like a dervish, then on through the rest of the dizzying day.

Cold steak. Cold cucumbers. Cold.

* * *

I turned to an old and dear friend for consolation, to give myself a lift, to talk out my problems with him as he talked out his with me.

Some time before I met Otto I became acquainted with a prominent Washington Democrat, Edward Cheyfitz. He was a redheaded Jewish lawyer between forty-five and fifty, the author of several books on labor relations, and he represented the Teamsters Union.

My friendship with Edward was platonic, but there was something in the association which embodied the entire problem I had with white men.

He had come into a club in New York where I was appearing. He was no night club roué or habitué; he was a man of position in Washington, in politics. He was all that I respected in a rounded-out human being. From the instant we met, we babbled like old friends.

I like many Jews. So often they seem to like me, and so many of the men who are drawn to me are Jewish. Is it a minority problem in common? Is it that Jews are often in the arts, politics, the professions? Whatever, from the outset, Edward poured out his thoughts, his problems. He even placed specific law problems in my lap and listened attentively to whatever ideas and suggestions I had.

This is classic mistress treatment. The mistress becomes the confidante, the listener and adviser. I had this same confidential relationship with him, without being his mistress.

He had two grown children, he told me, and he didn't want to upset their lives or the life of his wife by any adventure that would lead to divorce. I admired a man who wished to preserve his marriage. He told me that he and his wife had separate bedrooms; that he had in some ways outgrown her, for she was lost in household and

maternal obligations; there wasn't much in common there anymore. All so familiar, yet believable.

He found an outlet for his needs in my presence, comfort, and sympathy. He enjoyed merely looking at me. Once when our friendship warmed to the edge of intimacy, he remarked, "I wouldn't suggest that with you unless I could marry you, and I can't."

"But you say you're in love."

"In spite of that, I can't. Because of it, I won't."

"Why not then just an affair? Why can't we at least have that?"

"I wouldn't think of it unless I could marry you."

If I could only convey what that meant to me. I had received so little of that respect.

When Otto and I appeared to be breaking up, I phoned Edward from Los Angeles and told him I was going to New York, not on a singing engagement, but to get away from a certain person and a certain floundering situation. He knew who and what I meant, and we agreed to meet at Kennedy.

At the air terminal we embraced. It had been more than a year since I had seen him. We talked volubly.

We were getting ready to get into a taxi when I heard my name paged. Who could be trying to reach me? Who could know I was here and on what plane I had flown?

In the phone booth I heard Otto's voice: "Come home!" Said fiercely, like a man in command, a father or a lover.

I said no, I had an appointment with a friend.

"I know about that appointment. Ditch him! Come home! It's settled! Come home!"

I wilted and weakened. The command was so earnest. Maybe Otto . . . maybe?

I turned to Edward and told him that I must go back.

"Good luck," he said.

I flew back to Otto. The plane arrived in California in fog. We couldn't land at the regular airfield. We had to go on to Burbank.

It was raining when I got out. There at the edge of the field was Otto looking strong as a tree. Over his arm he carried an extra raincoat for me.

He draped the coat around me, he placed his arms around me. I walked at his side, as though I was being carried. He settled me in a limousine. All in silence, like an angry chastising father. We drove quietly, swiftly toward Hollywood.

He held his arms close around me all the way. I nestled in his ribs. He held me as if I were a perverse child who had done some ridiculous thing.

Pity I ever got into that car. I should have told him to go on home alone. For if I thought that Otto was going to change his mind, and I did, it was my last illusion.

But at that moment on that night, in that single performance witnessed by no one, in this gesture of silence and mastery, Otto was a magnificent actor.

I added a new dimension of failure when I grasped that Otto was another confrontation with a white man who would not follow through.

I ceased to have the motivations for "staying" that dominate many or most actors and actresses after they have arrived. I had proved to myself that I could act, that I might even have deserved the Oscar that season except that the political milieu wasn't right. I decided, Why should I break my head waiting for top roles, hoping for roles that weren't there because of the society in which I lived?

There was a limit to the professional vehicles avail-

able to me, as there was a limit to my acceptance in the white world and to white men. Whore roles were there, of course, like Bess in *Porgy and Bess,* or Carmen Jones. America was not geared to make me into a Liz Taylor, a Monroe, a Gardner. My sex symbolism was as a wanton, a prostitute, not as a woman seeking love and a husband, the same as other women.

I had realized everything except the limitations naturally placed upon me through being a Negro. If I thought that the world that had opened to me was to remain open, it was because I was ignorant of the Stoneface Mountain character of jimcrow. For me, as for the mass of Negro women, there was this enormous and well-defined barrier. God, if God were a beautiful black woman, probably couldn't surmount it.

Wildly, I began to wreck my career. I set out in ways of my own to upset offers that came my way, to be extravagant with money, to stifle starring roles that were offered me. I turned violent against my own career, because it wasn't the career I wanted.

Some people kill themselves with drink, others with overdoses, some with a gun; a few hurl themselves in front of trains or autos.

I hurled myself in front of another white man.

Part 7

Everything and Nothing

When I sang at the Riviera after I turned down Tuptim, each night after I returned to my dressing room I found a large bouquet of flowers. Always there was the card signed: Compliments, or Admiration, or Best Wishes of Jack Denison.

Ordinarily I would have ignored this attention. I had long since learned that men who pursue you to the dressing room are best avoided.

But when the flowers kept coming, when the pursuit was so ardent that it must somehow be handled, I made an inquiry and learned that he ran a local night club. That was all I knew of him till I met him.

He was a Canadian of Greek origin, handsome, well set, well spoken. He was older than I. He was, as far as I knew, respected in the community.

We had in common show business and the night club world, and when I left Vegas he remained in touch with me. He sent me wires, asking when I would return. He pursued me like a serious man.

When I knew that it was ended with Otto I telephoned

him. "Jack," I said, "I'm coming to Vegas. Your apartment needs a woman's touch."

Willy-nilly I invented a married life for myself. I treated Jack as though he were my husband and I was his wife. With him I could sit around at ease in a living room and watch television and pick my feet. I cooked and tried to please him with rare dishes. I cleaned his place until it shone.

In the early days we were tender with each other, and if it wasn't love it was at least companionable. Jack ran his night club and seemed to be affluent enough.

Whenever I could get away I would fly to Vegas and stay at Jack's apartment. I liked the privacy, even the secrecy.

Jack and I had our laughs. He was a good storyteller. He knew Las Vegas very well. He could talk about the gambling crowd. He liked to drink, and when he had a few in him he was good-humored, entertaining, a companion, and a man—a good lover.

He was handsome, and I liked him for that.

While I saw in Jack the possibility for a happy home life, the domesticity which a part of me craved, he saw in me something else altogether. I never knew in the early days what it was. But it was very simple—it was my overwhelming success, plus my style. He knew the huge sum I received for singing at Las Vegas when he first sent me flowers. He was wooing a rich and famous girl. He couldn't care less about a cook.

Yet for a year or more, I spent weeks at a time in Jack's apartment. Secret visits to the home of my handsome night club owner.

I had someone. I needed someone so badly.

The DuBose Heyward play *Porgy and Bess* was never popular with Negroes. The George Gershwin musical based upon the play fared no better and perhaps even worse. Actually the story is an accurate picture of the harsh, terrorized lives of Negroes forced to live in ghettoes. There are Catfish Rows all over America. The ghettoes of the North are large Catfish Rows, where the strain of living, the terror, tragedy, and disease shorten lives. That is what the fighting is all about, to change that.

But the thinking of many Negro civil rights leaders is that the impoverished conditions of Negroes should not be pictured in song or story, cinema or television. These advocates hold that you should show the "positive" side of black living, show the white man we can be as good and respectable and smug as is he. Show the whites we are nice American humans, and don't let them see the squalor in which nine-tenths of us live.

This controversy breaks out from time to time in Negro cultural circles when some play or story or novel reaches the public. There was such a furor over Richard Wright's *Native Son*. The fear was expressed by conservative Negro respectables that the figure Bigger Thomas would be viewed as a symbol of all male Negroes. Nothing of the sort happened.

I found myself, along with others, in the center of such a controversy when in 1956 Samuel Goldwyn undertook to film the Gershwin musical. As soon as it was announced that the picture would be made, organizations and individuals began protesting to Goldwyn and to his studio.

I was mentioned for the part of Bess. Harry Belafonte was asked to play the part of Porgy.

Harry telephoned me from New York. "Don't do it, it isn't right," he urged. "I'm out of it."

The character Porgy is a half-man, as it were; he is a stumped, legless figure who withal is human, real, warm, capable of love—and of murder. Normally this would be a prize role for any Negro male lead, and Harry must have had complicated pressures to decline the part.

"I'm going to think about it," I told him.

Otto telephoned. "Do it," he urged. "It'll make you as big a star as you were when you did Carmen."

While I wondered what to do, I received threat mail which asked, "Why do you always have to play a prostitute role, when you are supposed to be holding up Negro womanhood with dignity?"

Sidney Poitier was asked to play Porgy. He phoned me, asking what I intended to do. I said, "Look, I have spoken with Mr. Goldwyn about this. He told me of the letters he's received and of his correspondence with the organizations. He's going to do this picture with or without me. He will do it with or without you. Now the way I'm thinking, if I can help to bring some dignity to the role, maybe that is what it needs."

Sidney said, "Maybe you are right."

Sidney decided to play Porgy, but he wasn't too happy after he was finally in it. I think everything was terribly unreal to him.

There was no way to make Bess "ladylike." I didn't know this at the time. I decided that if Goldwyn was dead set on doing the picture, he might as well do it with me. I had had cinema experience, and the film might turn out better with me in it than with someone else.

When pressure is brought against an actress, a picture, a book, anything creative, you are apt to get a vitiated, neutralized product which comes out weak, mediocre, and not believable.

What happened was an attempt to clean up Catfish

Row! An actual attempt to make life on Catfish Row look not so bad. Everyone connected with the movie embarked on a program to take the terror, fright, and oppression out of ghetto living. You can't do a picture about the black lower depths and then wash up the street and wash the dogs that cross into the scene.

That was the kind of cleanup operation that was done in the film version of *Porgy and Bess*. That is what happens when people who are not artists, directors, actors, or writers make their influence felt on an art production. They come in with their fears and their great self-belief and their little button-pushing neighborhood political power, and they tell the actor how to act, the writer how to write, the singer how to sing and what to sing. The influence of this pressure permeated *Porgy and Bess* and wrecked it both as an entertainment vehicle and as a vehicle of instruction.

The filming was scheduled to be done on studio-made sets which would also make Catfish Row look to be not so bad. Actually the film should have been shot in the streets, in the shack-ridden quarters that fester throughout the South.

At the outset we had the services of one of the finest directors, Reuben Mamoulian. He and I got along well; he gave me sound ideas on how to approach the role.

Throughout the work the protests went on. I continued to receive critical letters.

Halfway through the filming there was a fire; the whole set burned down. As far as we knew, the fire was an accident.

After that there was a crisis on the producer-director level. Mamoulian was taken off the picture and Otto was brought in to complete it. We were by now manufacturing

a cut-up bastard of a film which would never be all one thing or another.

When Otto entered as a director, our relationship was a professional one. His famous temper was directed as fully upon me as I had been spared it in *Carmen Jones*. The vilification he once had for some poor actor named Glennet he now heaped upon me, telling me I was doing this wrong, that wrong. Now I was the idiot. He brought up my performance in an earlier and lesser picture, *The Decks Ran Red*. He lit into me. "You were rotten in that," he stormed for all to hear. The old romance was now as cold as iced cucumbers.

When my work ended at the studio each day, I disappeared back to my quiet house and my dogs.

The protests against the picture took a final form. A Negro community figure accused Otto of being prejudiced. The accusation appeared in the press. I don't know what grounds he had for saying this. In any case, I remained silent.

Later I heard that Otto was disappointed because I didn't go to the fore and explain that he was not prejudiced. My publicity advisers told me to stay out of it.

If Otto was prejudiced, he didn't know it.

Prejudice can show itself in many subtle ways in American movie-making. I remember an instance during the shooting of the film *Malaga*. The scene was this: I was lying on the banks of a river in Spain; the sun was shining; a shade tree threw shadows over me. The camera ground out shots of the rapidly running stream. The sun and the shadow played over my face. The camera panned from a river view to me; the light and the dark of my features showed. Now there were close-ups, and audiences would see a unique love scene. Above me was a white man, pas-

sionate, trembling—Trevor Howard, my co-star. His face, truly an Englishman's face, was close to mine. My features might look Spanish, or Anglo-Saxon, but the viewer would know that this was an American Negro, Dorothy Dandridge.

Close by the camera eye pointed. Trevor bent over me, his lips only a few inches from mine. I folded my arms around him, drew him close. The camera would show my fingers clutching into his back. Another instant and there would have been a bit of motion picture history—a white man kissing the lips of a Negro woman, on the screen, for the first time.

Suddenly the director's voice rang out. "Cut!"

Trevor started. I started. We looked at each other, still holding that pose, wanting to play out the business of lovemaking by the river edge.

I realized instantly what happened.

The kiss could not take place.

"That's all for today," the director said.

I was furious. Trevor and I discussed it, but the day's work was over.

The next morning we resumed shooting, Trevor and I in the same position, his lips close to mine. This time the director said, "Now break."

Trevor rose; I got up. The camera shot us as we stood, without that love scene being completed. Motion picture protocol had ruled again.

Very much the same thing had occurred to me a year earlier in making *Island in the Sun* in Jamaica. In that Darryl Zannuck picture a Negro-white relationship was suggested, and minimized. But a beginning was made by portraying an honest love relationship between a British attaché and a Jamaican girl of color.

These situations were very similar to the events in my

private life—my social relations with white men were also barred by protocol and law at a certain point.

Malaga was a difficult film to make, owing to constant script changes. It was a Twentieth Century Fox picture with Douglas Fairbanks Jr. as the producer. There was confusion among the makers of the film about the love relationship itself, whether it should be wholesome or suggestive, and these indecisions characterized the entire production and created tensions on all sides. These problems underlined why there never could be for me a true motion picture career. The limitations of life reached into art—at least, the screen art.

I returned to America in some disgust, not alone with that incident, but the complications of the entire picture. I wanted surcease from stardom, moviemaking, singing.

Whenever I returned from a singing engagement or a picture, Jack Denison was there. Sometimes he talked of doing a book. He knew Las Vegas very well and understood the inner workings of that notorious center. He was ambitious to make money, and as far as I knew, his night club prospered.

Once he took me around to five Las Vegas banks. He had ten thousand in each bank. Later I wondered whether this was his money, for when we were in trouble he had no such funds.

I heard whispers from time to time that he was this, that, or the other. But I remembered my mother's teaching that everybody had a good side. I felt that Jack, like all people, had a good side.

Hellbent on marrying a white man, I don't know what I wanted to prove. If it was respectability or wealth I was after, there was a question whether Jack at any time filled that bill. But he had the right look.

The thought kept going through my mind, Maybe I

could escape all of this, the work and the pressure, if Jack married me and took me out of it. He appeared to have the means to take care of me.

"Jack," I said to him, "don't you think we ought to get married?"

He was quick about it. "Sure, honey, why not?"

We set a date for several months away. I had to make a picture in France called *Tamango*. When I returned, we agreed, we would marry.

The picture ceased to interest me, but it had to be made. I would be able to get out of saloon singing forever, I told myself.

Pictures, saloons, oil wells, agents, managers, producers, actors, planes, maids, songs, family, bills, taxes, pressures, pressures. I was a very tired girl. Very, very tired. I dreamed of being alone quietly with Jack in my house in the Hollywood hills.

In France, doing *Tamanga* at ten thousand dollars a week, plus an extra thousand for expenses, I couldn't think of the picture and could only think about my coming marriage. The people I was associated with must have found me difficult to work with. My heart wasn't in it. I was upset by the knowledge that my oil investment was a disaster, and I had before me the spectre of incessant singing and endless making of unsuitable pictures. I was expecting Jack to be the gallant and the rescuer, for he had opened Jack Denison's, a night club on Hollywood Boulevard, and I thought, At last I have a man who will take me out of all this and support me.

Back in the States my friends were making arrangements for my marriage. It seemed to me that the date would conflict with the making of *Tamango*, and I decided that the picture be damned, I would leave it if necessary.

I was in a constant wrangle with Roland Girard, the producer of the Film Cyclope Company. The screenplay was derived from the original *Carmen,* a novel by Prosper Mérimée. There was a million-dollar budget and a sea background for the story of an exotic captured island princess and her love affair with a sea captain. A very pleasant man, Kurt Jurgens, had the part of the captain.

I was on the phone constantly with Jack, or with friends in Los Angeles who were arranging details of a marriage ceremony at St. Sophia's, a Greek Orthodox Church. As the marriage date came nearer and the filming bumbled on, I slipped into a mild hysteria. I had to phone my Los Angeles psychiatrist and talk with him.

Finally, I flatly refused to finish the picture. Everyone around me was frantic. Earl had worked up this deal, and he was with me in Paris, but he couldn't control me any more than anyone else. I dismissed him as my agent.

The producer called Jack and asked for a few days' postponement of the marriage. A few final shots for the film were made in London; then I found myself flying back to New York, thence to Los Angeles.

During the next few days I was on a carousel of indescribable trivial events. I arrived in Los Angeles in time to join with Jack in securing a marriage license. We were married at St. Sophia's, with the usual fanfare of television and press present.

What followed was a typical Hollywood honeymoon. Jack and I went to New York for the premier of *Porgy and Bess.* There I went through the conventional premiere photographing with Otto and Samuel Goldwyn. I couldn't wait to get away.

At last, I thought, Jack and I will have our honeymoon.

I have no recollection of the trip by plane with Jack

to San Francisco. The incessant cross-country travel and cross-ocean travel, plus the excitement of the marriage and the premiere, put me in a state of tension that made it necessary for me to remain under tranquilizers throughout.

When we were settled in the bridal suite at the Fairmount, I tossed myself on the bed. For a few hours I would sleep.

Through a soporific haze I heard Jack. "I am terribly worried about my business," he said.

"About your business?" I echoed.

"Yes. I'm going to go broke if something doesn't happen."

"Must we talk about business now?"

"You'll have to help me, Dottie."

I got into a negligee, a specially beautiful one which I bought for this event. "What do you want me to do?"

"You'll have to help me out at the club." He meant I would have to sing there, help him draw a crowd.

"We can take care of that when the time comes."

He droned on about being broke. The danger was imminent. He wanted to cut short the honeymoon and go right back to Los Angeles. He wanted me to start singing right away.

I was doing a slow burn.

He was drinking. He wasn't with me at all. "Look," he said, "if I can't do something about my business right away I am going to jump out of this window."

I went to the window and glanced below. Far far below it was solid cement. I could see those silly little Toonerville cable cars going up and down steep Powell Street.

"Look, dear heart," I shouted, *"jump!"*

I dressed and tore out of the room. I went below to the lobby where I met people I knew, and joined them in some drinks.

Honeymoon? Honeymoon!

Later I returned to the bridal suite, and this time Jack calmed down. But the note on which we started our honeymoon was a banknote.

After Jack fell asleep I got up. I sipped on champagne and looked out of the window below me at the surrealistically laid out city of San Francisco, the electric many-colored pattern of lights over the Bay Area. Green, red, yellow, and orange flickered along the highways.

I thought how the world sees only the surface of all things, the glitter, the blinking multi-colored exterior. I was thinking how specious was this surface beauty, like the glamour surrounding the world of cinema and fashion—my world.

I wondered what might be going on two miles away beneath one street lamp in the Western Addition or the Fillmore District. What torment and strife might not be occurring beneath just one of those lights.

I knew that the world in which I lived was seen by people as the same blinding incandescence, while beneath, under my own street lamp, there was my private world.

Because Jack wanted me to, I began singing at his club. I neither wished nor expected money; he was my husband and I wanted to help out.

But the place wasn't right for me. Maybe it was too small, or the acoustics weren't right. I wasn't bringing the crowd in. It was clear to each of us his club was headed

for failure. When he was forced out of business, he began to spend most of his time around the house.

Jack liked the sun. He went into the sun whenever he could. He went about with a sporty outdoors air.

It was at this time that Rual Steddiman called to tell me that the work had stopped on the oil wells. "We have to pay the workers or quit pumping," he said.

"You know I can't keep those pumps going any longer."

"If we don't pay those workers, they won't pump."

"You didn't tell me I had to keep workers going forever. You told me I'd retire by the time I was forty."

"These wells have to have a chance to produce."

"I've given them a chance. I can't put any more into them." The dialogue became irritable on both sides.

I didn't even part with Rual over the oil. I broke with him in a fight over a motion picture deal. Yet even after I dropped him as my lawyer and investment handler, I continued to make a few payments on those wells, hoping against hope that I could shore up the huge loss.

Jack knew I was going broke, but he wasn't much of a help. "Jack," I asked, "when are you going to get something to do? I need help badly."

He said he would get going again very soon. He did make certain efforts, flurries of motion that I hoped would lead to a new business or even to a maitre d's job at a hotel. But he was always at the house, drinking heavily, and not quite getting back into the swing.

He asked, "Honey, when are you going out on a new job?"

I hated that. Once more I was wearing the old jockstrap and suspenders. Once more I had to work to maintain a house, even a husband, and I hadn't solved a thing.

I didn't want to be packed off to work like that, while

there was an able-bodied experienced businessman around to help carry the load. The house in the hills was a huge drain. I had to pay more than fifteen hundred dollars a month, sometimes two thousand a month, to keep up mortgages and other expenses. I had heavy insurance, taxes; lawyers and agents had to receive their commissions. Picture deals flitted around my head, but with much less frequency. Once more I had to rely on cabaret work.

I went off to Pittsburgh or Tahoe on a singing deal. As I flew out, I carried with me the picture of Jack back there in the house sunning himself. His color was getting deeper; he was a shade or two darker than me. When he saw me off on a plane he was gallant as a knight. He leaped around the car doors, opening and closing them for me—my car.

When I returned from an engagement, the wrangle resumed. "Jack," I said, "it seems to me that your ego must be suffering undue agony to be around here not doing anything, with me out there doing it all."

He didn't want to talk about it. Heavy drinking began. Rousing fights became more frequent.

I had contrite moments when I felt how all this must be hard on a man. He couldn't possibly have liked it. But he couldn't get going again. He had moments when he bubbled with ideas, things he was going to do, television ideas. He was, to meet the eye, busy, busy. With leisure he looked magnificent—the dark tan, the prematurely gray hair at the temples. I had a husband who was the best-looking thing. I even think he loved me.

We began early morning drinking. Now and then, in one frenzy or another, Jack ripped a phone cord out of the wall. He swung from one room to the other on cussing sprees. The war of nerves that began on the wedding night now entered its violent phase.

The big earnings were falling away. By 1960, no more picture offers came my way. I was having to fight it out in the saloons. I earned forty thousand dollars in 1961, and sixty thousand dollars in 1962. For me, that was bad. It wasn't enough to keep me solvent. I had stayed out of the public eye a little too long for movie offers to come my way now. Nobody told me that you can't let your publicity die away or Hollywood swiftly forgets you.

It seemed everybody was after me now. Uncle Sam came hunting for taxes they said I hadn't paid. The house was mortgaged to the hilt.

Mel called me to say, "You know how much you dropped on that oil?"

"How much?"

"A hundred and fifty thousand. Your assets are down to five thousand. Your debts are around a hundred thousand." That was when he told me I would have to file in banktruptcy.

By now the war between Jack and me was at its bitterest. I talked of divorce.

"We just can't go on this way, Jack."

He swigged from his tall glass and told me to go to hell.

"I'm broke," I said, "for God's sake, don't you understand?"

In November of 1962 I filed a divorce petition.

Four months later, in March of 1963, the whole world tumbled around my head in a three-week period. As the divorce decree from Jack came in, my house was foreclosed. I was getting a legal, physical ejection from the big place in the hills. Then, as if this wasn't enough, Lynn was returned to me.

There was my darling dwarf of a girl in the house as I prepared to leave it. I had missed a few payments to Helen Calhoun, the woman who took care of her. They were the first payments I missed in ten years she had been in that woman's hands. And now Lynn was in my care and once more playing do-re-mi-fa-so-la-ti-do on the piano just as she had sixteen years earlier.

Lynn's grandmother, Viola Nicholas, took Lynn into her home while I looked for an apartment in Hollywood. A few days later I was called and told that Lynn was frothing at the mouth. She had been with me for two weeks and nothing like that happened.

Again I was called and told, "Lynn went down the slide. Then she lifted up her dress and peepeed in front of everybody."

"She didn't know where the bathroom was," I said. "When you take her to the park you have to show her where to go peepee. She doesn't know how to ask you. She can't speak."

Whether it was because they didn't know how to handle her or because Lynn was easily aroused to erratic or unpredictable behavior, she bit Mrs. Nicholas and did other terrible things, so I was told.

One of my friends phoned and frightened me. "She might be dangerous. She could come in and hit you over the head with something if you were asleep and she was playing do-re-mi-fa-so and you didn't applaud. She could conk you on the head. It is very dangerous to have her around."

Mother Nicholas and I took Lynn to General Hospital for an examination and for some recommendation as to what might be done with her next. The hospital said she was normal!

I tried at another local mental care facility. There I

was told I could go through the wards and see what they looked like. Maybe this might be the place for her.

It was like walking in hell. Death masks on all sides. Old people flat on their backs, just hanging on. This was no place for Lynn.

What I was in dread of was that Lynn would be sent off to the state mental hospital, Camarilla. For twenty years I had warded off having her put away in a place like that, but now, in bankruptcy, it was clear that I had to. The law says that cases like Lynn's must be judged; the retarded must be cared for in some way that the state deems adequate.

My child's case came up for disposition in the Los Angeles Medical Court. I walked into a room that looked very much like a court. Other persons sat in the rows waiting for their cases to be called. An armed officer was at the door.

A few cases were called before Lynn's. Mostly these were adults, and some articulated their problem and put up a defense against being sent to the state institution.

With me was my ex-mother-in-law and Lynn's doctor. The physician advised me not to say anything, but only to listen to what the judge and his committee of doctors and psychiatrists had to say.

"Miss Dandridge, will you step forward?"

I walked to a table up front. I glanced at the door through which Lynn would come. They opened the door and that little figure walked through.

The state recited the facts in her case. When they said that she was dangerous, I asked only one question, "Dangerous to who? Herself or other people?"

"Herself," said the official prosecuting the case.

From the bench came the sharp decision, "Camarilla." Out Lynn went.

I needed a drink of water. The doctor walked with me down the aisle and out of the courtroom. There my knees buckled. He picked me up, asked me how I was. All right, I told him.

Back in the courtroom I listened as the bench recited instructions for those who would be sent away—what clothes they would need, when they might be visited. The bus would be along in forty-five minutes.

The doctor tried to reassure me about Camarilla. It was no longer a bedlam, he said; they had recently investigated the place and made changes.

So, suddenly, Lynn was seized out of my hands and out of my life.

My two friends, Jerry and Maria Cole, the wife of Nat King Cole, promised me that they would go and see her from time to time, and they urged me to stay away.

But I didn't. One day I ran out and bought clothes that she might be able to wear. I put them in a suitcase and drove to Camarilla.

They brought her to me. She was wearing the drabbest dress. She looked strange and sad. Her belly stuck out. The food couldn't have been right for her. She gave me her smile, the same smile she gave anyone she liked.

Off there in Camarilla Lynn is very "happy," if that's the word for a neutral state. Out there she eats and sleeps, and there is a piano on which she goes do-re-mi-fa-so-la-ti-do. Last time I saw her she looked so small. She reminded me somehow of her father, for he too is slight.

If a child is born with brain damage and lives, give it up, the sooner the better. Have another child if you can, if your marriage is set up right.

But it's merciful if a brain-damaged child dies at birth. That's a cold thing to say. Believe me, it's true.

Not long after Lynn was sent to Camarilla, I was on a show in Cleveland for the Kennedy Foundation for Mental Retardation. I had to make a six-minute talk on mental retardation to the audience.

Prior to the talk, I had an interview backstage with the doctor for the foundation.

I went through with the talk, saying about what I have said in this book about Lynn—all of it in six minutes. They told me that a part of the crew cried. I didn't cry.

Backstage the doctor said, "There's nothing for me to say. She's said everything."

I have done a few other stints for mental retardation. If I wasn't bound up in cabaret singing and if I had time and the choice to do other things, I would devote myself to the world of the mentally retarded. I would love that. Working with the Kennedy Foundation would mean more to me than singing in a thousand saloons.

W hile I was in Cleveland—this was 1962—my father called from the lobby of the hotel. Another decade had gone by since I last saw him.

Same old conversation third time around. "Hello, Dorothy?"

"Who's this?"

"This is your dad. How are you feeling?"

"Fine. How are you?"

"Good. I'm here with Sugar."

My first reaction was emotional. I told him it was nice of him to call, but I was busy. Sugar got on the phone. I was a little more civil, but I hung up.

The bell captain telephoned me to say that he had some flowers my father wanted to send up. I felt contrite.

Maybe Cyril Dandridge had something to say. There is no story but that it has two or more sides. I called the lobby and asked the bell captain to please page Cyril Dandridge.

By now I had been through friends, lovers, pictures, two husbands, two colors, international travels, ups and downs. I hastened to fix myself up. I wanted to look nice.

The knock came at the door. My maid opened the door, and my father and Sugar entered in such a spirit of humility that I couldn't help but be touched.

As we talked, he explained why he and Ruby couldn't go on together. He was very sweet, it seemed to me, a nice man.

I liked him. I liked my father. I liked Sugar. She was a chubby replica of Ruby.

I seem to have come out in the middle, as between my father and mother, and there I want to let it rest. Mother is alive, and she will read this; and my father, who pursued me over the years in his way, as I have been pursuing some father I never found, he will read this.

All is forgiven.

How much will to survive was in me I don't know. I responded like an automaton.

Stop crying, I told myself, or you'll get mushroom eyes. Mother had always warned me about that, saying, "If you're going to get up before audiences, don't have mushroom eyes; don't cry." It was only a million bucks, I told myself, so go get another.

In a matter of days I hit the road, making an appearance at the Chi Chi in Palm Springs; the billing: The Chi Chi is Proud to Present the Glamorous Star of *Carmen Jones* and *Porgy and Bess*.

Out I went again, all through 1963, gay, sensuous, gowned to the hilt, swinging at the hips, moving my hands

as sinuously as an East Indian dancer. As far as they knew, all was well with my world. I knew what they wanted and expected. I knew what the white spenders thought: "Look at this beautiful brown broad. What a boff! Wouldn't I like to. . . ."

Nobody knew anything about me, and perhaps I did not know too much about myself. What were public images? The saloon crowd thought I was a figure of sex and hot stuff. The Negroes wanted to believe that I was an image of a successful star, a ladylike figure who must be an example to other young women of color entering the theatre. Nothing is more fleeting or fragmentary or false than an invented image.

Supposedly it was the beginning of a comeback trail, but I am not sure that it amounted to that. It was merely keeping on, every few weeks making an effort to fly to this place or that, to get hold of enough money to keep afloat.

I had begun with the music of Phil Moore. Maybe I ought to go back to him, have him work out new music for me. It was a bitter pill to have to go back to Phil, but I was desperate.

This time it was a hard cash business. He charged me twenty-five dollars an hour for studying me, analyzing me for the purpose of writing new song material. I worked with him for three or four days at that hourly rate, and I wound up having to borrow to pay him. The new songs he worked up weren't right for me.

I was near forty. Champagne, that memoir of Otto, was a regular part of my diet: a little every day, sometimes a lot. And by now regular visits to that doctor who prescribed a medicine cabinet full of drugs. None of this much altered the youthful look I always had. I had no wrinkles in either face or neck. Mechanically, from life

habit, I went to the gymnasium, and there I whirled like an acrobat.

A screen writer once grabbed hold of me by the waist, looked closely at my color, and this is what he said I looked like, even after all those trials: "Your skin is neuter. It is all the skin colorings of the world. It is chameleon, it changes in each swath of light, ranging white to dark by the instant. It is buff color, it is East Indian soft, it is South American blend, it can be Israeli, Gypsy, Egyptian, Latin. What is your color? It is a blend of the world's skin tones. Your hair is black, soft, universal. Your eyes are black and white flames; your nose is pert; the color in your cheeks, crimson, is your own and it sets off the tan. Your lips are blood-filled and esthetically shaped. You have three small moles, like beauty marks, one just below your right eye, a second below that near the lips, and a third on the chin at the right. These three moles set off the rest of your face."

These moles are real, not artificial. My maid once told me not to conceal them, but to exaggerate them. No one ever seems to regard them as moles or disfigurements, but instead as touches of cosmetic art. I use no cosmetics— nothing but a granular facial scrub which keeps my skin smooth, my cheeks red, and the skin tone vibrant. Nothing but that scrub, a little thickening of my eyebrows, and colorful bandanas for my hair. I wear clothes in har- monies of brightness against my "integrated" blackness- whiteness.

I am an integrated product. "The dream of integra- tion," somebody remarked.

But I don't feel like an experiment in human relations. I feel I am a person alive like you . . . and you . . .

It has been my fortune or misfortune to suffer both the separateness and the acceptance by the white world. It was my fortune or misfortune to be part Negro and part

white, and to be committed totally neither to one nor the other. It has been my fortune or misfortune to have made something of myself and to have partially lost that something.

Contradictory currents flow inside me; they often go in opposite directions at the same time. If you have a part of white America in your soul, and a part of black America in your spirit, and they are pulling against each other, your values, if any clear ones exist to begin with, can get lost or unsettled. Add to that, if you take a girl like me, intended by our environment to be a housemaid, then make a star out of her, don't look for simplicity of personality—look for complexity.

Over the years I have had a friend, Edward Stelton, an unrealized Negro actor, who has been acquainted with the main events in my life as far back as my first marriage. One day he stammered his sentiments about my travels on all sides of the color line: "You know what you need, Dottie . . . what you need to do is . . . you haven't met a Chinaman yet, have you? You need to meet a Chinaman. I bet you and a Chinaman would get along just fine."

That is how some have looked upon us, as if I am some kind of New Cosmopolitan, with lines out to the whole human race. Then again, I wonder. Why not? For I can't believe that men and women can be so very different from one another anywhere in the world.

In my wide travels and wide knowledge of a variety of men of different countries, I have had no experience that leads me to believe that the differences between people are significant. Men of whatever color and whatever physical variation are more alike than they are dissimilar. They are ninety-five per cent alike all over the world. The small physiological and psychological differences are slight, and

they ought to be the source of our genuine and curious interest in one another.

In our country there is a great deal of fretting over imagined differences between white men and women and Negro men and women. All of this stems from the simple fact that much normal contact between the two groups is illegal, has been illegal for centuries. This lack of knowledge of each other has bred ignorance, fear, fantasy, and a cultivated genre of lies and untruths. If you hold people apart by force and law, it is inevitable that they invent fallacies about each other. I was in some position to learn this simple truth.

One of the fondest notions whites seem to have is that Negro men have a larger phallus than white men. This is unproven, and it can't be proved by me. Anyway, even if this were so, it has nothing to do with sex or love. It is not the sex apparatus that makes the man. I am inclined to agree with the anthropologist Gordon Allport who said that the only issue of size is in the minds of a sick people and a sick nation, *psychological size,* he called it, a disease of the white imagination.

I resent it that ill and fearful minds attribute to the manhood and humanness of the dark-skinned male an unfounded characteristic so loaded with emotional content. It has aroused unnatural fear and curiosity among many white women; it has aroused fear and jealousy among white men. It is a matter of indifference to Negro women, whose main concern is having a family life with the male. An erroneous and evil sex emphasis has handicapped the decent human relations to which society ought to commit itself.

Whether with white or Negro men I have always sought companionship, friendship, good talking relationships. I like a good-looking man and a man who takes care

of his physical appearance. It is too one-sided for the man to expect a woman to be beautiful and then to be careless about himself. Love and lovemaking depend upon training, freedom from inhibitions, what people teach each other, and finally upon the closeness of understanding between them.

My prime experience with white men, however—and I think it is typical of what most Negro women feel—is that I have been treated finally with the disrespect which has historically been accorded the women of color. I found that I couldn't cope with or outsmart the rigid controls which old Mister Charley propagated and which he still successfully maintains.

On the lower levels, in the South, the black woman was often the classic "kept woman" in a cabin. Today she might be in an apartment, or more likely she is simply visited from time to time, but in any case she is sexually used. I went up the ladder of American public life, but only to get the same treatment up there where the bank accounts might be bigger or the reputations greater, but the attitudes were the same. I learned that the same thing applied to me as to any good-looking washwoman or houseworker in Mississippi: you can be used but don't expect to be received publicly and legally as a wife. Nothing that I had—beauty, money, recognition as an artist— was sufficient to break through the powerful psychological bind of racist thinking.

The civil rights world is quiet about white-black sex relationships. It is the last frontier of the civil rights world. If I was first to break some color barriers in the cinema community, I was also one of the first in the color-emotional area—and it is a bitch.

* * *

All through 1964 I chased a will-o'-the-wisp called Comeback. It was no comeback: it was jobs, jobs, travel, travel, till being in airplanes wearied me. I went on a tour of Europe during that season. In London, Venice, Lisbon, I sang, appeared on TV, fended off managers and agents who made the usual advances. For a time I worked in Lisbon with Xavier Cugat; and I performed at an Army show in Venice for American soldiers. But my performances were unstable, I was moving around in a neurotic haze, having spasms before or after singing, sneaking in drinks, taking pills to dehydrate myself.

I couldn't recoup. My expenses equalled my income. The Government stepped into the night club treasuries to grab my income—five hundred a week to pay for back taxes stemming from the period of my marriage to Jack. I couldn't pay commissions to agents, and that got me into trouble.

Uncle Sam moved in on a show in New York and took a haul. The Internal Revenue Service was more relentless than any private creditor I had. I figured that they must have a department in New York or Washington that keeps its eyes on artists—on the handful that make it out of the thousands who don't.

When I sang at the Key Club in the Shamrock Hotel in Texas, Uncle Sam moved in again. Glenn McCarthy, the manager, helped me to work it out so that the IRS couldn't quite kill me off entirely. I felt that Washington pursued me like Detective Javert pursued Jean Valjean in *Les Misérables*. The tax men watched the press to see where I'd be singing, and they posted themselves like grenadiers at the box office. Finally when friends, physicians, and lawyers managed to convey to them that I was sick and broke beyond repair, they put my case in the dead file. Dead file. How true.

When I paid off for wardrobe repairs, paid the pianist, paid off on loans, I literally didn't have money for food. I would get back to Los Angeles after a week or two abroad and wait for my friends to bring in a pound of fatback, a steak, or some fried chicken.

Once I had been one of the biggest headlines in Las Vegas. Only a few years before. Now I returned there to sing at the Flamingo, and I entertained in the lounge where the bar was and not in the main room. At that time Nancy Wilson was working in the main room, and I had to make out in a lounge where I couldn't project. I could hear the gambling machines. I hated looking at a bar while I sang, and now, each night for two weeks as I went through this ordeal, I was drunk. First time I ever sang drunk. Drunk each night when I got up to sing, and the folks knew it.

Earl was with me again as my agent, and he had not known of my increased drinking. He was all broken up trying to get me to cut the drink. I could take a bottle of champagne now and get it down much easier than the same quantity of water. Why not?

I worked three shows a night, practically all night. The manager wanted to fire me after the third day, but the owner of the Flamingo was Morris Landsberg who remembered me from my early days at Miami Beach. He protected me as much as he could from the wrath of the manager.

When I was in Los Angeles, I became a complete night owl. I never went to bed before six o'clock in the morning. I seemed to have to stay up all night while the rest of the world slept. Then I got busy. I placed calls to my friends locally and all over the world. My phone bill ran hundreds of dollars a month. I kept my friends awake half the night. When one call ended, I called someone else. I rattled on

about everything in the world. I sometimes talked for an hour or two without hearing a voice at the other end.

One night I called Camarillo State Hospital. I was in excellent voice, calm, lucid. "You know," I said to someone at the other end, "all that Lynn needs is some dancing lessons. I think she should have some ballet. Also, please don't let her overeat. The weight question is vital to her. She tends to get overweight. Also make sure she finger-paints and plays the piano. You understand."

Whoever it was at the other end called my friends in Los Angeles and told them that I had called and sounded strange and incredible in my requests. The hospital threatened to return the child to me if they were troubled any further in that way. I didn't know it, but Lynn was under deep sedation. The brain injury was now suffusing her with pains in various parts of the body.

I wanted less and less to go out on trips. I passed up engagements. It seemed endless and foolish that the more I sang, the less money I had to show for it.

Late in the year one interesting event occurred. I played and sang the part of Julie, the mulatto girl in *Show-boat*, at the Hyatt Music Hall at Burlingame, California. Kathryn Grayson had the lead role. We reheared the show for a few days, then played for three weeks. Kathryn and I got along well, and it was good to perform with someone so distinguished.

But the Hyatt Theatre is a theatre-in-the-round, and I wasn't used to it. I didn't actually like it. I was anxious, panicky, trying not to drink. But my balance wasn't good; I tended to reel once in a while.

Even so the show went on each night, and so did I—all except for one night. That night I went into a paralytic state for hours. I couldn't stand and had to be carried. Face, arms, and legs were frozen. Four physicians thought

I would never walk again. A standby took over for me that night.

Next day I performed again. I wanted to show Earl I could do it. In fact, they said I turned in a real good performance that night. I think in some way I was distressed by the role of the mulatto in Edna Ferber's classic. But by now anything might get me overwrought.

In Toronto on a singing engagement, my morale was so low that I no longer cared what I did. I threw myself away on a few men, thinking I might as well have an orgasm as there isn't much else. But I didn't succeed. It was an escape or a lapse alien to my real self, and it served only to deepen my self-loathing. If you acquire enough of that, you can hasten an exit off any stage.

After that I went to Tokyo. I had never seen Japan before. They wheeled me off the plane. I sang for eight days at a big beautiful Tokyo entertainment palace, two shows a night. I was on Benzedrine, pep-up pills, antibiotics, champagne. I called Earl each day from across the world.

I was running backward against time. I was on a carousel going backward. I could sing here or in Tokyo, but I wound up somehow swiftly moneyless. I could never sing long enough or loud enough or well enough or true enough to earn the money that I had to shell out just moving around the world and paying everybody that had to be paid.

The telephone company alone should rig up a monument to me. I kept their operators busy day and night. Stockholders in telephone stock owe me something, I don't know what.

When I got back to Los Angeles I was in such jittery shape that it dawned on Earl I could not be alone. I kept him up all night on the phone, or he had to come over and

stay with me. With time, he stayed all night on the living room cot while I tossed sleeplessly in my room.

One Sunday late in 1964, as I prepared to do this book and held the contract in my hands, I telephoned some friends to break the news.

Much to my astonishment they said, "What, an autobiography? Who are you to do an autobiography? What have you accomplished? If you tell your story, you'll set Negro womanhood back a hundred years. You make a damned poor image of a Negro woman. You will do us no good. Nothing in your career has any meaning for the Group."

As I listened I wanted to die . . . to hear my friends tell me that they viewed me and my career as meaningless trash. I can't even recall all of the invective I listened to. The receiver stayed in my numbed hands as I got one view of who I was from people I had known for over twenty years. It was about all that I needed to finish off any profound interest in living. I lay as near to death from that Sunday through Wednesday as I can ever be, without dying.

From time to time Earl brought in a little food, and I tried to take it. Now and then I reached for tranquilizers or Benzedrine, any bottle I chanced to touch.

There was only one decision I could make: I must either kill myself if I was that unworthy, or die of attrition then and there—simply will myself to death, which I felt like doing—or tell my story. Let outsiders decide whether my life, my work, my motherhood, my quest for security, my friendships were so reprehensible, so poor a human story.

In time I got out of bed.

During the next few days and in the subsequent weeks word spread that I contemplated telling this story. Calls

came from a variety of people urging me to keep quiet, even reviling me. So many who amount to very little or accomplish less are in a hurry to advise the few who may be fortunate enough to have struggled through to some slight achievement.

Once in the mid-fifties when I was working at the Chase Hotel in St. Louis, the local NAACP reached me and criticized me for performing at a segregated hotel. I talked with the owner, who agreed to allow the NAACP a table at my opening and permit the Negroes to enter the front door. With that, the hotel adopted permanently an integrated policy, and anybody who could afford the luxury prices could be admitted.

You could have that kind of experience one day and another not long afterward. Soon after that I went to London for the opening of *Carmen Jones*. The press and reception I received was enormous, like for a conquering general. I had an engagement at the Savoy where Princess Margaret and other royalty were patrons. I was entertained by Randolph Churchill, and I appeared as a guest, not as entertainer, at the Parliamentary Dinner held at the hotel. Prince Philip walked up to me, and I was naive enough at the time not to know who he was. But right after that, I met the owner of London's most famous night club, and he offered me ten thousand dollars to spend the weekend with him. The variety of social levels I operated on, from jimcrow in St. Louis to the mingled attitudes of the British, created the social-human carousel I was on. Such ranging experiences have left me with the reflections I have made.

The sad theme of my life is *the man who wasn't there*. My father was not there. My first husband, Negro, wasn't

there. My second husband, white, was around for a while, but at last he wasn't there. The other white men I knew, they were around for a time; then, like wraiths, they silently or abruptly slipped away, and they were never there.

I looked back upon a life of two husbands, friends, a few lovers, a span devoted to entertainment and the arts and performing for people, and to a fortune made and lost, and time spent marvelously, turbulently. I can hear my own laughter, and if I had a bucket at my feet I could see it brimful of my tears. I hear myself applauding myself at the age of three after my first recitation, and I also see and hear those drunks whistling in the barrooms of the world and myself taking a bend.

One child had I, and what a wonderful thing it is to bear and rear a human being—but a normal, feeling human being. All the rest is nothing, and all the rest has been nothing. The work was nothing, the applause nothing, the fortune made, that was nothing, and who knows, perhaps in my fury I let it all go.

In the last analysis what this society denied me was what it denies most women of color, perhaps all: simple respectability. If my story means anything, it means that the white millions still have to grant that simple and cost-less right to black women.

Negro women remain the last to be counted in our country. Our rights in sex and marriage and law are before the Supreme Court now in several tests. Time and the practical actions of people will change all this anyway. Human appeal across color and between sexes will always outrun the law.

The beauty, the humanness of black women is the next thing that will be noted. The problem in America is not exactly race, but racism, which is hatred.

Years have passed since that childhood when I went through the Southern states reciting light verses of Paul Laurence Dunbar. Several times since then, I have picked up his *Complete Poems* and looked inside, as if trying to get a glimpse backward or find a ray of light for my own experience since then. And of course it is true Dunbar, perhaps more than any other rhymester, captured the nitty-gritty of American Negro life, the mother wit, the homespun, the two feet in the mud character of my own background and the background of other millions.

I am weary now as any river that ever flowed: the disasters, the mistakes, the fortune made and misplaced, the lovers held and lost. What do you do when you are still young, and, so they say, still beautiful, and nothing much has meaning except to stay, to last, to hold on, to carry on regardless each day, wondering sometimes what for. Then what do you do? Why, of course, you pray. As Dunbar put it in his stanzas called "A Prayer":

> O Lord, the hard-won miles
> Have worn my stumbling feet;
> O soothe me with Thy smiles,
> And make my life complete.
> The thorns were thick and keen
> Where'er I trembling trod;
> The way was long between
> My wounded feet and God.
> Where healing waters flow
> Do Thou my footsteps lead.
> My heart is aching so
> Thy gracious balm I need.